FIFTH AVENUE, 5 A.M.

ALSO BY SAM WASSON

A SPLURCH IN THE KISSER:
THE MOVIES OF BLAKE EDWARDS

FIFTH AVENUE, 5 A.M.

Audrey Hepburn,

Breakfast at Tiffany's, and

the Dawn of the Modern Woman

SAM WASSON

HARPER

An Imprint of HarperCollins*Publishers*

Grateful acknowledgment is given to the following sources for photographs in this book: Allied Artists Pictures, MGM, Paramount Pictures, Photofest, and Richard Shepherd.

HarperCollins books may be purchased for educational, business, or sales promotional use. For information please write: Special Markets Department, HarperCollins Publishers, 10 East 53rd Street, New York, NY 10022.

FIRST EDITION

Designed by Eric Butler

Library of Congress Cataloging-in-Publication Data

Wasson, Sam.
 Fifth Avenue, 5 A.M. : Audrey Hepburn, Breakfast at Tiffany's, and the dawn of the modern woman / Sam Wasson. — 1st ed.
 p. cm.
 ISBN 978-0-06-177415-7
 1. Breakfast at Tiffany's (Motion picture) 2. Hepburn, Audrey, 1929–1993. I. Title.
PN1997.B7228W37 2010
791.43'72—dc22

 2009052439

10 11 12 13 14 OV/RRD 10 9 8 7 6 5 4 3

To Halpern, Cheiffetz, and Ellison,
without whom, etc.

IF THERE IS ONE FACT OF LIFE THAT
AUDREY HEPBURN IS DEAD CERTAIN OF,
adamant about, irrevocably committed to, it's the
fact that her married life, her husband and her baby,
come first and far ahead of her career.

She said so the other day on the set of *Breakfast
at Tiffany's,* the Jurow-Shepherd comedy for Para-
mount, in which she plays a New York play girl, café
society type, whose constancy is highly suspect.

This unusual role for Miss Hepburn brought up
the subject of career women vs. wives—and Audrey
made it tersely clear that she is by no means living
her part.

PARAMOUNT PICTURES PUBLICITY,
NOVEMBER 28, 1960

CONTENTS

STARRING

Audrey Hepburn
as The Actress who wanted a home

Truman Capote
as The Novelist who wanted a mother

Mel Ferrer
as The Husband who wanted a wife

Babe Paley
as The Swan who wanted to fly

George Axelrod
as The Screenwriter who wanted sex to be witty again

Edith Head
as The Costumer who wanted to work forever, stay old-fashioned, and never go out of style

Hubert de Givenchy
as The Designer who wanted a muse

Marty Jurow and Richard Shepherd
as The Producers who wanted to close the deal for the right money and get the right people to make the best picture possible

STARRING

Blake Edwards

as The Director who wanted to make a sophisticated grown-up comedy for a change

Henry Mancini

as The Composer who wanted a chance to do it his way

and Johnny Mercer

as The Lyricist who didn't want to be forgotten

COSTARRING

Colette

Doris Day

Marilyn Monroe

Swifty Lazar

Billy Wilder

Carol Marcus

Gloria Vanderbilt

Patricia Neal

George Peppard

Bennett Cerf

Mickey Rooney

Akira Kurosawa
as The Offended

AND INTRODUCING

Letty Cottin Pogrebin
as The Girl who saw the dawn

HOLLY GOLIGHTLY'S NEW YORK

1. COLONY RESTAURANT, MADISON AVENUE & 61ST STREET
Where producer Marty Jurow won the rights to *Breakfast at Tiffany's*.

2. GOLD KEY CLUB, 26 WEST 56TH STREET
Carol Marcus and Capote would meet here at 3:00 A.M., sit in front of the fireplace, and talk and talk.

3. COMMODORE HOTEL, LEXINGTON AVENUE & 42ND STREET
Where Paramount held an open cat-call to cast the part of Holly's cat, Cat.

4. PALEY PIED-À-TERRE
A three-room suite on the tenth floor of the St. Regis Hotel where Bill and Babe Paley lived when they weren't at their estate on Long Island.

5. 21 CLUB, 21 WEST 52ND STREET
In the film of *Breakfast at Tiffany's*, where Paul, after Holly bids farewell to Doc, takes Holly for a drink.

6. GLORIA VANDERBILT, 65TH STREET BETWEEN FIFTH & MADISON AVENUES
A brownstone that served as the model for Holly's, and the place where Carol Marcus met Capote.

7. EL MOROCCO, 154 EAST 54TH STREET
Where Marilyn Monroe kicked off her shoes and danced with Capote.

8. LA CÔTE BASQUE, 5 EAST 55TH STREET AT FIFTH AVENUE
Favorite lunch spot of Truman and his swans. Also the setting for Capote's incendiary "La Côte Basque, 1965," which nearly cost him everyone he professed to love.

9. PLAZA HOTEL, 58TH STREET & FIFTH AVENUE
Frequented by Gloria Vanderbilt and Russell Hurd,
one of Capote's inspirations for *Breakfast at Tiffany's*
unnamed narrator.

**10. FOUNTAIN ON NORTHEAST CORNER OF 52ND STREET &
PARK AVENUE**
Exterior location for *Breakfast at Tiffany's*.

11. TIFFANY & CO., 727 FIFTH AVENUE AT 57TH STREET
Site of the first scene of *Breakfast at Tiffany's*, shot on the
first day of filming, Sunday, October 2nd, 1960, 5:00 A.M.

**12. BROWNSTONE AT 169 EAST 71ST STREET, BETWEEN
LEXINGTON & THIRD AVENUES**
Chez Golightly in the movie *Breakfast at Tiffany's*.

**13. NAUMBURG BANDSHELL IN CENTRAL PARK,
72ND STREET & FIFTH AVENUE**
Exterior location for *Breakfast at Tiffany's* where Doc
and Paul have their chat about Holly.

**14. NEW YORK PUBLIC LIBRARY ON 42ND STREET &
FIFTH AVENUE**
Exterior location for *Breakfast at Tiffany's*.

15. RADIO CITY MUSIC HALL, 1260 AVENUE OF THE AMERICAS
Site of *Breakfast at Tiffany's* New York premiere, October 5,
1961.

Holly Golightly's New York

Central Park

W. 72nd St.
E. 72nd St.
71st St.
65th St.
61st St.
E. 59th St.
58th St.
Central Park South
W. 57th St.
E. 57th St.
56th St.
55th St.
54th St.
53rd St.
52nd St.
Rockefeller Center
46th St.
Grand Central
Times Square
W. 42nd St.
E. 42nd St.
W. 34th St.
E. 34th St.
P.O.
Penn Station
W. 23rd St.
E. 23rd St.

Columbus Circle

Ninth Ave.
Eigth Ave.
Broadway
Seventh Ave.
Avenue of the Americas (Sixth Ave.)
Fifth Ave.
Madison Ave.
Park Ave.
Park Ave. South
Lexington Ave.
Third Ave.
Second Ave.
First Ave.
York Ave.

FDR Drive
East River

Bon chers amis -

Those simply <u>marvelous</u> people at Paramount are showing that divine movie, "Breakfast at Tiffany's" Thursday evening, July 6th, and you, pet, are invited.

It'll be at: Grauman's Chinese Theater, (such a quaint name, eh bien?) at 8:30 o'clock, pee em, that is.

Do <u>be</u> there because this will be a <u>tres</u> exclusive entertainment, the first and only screening until the film is released to the provinces and so on for just every old body.

I'll look for you and votre âme.

Mille tendresse,
Holly
xxxx

Repondez, s'il vous plait.
Hollywood 9-2411
Ext. 843
(Just ask me or Flossie for your tickets. You'll need them to get in.)

Invitation to *Breakfast at Tiffany's* Hollywood premiere, October, 1961.

COMING ATTRACTION

Like one of those accidents that's not really an accident, the casting of "good" Audrey in the part of "not-so-good" call girl Holly Golightly rerouted the course of women in the movies, giving voice to what was then a still-unspoken shift in the 1950s gender plan. There was always sex in Hollywood, but before *Breakfast at Tiffany's,* only the bad girls were having it. With few exceptions, good girls in the movies had to get married before they earned their single fade to black, while the sultrier among them got to fade out all the time and with all different sorts of men in just about every position (of rank). Needless to say, they paid for their fun in the end. Either the bad girls would suffer/repent, love/marry, or suffer/repent/marry/die, but the general idea was always roughly the same: ladies, don't try this at home. But in *Breakfast at Tiffany's,* all of a sudden—because it was Audrey who was doing it—living alone, going out, looking fabulous, and getting a little drunk didn't look so bad anymore. Being single actually seemed shame-free. It seemed fun.

Though they might have missed it, or not identified it as such right away, people who encountered Audrey's Holly Golightly in 1961 experienced, for the very first time, a glamorous fantasy life of wild, kooky independence and sophisticated sexual freedom; best of all, it was a fantasy they could make real. Until *Breakfast at Tiffany's,* glamorous women of the movies occupied strata available only to the mind-blowingly chic, satin-wrapped, ermine-lined ladies of the boulevard, whom no one but a true movie star could ever become. But Holly was different. She wore simple things. They weren't that expensive. And they looked stunning.

Somehow, despite her lack of funds and backwater pedigree, Holly Golightly still managed to be glamorous. If she were a society woman or fashion model, we might be less impressed with her choice of clothing, but because she's made it up from poverty on her own—and is a *girl* no less—because she's used style to overcome the restrictions of the class she was born into, Audrey's Holly showed that glamour was available to anyone, no matter what their age, sex life, or social standing. Grace Kelly's look was safe, Doris Day's undesirable, and Elizabeth Taylor's—unless you had that body—unattainable, but in *Breakfast at Tiffany's,* Audrey's was democratic.

And to think that it almost didn't come off. To think that Audrey Hepburn didn't want the part, that the censors were railing against the script, that the studio wanted to cut "Moon River," that Blake Edwards didn't know how to end it (he actually shot two separate endings), and that Capote's novel was considered unadaptable seems almost funny today. But it's true.

Well before Audrey signed on to the part, everyone at Paramount involved with *Breakfast at Tiffany's* was deeply worried about the movie. In fact, from the moment Marty Jurow and Richard Shepherd, the film's producers, got the rights to Capote's novel, getting *Tiffany's* off the ground looked downright impossible. Not only did they have a highly flammable protagonist on their hands, but Jurow and Shepherd hadn't the faintest idea how the hell they were going to take a novel with no second act, a nameless gay protagonist, a motiveless drama, and an unhappy ending, and turn it into a Hollywood movie. (Even when it was just a book, *Breakfast at Tiffany's* was causing a stir. Despite Capote's enormous celebrity, *Harper's Bazaar* refused to publish the novel on account of certain distasteful four-letter words.)

Morally, Paramount knew it was on shaky ground with *Tiffany's;* so much so that they sent forth a platoon of carefully worded press releases designed to convince Americans that real-life Audrey wasn't anything like Holly Golightly. She wasn't a hooker, they said; she was a kook. There's a difference! But try as they might, Paramount couldn't hoodwink everyone. "The *Tiffany* picture is the worst of the year from a morality standpoint," one angry person would write in 1961. "Not only does it show a prostitute throwing herself at a 'kept' man but it treats theft as a joke. I fear 'shoplifting' will rise among teen-agers after viewing this." Back then, while the sexual revolution was still underground, *Breakfast at Tiffany's* remained a covert insurgence, like a love letter passed around a classroom. And if you were caught in those days, the teacher would have had you expelled.

So with all that was against *Breakfast at Tiffany's,* how did they manage to pull it off? How did Jurow and Shepherd convince Audrey to play what was, at that time, the riskiest part of her career? How did screenwriter George Axelrod dupe the censors? How did Hubert de Givenchy manage to make mainstream the little black dress that seemed so suggestive? Finally—and perhaps most significantly—how did *Breakfast at Tiffany's* bring American audiences to see that the bad girl was really a good one? There was no way she could have known it then—in fact, if someone were to suggest it to her, she probably would have laughed them off—but Audrey Hepburn, backed by everyone else on *Breakfast at Tiffany's,* was about to shake up absolutely everything. This book is the story of those people, their hustle, and that shake.

FIFTH AVENUE, 5 A.M.

1

THINKING IT

1951–1953

THE FIRST HOLLY

Traveling was forced upon little Truman Capote from the be-
ginning. By the late 1920s, his mother, Lillie Mae, had made a
habit of abandoning her son with relatives for months at a time
while she went round and round from man to high-falutin'
man. Gradually the handoffs began to hurt Truman less—either
that, or he grew more accustomed to the pain—and in time,
his knack for adaptation turned into something like genius.
He was able to fit in anywhere.

After his parents' divorce, five-year-old Truman was sent
to his aunt's house in Monroeville, Alabama. Now was Lillie
Mae's chance to quit that jerkwater town and hightail it to a big
city. Only there could she become the rich and adored society
woman she knew she was destined to be, and probably would

have been, if it weren't for Truman, the son she never wanted to begin with. When she was pregnant, Lillie Mae—Nina, as she introduced herself in New York—had tried to abort him.

Perhaps if she had gone away and stayed away, young Truman would have suffered less. But Nina never stayed away from Monroeville for long. In a whirl of fancy fabrics, she would turn up unannounced, tickle Truman's chin, offer up an assortment of apologies, and disappear. And then, as if it had never happened before, it would happen all over again. Inevitably, Nina's latest beau would reject her for being the peasant girl she tried so hard not to be, and down the service elevator she would go, running all the way back to Truman with enormous tears ballooning from her eyes. A day or so would pass; Nina would take stock of her Alabama surroundings and once again, vanish to Manhattan's highest penthouses.

Had he been older, Truman might have stolen his heart back from his mother the way he would learn to shield it from others, but in those days he was still too young to be anything but in love with her. She said she loved him, too, and at times, like when she brought him with her to a hotel, promising that now they'd really be together, it looked to him as though she finally meant it. Imagine his surprise then when Nina locked him in the room and went next door to make money-minded love with some ritzy someone deep into the night. Truman, of course, heard everything. On one such occasion, he found a rogue vial of her perfume and with the desperation of a junkie, drank it all the way to the bottom. It didn't bring her back, but for a few pungent swallows, it brought her closer.

For the better part of Capote's career as a novelist, that

bottle—what was left of his mother—would be the wellspring of most of his creations. The idea of her, like the idea of love and the idea of home, proved a very hard thing to pin down. He tried, though. But no number of perfume bottles or whiskey bottles, no matter how deep or beautiful, could alter the fact of her absence. Nor could most of the women or men to whom Truman attached himself. They could never pour enough warmth into the void.

In consequence, Capote was equal parts yearning and vengeance, clutching at his intimates with fingers of knives that he would turn back on himself when left alone. However sharp, those fingers pulled his mother from the past and put her on the page where, in the form of language, he could remake her perfume into a bottomless fragrance called Holly Golightly. That's how Truman finally learned the meaning of permanence.

Once the reading world got a whiff of it, eau d'Holly made everyone fall in love with Truman, which, since his mother had left him that first time, was the only thing he ever wanted. That and a home—a feeling of something familiar—like an old smell, a favorite scarf, or the white rose paperweight that sat on Truman's desk as he wrote *Breakfast at Tiffany's*.

THE WHITE ROSE PAPERWEIGHT

When he was in Paris in 1948, soaking in accolades for his lurid first novel, *Other Voices, Other Rooms,* Truman was delivered by Jean Cocteau to Colette's apartment in the Palais Royal. She was nearing eighty, but the author of *Gigi,* the *Claudine* novels,

and countless others, was still France's grandest grande dame of literature.

In full recline, Colette, racked with arthritis, no doubt smiled at Truman's author photograph on the dust jacket of *Other Voices*. Staring out at her with his languid eyes and slick lips, the boy's salacious look was one the old woman knew well; in her day, she had rocked Paris with a few *succès de scandales* of her own, both on the page and off. Now here was this rascal with his angel's face—a hungry angel's face. How delicious. She felt for sure there existed a kind of artery between them, and even before he entered her bedroom, Truman sensed it too. *"Bonjour, Madame." "Bonjour."* They hardly spoke each other's language, but as he approached her bedside, their bond grew from assured to obvious. The artery was in the heart.

After the tea was served, the room got warmer, and Colette opened Truman's twenty-three-year-old hand. In it she placed a crystal paperweight with a white rose at its center. "What does it remind you of?" she asked. "What images occur to you?"

Truman turned it around in his hand. "Young girls in their communion dresses," he said.

The remark pleased Colette. "Very charming," she said. "Very apt. Now I can see what Jean told me is true. He said, 'Don't be fooled, my dear. He looks like a ten-year-old angel. But he's ageless, and has a very wicked mind.'" She gave it to him, a souvenir.

Capote would collect paperweights for the rest of his life, but years later the white rose was still his favorite. Truman took it with him almost everywhere.

AUDREY AWOKEN

It all began for Audrey Hepburn in spring of 1951 on a gorgeous day like any other. She rose at dawn, had a cup of coffee in bed, and took her breakfast—two boiled eggs and a slice of whole wheat toast—to the window, where she could watch the morning people of Monte Carlo sail their yachts into the sea. Such a leisurely breakfast was a rare pleasure for her; back in England, where she had been working regularly, they started shooting at sunup. But the French liked to do things differently. They didn't really get going until *après dejeuner,* and they worked late into the night, which gave Audrey mornings to explore the beaches and casinos, and time to place a call to James, her fiancé, who was off in Canada on business—again.

He really was a very sweet boy, and attractive, and from the Hansons, a good and wealthy family. He loved her of course, and she loved him, and from the way it looked in the press, they had everything. But everything is nothing when there's no time to enjoy it. With her schedule taking her from film to film, and his seemingly endless tour of the world's ritziest boardrooms, it was beginning to look like they were betrothed in name only. Perhaps, Audrey thought, she was foolish to think she could be an actress and a wife. If she wanted to settle down—and she did, very badly—she would have to put films aside. At least, that's what James said. Only then could they really truly be together.

Somewhere in her mind they were. They had a house, two or three children, and a limitless expanse of days broken only

by sleep. Thankfully, her role in *Monte Carlo Baby* was only going to last a month. That was no small consolation.

COLETTE AWOKEN

The Hotel de Paris was unquestionably the most stunning hotel in all of Monaco. Judging from its façade, a Belle Epoque confection of arches and spires, only the absolute cream of society could make a habit of staying there. For Audrey, who had never been to the Riviera, being at the Hôtel de Paris was a thrill tempered only by her longing for James and the inanity of the film (the script was drivel; some semimusical fluff about a missing baby). But for Colette, it was nothing unusual, just another drop in the great gold bucket of luxury; she had been a regular since 1908. Now, as a guest of Prince Rainier, Colette was the palace queen, and as her wheelchair was turned down the hotel's stately corridors, that's exactly how the footmen greeted her. No doubt they saw in the old woman all the arterial fire of her novels, which seemed to throb through her from toe to *tête,* culminating in an explosion of red-broccoli hair.

The doctors sent her there to rest, but resting, for Colette, required more effort than working. Since her New York agent's assistant had taken it upon himself to single-handedly produce a play of her novel *Gigi,* Colette couldn't get the idea out of her mind. She'd even gone a little delirious trying to cast the title part and began to see Gigis everywhere—on the street, in the sea, and popping up in photographs. But none quite satisfied Colette, and time wore expensively on. Those who had invested in the project grew restless, and—as tends to be the

case in most casting legends—they were about to force the play upon a proven star, when, at the last minute, Colette was disturbed on her way to dinner.

What was about to happen would change Audrey's life forever.

To her annoyance, Colette discovered that the main dining room had been closed for the shooting of *Monte Carlo Baby*. Would she, the maître d' asked her, take her dinner in the breakfast room instead? *Absoluement non!* Insulted, Colette pushed her way right into the dining room and right into the middle of a take.

The scene stopped dead in its tracks. The crew looked up. No one breathed, except Colette. Catching sight of a strangely compelling young woman, Colette squinted through the beaming lights and raised her eyeglasses for a closer look.

Audrey, of course, had no inkling of being watched. Nor had Colette any inkling of who she was. What she did know, however, was that she seemed to have stepped into her own novel: in face, body, and poise, she was staring at Gigi come to life.

Perhaps Colette stared for full minutes, or perhaps just moments, but most likely she spoke out instantly, for as Audrey has proven millions of times since, that is all it takes for her to overcome whoever lays eyes on her. In an instant—a scientific measurement when speaking of stars—she conveyed to Colette what it took the author an entire novel to describe. That is, the story of a Parisian girl, who at sixteen, was set to undergo the education of a courtesan.

"*Voilà*," Colette said to herself, "*c'est Gigi.*"

And like that, Audrey's transformation had begun.

"*Voilà* . . ." Like that.

It all sounds so magical, and indeed in a way it was, but like all perfect acts of casting, Colette's epiphany was born of more than just gut feeling—it was born from fact. Although Audrey's innate sensuality, her Gigi-ness, was written all over her, no one until Colette had seen it. Perhaps it was because of Audrey's strangeness. Her legs were too long, her waist was too small, her feet were too big, and so were her eyes, nose, and the two gaping nostrils in it. When she smiled (and she did often), she revealed a mouth that swallowed up her face and a row of jagged teeth that wouldn't look too good in close-ups. She was undoubtedly not what you would call attractive. Cute maybe, charming, for sure, but with only the slightest hint of makeup and a bust no bigger than two fists, she was hardly desirable. The poor girl was even a bit round-faced.

And yet Colette couldn't stop staring. She was fascinated.

WHAT SHE SAW PART I: THE FACE

Audrey's might not have been the face of a goddess, but like most teenagers, Gigi did not begin as a goddess. She was simply a girl on the precipice of young adulthood, full of potential, but without experience. And her eyes said that, didn't they? They were certainly on the big side, but they were also wide, and wide-eyed people have a look of perpetual curiosity. Colette's Gigi had that. So do all those who don't yet know the world. But that nose would be a problem, wouldn't it? It was not sleek or pretty in the manner of high society ladies, and neither were her hair, teeth, or thickset eyebrows. So how would such a Gigi, looking not unlike a stray puppy, gain access to the haut monde?

There was little that was womanly about her in the sexual sense, nothing that said she was capable of pleasing a man, and certainly nothing that looked ahead to the naughty insinuations of Holly Golightly.

Or was there? Was there a drop of sex someplace beneath?

Smiling now, Colette lowered her eyeglasses and leaned forward for a closer look.

WHAT SHE SAW PART II: THE BODY

The girl carried herself like a suppressed ballerina. Despite what were then considered physical imperfections, Audrey had a remarkable discipline in movement, one that told of self-possession impossibly beyond her years, and so much so that to watch her, Colette had to wonder at how a thing so young could have understood poise so completely. In her simplest gesture Audrey communicated a complete knowledge of propriety, and by extension, an inner grace that belied whatever made her look that unusual in the first place. She wasn't dancing, but she might as well have been.

EVERYTHING THAT IS IMPORTANT IN A FEMALE

"Madame?"

A flock of admirers had approached Colette. She swatted them off. (Colette would enchant them later. If she was in the mood.) The old woman reached up and pulled down an unsuspecting member of the crew.

"Who is that?" she croaked, nodding in Audrey's direction.

"That is Mademoiselle Hepburn, madame."

"Tell her I want to speak with her." She released him and added a touch of pink powder to her nose. "Tell them to bring her to me."

Colette's conviction grew as she watched Mademoiselle Hepburn approach. This girl was even more startling up close than she was from afar.

"*Bonjour, madame,*" she said.

"*Bonjour.*"

Colette took her hand, and together, they moved into the hotel foyer. There she told Audrey that she intended to cable her producer and writer in New York and tell them that they should call off their search, that she had found her Gigi, and though they wouldn't have heard of her, they were to fly to London and meet her at once.

Audrey listened to it all, but was not quick to respond.

Finally, she spoke. "I can't" is what she famously said. "The truth is, I'm not equipped to play a leading role. I've never spoken onstage." Then she added, "I'm a dancer."

"Yes, yes, you are that," Colette returned. "You are a dancer because you have worked hard at it, and you will now work hard at acting, too."

Months later, Audrey was at the Savoy Hotel in London to meet with the play's writer, Anita Loos, and Gilbert Miller, its producer. She told them what she had told Colette, that she was not an actress, and that playing Gigi would be impossible for her. Miller nearly buckled under the weight of her protestations, but Loos wouldn't leave it at that. Though Audrey stood before her a wholly inexperienced girl, wearing, somewhat gawkily, an oversized shirtwaist and flat shoes, the author of *Gentlemen Prefer Blondes* knew she had spotted something

special. With Audrey's gender-redefining interpretation of Holly Golightly still ten years off, Loos had the keen sense— a sense so many flappers like her once had—to note the tides changing a generation in advance. Audrey Hepburn, she said sometime later, had "everything that is important in a female." She would be proven right in the years to come.

But it would take Audrey a long time to get there. Since she was a little girl, what Audrey had really wanted to be was a ballerina. But her body was wrong, and she was left with no choice but to join a music hall chorus where she was spotted and rushed into films. From there, it was bigger parts in bigger films, and she soon saw that her dream of getting married to James Hanson, like her dream of dancing, had to be put on ice. Now if she took *Gigi,* it would have to be put off again. But Audrey's star was stronger than she was. At the urging of all who were close to her, she reluctantly accepted the part of Gigi. Colette, Audrey maintained, was wrong.

THE CIGARETTE GIRL

Sitting at his desk, fretting over the dreary state of *Roman Holiday,* the impossible-to-cast production they were trying to cobble together at Paramount, Richard Mealand, the studio's man in London, recalled a brief scene in a film called *Laughter in Paradise.* It was the summer of 1951.

Of the picture's regrettable ninety minutes, a certain twenty-two seconds stood out. In it, a distinguished-looking sort of gentleman, sitting alone at a bar, is interrupted by a soft and knowing "Hello!" He looks up. The cigarette girl, a twenty-one-year-old waif called Audrey something, is standing over him.

"Want a ciggie?" she asks with an open smile.

"Hello, sweetie," he chuckles. "No, I'll be smoking cigars from now on. But what about a date later on this evening? I feel like celebrating."

She smiles again, but guilelessly, as if the word *date* were never mentioned.

The man gets up. "Well," he says, putting his hand on her shoulder, "I don't want that old goat in the telephone box to see us talking."

"Why?" she asks.

"Well, don't think me mad," he says, sitting again, "but just for the moment I'm not allowed to talk to women."

The smile fades. She looks down. "Don't I count as a woman?"

She was adorable. It was worth a shot, Mealand thought, but would the studio go for it? They had Gregory Peck, and they wanted a name, a name just as big, for the part of Princess Ann, one like Elizabeth Taylor or Jean Simmons. But their schedules had not aligned. Both were unavailable.

The studio was desperate when Mealand wrote Hollywood about the young actress he saw in *Laughter in Paradise*.

THE TEST

On September 18, 1951, just before she was to begin rehearsals for *Gigi* in New York, Audrey was led into a soundstage at England's Pinewood Studios for a screen test.

To see if Audrey Hepburn the person was like Audrey Hepburn the actress, and genuinely had that combination of naïveté and worldliness he wanted, William Wyler, director

of *Roman Holiday,* secretly instructed his cameraman to keep the camera rolling after her scene had ended.

"Cut!"

Audrey bolted up in bed. "How was it?" she asked. "Was I any good?"

There was no response, only silence, and she heard the clicking whir of the camera. Oh, she realized, I've been tricked. *They're still shooting.* Her embarrassment turned to laughter and her heart burst open. She shone then a forthright humility so pure and a joy so pervasive, the crew could see in her a certain royalty of spirit, if not real royalty itself. And yet, when she spoke, it was without the stiffness or pretentious solemnity that afflicts those too accustomed to the spotlight. Her voice had a natural-sounding richness, and as it reached the end of her sentences, it expanded like an afternoon getting warmer, or a heart beating faster.

She got the part.

However, schedules would have to be rearranged. Because Audrey was obliged to begin rehearsing *Gigi* for Broadway, Paramount was forced to put *Roman Holiday* on hold until the show's run was complete.

MRS. JAMES HANSON, DEFERRED

To Audrey's utter astonishment—not to mention the astonishment of the entire company of *Gigi*—she opened on Broadway to good reviews. *Times* critic Brooks Atkinson praised her "charm, honesty and talent," and Walter Kerr, her "candid innocence and tomboy intelligence." But it was from Gilbert Miller himself that Audrey received her best publicity. He

ordered the Fulton Theater marquee be changed from *"Gigi"* to "Audrey Hepburn in *Gigi.*"

Audrey sighed when she saw it. "Oh dear," she said, "and I've still got to learn how to act."

Audrey's run of *Gigi* ended in June of 1952, and without a moment to lose she flew to Rome to begin *Roman Holiday*. Once again, she told James they would have to postpone their plans to marry. There was too much work. Now they would do it in September, after shooting was complete.

THE ELECTRIC LIGHT

James could only wait. He would appear during the production to steal a walk with his fiancée between setups—that is, if she could spare the time—but on the whole, he was relegated to the sidelines and passed the hours trying not to think about what was becoming more and more obvious to him and everyone else (though they said nothing). Audrey was disappearing from him. Not that James wasn't prepared— this was just the kind of thing he had heard film people talk about—but he had never understood it until he got to Rome. It wasn't coldness, it was necessity; show business folk were just a different animal. Perhaps the species shouldn't intermingle.

James had time. He played cards with Gregory Peck and strolled from café to café and chatted with those who recognized him as Audrey's fiancé. Later, he'd wait for her at their apartment on the Via Boncompagni. She'd be delayed and he'd wait. Making films, he saw, was so much about waiting. Waiting for the light. Waiting for the location. Waiting for the stars.

It seems they did more waiting than anything else. How could they stand it?

He would sometimes stroll to the set to watch a few takes, or conduct a bit of business, or meet Audrey for lunch. But when he did, she was clearly someplace else. Her mind was on work, the stunning sensation of starring in a big movie, and though she was careful how to frame it, the surprising generosity of Gregory Peck. He knew Audrey was scared to be in front of the camera. Take after tiring take, her emotions would harden and break away from her. She'd get stiff. When the lines came out naturally, it seemed like an accident, like Audrey wasn't the one doing it, and she'd look up to Wyler's face for reassurance, for anything, and he would offer a word of support. But then, a few minutes later, they'd be doing the scene again, and then again. By midday, Audrey's reserve would be nearing depletion.

"What is it?" James asked.

"I'm not like an electric light," she muttered. "I'm incapable of switching my feelings on and off."

He might not have known she was talking about acting.

"Miss Hepburn?"

She looked up. It was an Italian boy sent to bring her back to the set. Apologizing to her fiancé, Audrey went with him.

James would have to wait.

THE ENCHANTING UNKNOWN

Back at Paramount, the early footage of *Roman Holiday* was a sensation. Everyone agreed there was something enchanted about the Hepburn girl, something new and wonderful, though

it was difficult to say exactly what. Audrey was beautiful, but not the *most* beautiful. She was talented, but she wasn't brilliant. The paradox was consuming. All across the studio, people were sneaking away from work just to try to steal a peek at the dailies. Directors wrapped early, writers' offices shut down, and soundstages were covertly vacated, all for a shot at a glimpse of a hit. Only the publicity department stayed at their desks. They were already talking Oscar.

As Paramount's chief publicity man, what AC Lyles needed to do was ensure that Audrey would be as popular outside the gates of Paramount as she was within. He'd have to make sure they got her to the right audience. But what was the market? Who was the audience of 1953?

THE MARKET

It was the 1950s, and the entire country, it seemed, was on vacation. But who could blame it? The six years of World War II had been pure horror, separating man from wife and limb from torso. The task now was to forget, or at least deny. Anything to take the edge off. Anything to keep everything at bay. Booze helped, and so did psychoanalysis, but tranquilizers were best. If you could get it, chlorpromazine cleared the mind like Clorox bleached the sink. (And so what if it made the mouth a little dry? The doctors said it was okay.) In those postwar years, the anxiety-relief industry hit an unprecedented high, growing ever higher through the decade as the Bolsheviks grew ever closer. But fifties America was well armed. Everyone could stop worrying and love the bomb, because for every Russian vodka there was a perfect tonic.

Marriage was one such tonic. In 1951, when Audrey was off shooting *Monte Carlo Baby,* one-third of the nation's nineteen-year-old girls had found husbands, and those husbands, many of them veterans racked with battle fatigue, had taken too long to get home. Now that they had, their brides were pulled out of the workforce and sent back to the kitchen where they were meant to be—or afraid to become anything other than—mothers and wives. To keep the order, gender lines, formerly blurred, had to be reinstated and the American woman found herself alone at the sink, wondering how it all happened. Why did getting what she'd wished for suddenly feel so wrong?

Thank God for popular entertainment, which gave her something to look at all day. It reminded her that she was doing the right thing to sit and sip and wait, and that being perfect was, as she suspected, absolutely perfect. Consider, for instance, the brand-new Alligator White Philco Seventeener TV she kept in the kitchen. The little box fit just about anywhere and weighed next to nothing, so she was able to carry it into the dining room for *Father Knows Best,* bring it right back into the den for *Ed Sullivan,* and then take it with her into the bathroom for a nice long soak and a moment alone with a fresh pack of Chesterfields.

She listened to the man on TV talk about a senator from Wisconsin named Joseph McCarthy and his defense of our perfect union against communist subversion, and asked herself all the while if she understood everything he was saying. She decided instead not to worry and turned the channel to *Ozzie and Harriet.* He'll be home soon enough, she thought, and he'll explain everything.

If he was delayed—and he often was—she could open up *Modern Screen* magazine and read all about the real-life marriages of Hollywood stars like Tony Curtis and Janet Leigh: "In 1954, a close friend relates, 'Janet made the greatest sacrifice she had ever made. She relinquished the career that had taken so many years to build' for Tony's sake. On New Year's Eve, 1959, Janet summed up her feelings. 'Scout's honor, Tony,' she whispered. 'I resolve not to forget all the wonderful ways God has blessed us.'" And under a photograph of Janet and Tony engaged in what appears to be serious conversation, the caption: "Sharing hopes and dreams with Tony, Janet learned that it is better to be wrong and happy sometimes, than to be right but alone and in tears."

With an unprecedented degree of leisure time, and more media access than ever before, the fifties woman was the single most vulnerable woman in American history to the grasp of prefab wholesale thought, and by extension, to the men who made it. The message of conformity poured in through every opening from the outside, making it impossible for her to shut it out without shutting out the world. Banish the crazy, she discovered, and sit in silence, or sit in silence and go crazy. Either way, the unwanted voices of rebellion were quieted by the self-soothing mantras she learned from TV, print, and movies. They told her, through the likes of Doris Day, Marilyn Monroe, and Debbie Reynolds, that happiness was right where she thought it was: at home. All along it was right there ("Have another drink, honey"); it was right there all along.

She was the market, and from his desk at Paramount, AC Lyles had his eye on her. He knew what she liked and what

she didn't like, but he couldn't be certain of what she'd make of Audrey.

THE PRODUCT

No one was quite sure how Audrey would fit. Just look at the movie stars around her. From man to wife and boy to girl, they were cut from the same benumbingly conformist mold. And each and every one of them was a product made to order.

Working at full speed, the Hollywood studios cast their stars from an amalgamated mold of cultural, political, and financial factors, which, when mixed in the right proportions, could hit the zeitgeist's bull's-eye with profitable regularity. Sure, some of them may look to us, the paying audience, like a beautiful, magical accident fresh off the bus from Wherever, PA, but in fact, beauty, as has been proven many times over, has very little to do with stardom (if it did, we'd still be talking about the most beautiful movie stars of all time, but the names Loretta Young and Hedy Lamarr rarely come up).

Movie stars were built, not born, and their parents were not their mothers and fathers, but the legions of writers, directors, costumers, and most of all, studio heads, who saw to it that their personae—their screen personalities—fit the particular needs of their place and time. That was a good way to sell tickets.

Paramount, Universal, Fox, Columbia, and MGM were companies after all, and though they were capable of making the greatest movies in the whole world, refining their aesthetic was not their objective. Like every other industry, the picture business endeavored to minimize its losses by making a science

of its gains, and that meant if something worked, they did it again. And again. It also meant that if something worked for someone else, they stole it, renamed it, and turned it loose. If Fox was making a mint off Marilyn Monroe, then Columbia needed their own (enter Kim Novak), just as they needed a Cary Grant, or Katharine Hepburn, or any other x that = a lot of $. That was the formula, and since the beginning of Hollywood, the studio star machines used it to turn out stars like power plants churn out power, solving for x again and again until Archie Leach became Cary Grant and Norma Jean Baker became Marilyn Monroe.

But why Cary Grant? Why Marilyn Monroe? Why did they become stars and not the hundreds of other actors who were nipped and tucked and primped and plucked only to board Greyhounds back to sunny Wherever? Was it "star quality" that made the special people special? Was it "It'"? Was it "That thing"? No: it wasn't magic. Like the stars themselves, magic was all construct, a precious commodity manufactured by Hollywood PR to up the value of its product, something they wanted the woman of the 1950s—indeed the paying people of any decade—to believe about the marvelous show folks of the silver screen.

The real reason certain actors become stars and others do not is regrettably not so glamorous. True, there is often something exceptional in attendance—be it Fred Astaire's feet or Judy Garland's voice or Audrey's face—but the crude reality of supply and demand contends that great talent, no matter how awesome, must be a salable commodity marketable to its era, as desirable to its audience as the new Philco Seventeener or the myth of Soviet takeover were to theirs. To foster that

desirability, studios manufactured stars to suit the fears and fantasies of the day, giving faces to paradigm shifts, and therefore historical consequence to their chosen personae.

And so it has always been. Since the era of Hollywood's first stars, American moviegoers have been devouring a steady dosage of self-image. Whether it's man or woman, boy or girl, the screen holds up mirrors to its audience, reflecting the shoulds and should-nots of family, love, war, and gender—sometimes knowingly, sometimes not, but always with an eye on sex. And in the fifties, if you were a woman, too much of it was wrong, and too little of it was honorable. You were either a slut or a saint.

DORIS AND MARILYN

For women in the movies, there existed an extreme dialectic. On one end, there was Doris Day, and on the other, Marilyn Monroe.

Doris Day was one of the saints. Take her in *Lover Come Back*. Sparring with Rock Hudson, a successful ad executive who uses any means necessary to get what he wants (even sex!), she says, defiantly, *"I* don't use sex to land an account!" "When do you use it?" he asks. Her reply: "I don't." *Lover Come Back,* like *Pillow Talk* and every other Doris Day–Rock Hudson pairing, is a sex comedy without the sex, a story of how the sturdy all-American guy fights hard to get into Doris's cold, cold bed. She's always appalled, always shocked, huffing and puffing herself out of his arms, and never for a moment wanting so much as a kiss unless there's a legal agreement of marriage to go along with it. (Oscar Levant famously said, "I knew

Doris Day before she was a virgin.") Toward the end of *Lover Come Back,* when Doris and Rock wake up together in a motel bed, she endures a requisite moment of absolute panic. *Did they?!?! Could they?!?!* The poor thing nearly explodes. "It's all right," Hudson reassures her. "You're my wife." Phew. Apparently they got so drunk the night before, she doesn't remember that they also got married. Doris, duped, is so enraged, that she has the marriage annulled immediately, but there's still a problem—a very 1950s problem—that she can't reverse; that is, sex, and having had it with a man who is no longer her husband. Well, as it turns out she's pregnant (birth control still to come), and is on her way to deliver the baby when, thank God, Rock arrives at the hospital, his lessons learned, in time to marry her before she has the kid.

But this is Hollywood, and every "Good" has a "Bad." If marriage was deep in the heart of the fifties heroine, what was in the heart of the fifties villainess? The answer: sex without marriage. Gentlemen may marry brunettes, but Marilyn Monroe was living proof that they preferred blondes, and not always the smartest or most willful blondes, in fact, the dumber and more childlike the better. Joining her were the likes of Kim Novak, Mamie Van Doren, and Jayne Mansfield, who helped turn ladies into girls and girls into Barbies (Barbie herself was born in 1959) and revealed in the process the adolescent boy lurking latent within the American adult male. And why not? When the nation represses its sex drive, it should come as no surprise that deep within every daddy is a teenage boy just burning to brush up against anything. But of course he can't. This is the age of look but don't touch. If you're a mom, it's worse; you're not even allowed to look. And if you're

a daughter, like Sandra Dee, or Debbie Reynolds in *Tammy and the Bachelor,* you can touch, but it should only be a kiss—your first kiss—and also your last. Keep in mind: once you've gone all the way, you can never come back. Ever.

So remember, American girls: be good. You're princesses.

BIRTH OF THE COOL

But princesses come in all shapes and sizes. With Audrey, in whose face and gait Colette saw the whole history of girlhood, *Roman Holiday* becomes about discovering the world, and not, as was true of Audrey's predecessors, about attracting a man. As Princess Ann, Audrey says she wants only "to do just whatever I like the whole day long . . . to sit at a sidewalk café and look in shop windows, walk in the rain, have fun, and maybe some excitement."

The baby boom produced a fresh batch of American youngsters—teenagers they were called—and they were suddenly coming of age. But until *Roman Holiday,* it was hard for them to see themselves in the movies. What Audrey offered—namely to the girls—was a glimpse of someone who lived by her own code of interests, not her mother's, and who did so with a wholesome independence of spirit.

Wholesome *and* independent. AC Lyles saw the value in this combination, one so appealing, it seemed Audrey's reach might even extend beyond the teenage girl. Men could fall in love with her, that was no surprise, but significantly (unlike Marilyn), she didn't antagonize their wives in the process. Mothers would be happy if their sons brought Audreys home—and so too would their daughters.

How did Audrey do it? With a haircut.

It's Princess Ann's first and only day in Rome, and she wants to change the way she looks. How much does she get cut? So much that the barber is scandalized. Never in all his career, we are led to believe, has he ever heard of hair so short on a girl so pretty. "Are you sure, miss?" asks the barber. "I'm quite sure, thank you." "All off?" "All off."

The barber does as he's told, and by the end of it, Audrey looks so utterly changed that he surprises the both of them by asking her out. But this is not an ugly duckling transformation— one of those scenes where the girl removes her glasses and she becomes a babe—this is a transformation from Ann's conform- ist self (a girl with traditionally long, traditionally "feminine" hair), to Ann's *true* self. That is why the barber calls her new do "cool." The idea is that he appreciates it, not lusts after it, and the distinction denotes a notable change in the feminine ideal, from the fifties young lady who matures by falling in love and becoming wifelike, to the early sixties girl who matures by cultivating a fashion sense so unique, it could only be hers and hers alone.

Voilà. In this era of stark conservatism, Audrey managed to make different okay. Better than okay: she made it good, and she was able to rally her troops with a visual dialect only they could understand, like an underground spy leaving coded messages for her emissaries. Often without knowing it, moth- ers and daughters of the 1950s saw in *Roman Holiday* a star who spoke directly to them, politely pointing the way out without ever having to wave a flag. "Audrey had it in her to be the sugar coating on a bad-tasting pill," Lyles said. "She made everything palatable." Now that's antiestablishment with a smile.

Princess Ann walks early 1960s, but she definitely talks mid-1950s. Yes, she yearns for more, and based upon her brave new personality and look she might even get a hand on it, but as *Roman Holiday* draws to its bittersweet end, it becomes clear that no matter how unique the individual (or haircut), duty must eclipse freedom. A fifties princess was still castle-bound.

ANN: I'm sorry I couldn't cook us some dinner.

BRADLEY (Gregory Peck): Did you learn how in school?

ANN: I'm a good cook. I could earn my living at it. I can sew, too, and clean a house and iron. I learned to do all those things. I just haven't had the chance to do it for anyone.

BRADLEY: Well, it looks like I'll have to move, and get myself a place with a kitchen.

ANN: Yes.

It wasn't just the movie that kept Audrey's provocative allure in check; the press was only too eager to lend a hand. Published in time for *Roman Holiday*, the article "H.R.H Audrey Hepburn" showed a demure Audrey, white gloves pressed sweetly to her chin. The idea was to further the notion of Hepburn, an elegant thing, pure of word and deed, and bred to continental perfection. Included in the piece was the following:

She thinks the authenticity she was able to assume for her role of the princess was due in part to her early training—"My mother brought me up to always stand erect and keep my head up and sit straight when I sat in a chair"—and also to the fact that she spent so many years

in England and Holland, where she was able to observe queens and princesses in person.

AC Lyles made sure a very modern Audrey was packaged in a very fifties way.

MRS. JAMES HANSON, DEFERRED, AGAIN

Production on *Roman Holiday* came to a close, and Audrey's plans to marry were thwarted again. She had to begin the American road tour of *Gigi*. There would be no honeymoon, no week of afternoons to lie about as Mr. and Mrs. Hanson, just listening to records, eating and sleeping. Worse still, there would be no children, and no family. At least not now, while she was on the road. And so, rather than struggle forward, Audrey and James solemnly acquiesced, believing, even if what they were doing didn't feel right, doing as they should was the way of the world. And in a single snap, Audrey's dream of family, her one unyielding dream, was boxed up and shelved.

By December of 1952, their engagement was off for good.

Audrey was single again. All over the media, she made her good intentions clear. She was a dear to the press, a girl who wanted to find a husband, become a mother, and then, finally, be what she was raised to be: a housewife. She only smoked six Gold Flake cigarettes a day, and restricted her lunches to milk, fruit, cottage cheese, and sometimes yogurt. See? She was just the girl American daughters were supposed to be. Best of all, there wasn't a drop of sex on her.

Boy, were they wrong.

2

WANTING IT

1953-1955

ONE HOT SPURT

There was a time when George Axelrod, the would-be screen-writer of *Breakfast at Tiffany's,* didn't have to fight so hard to have sex—in his work. But these days, it was tougher to pull it off. TV was the problem. When he wrote for radio, George could get away with a lot of sex comedy because no one could actually see it, and if he were smart and judicious, most of them wouldn't even catch it, but if they did, it didn't matter because it was all live, and once they said it no one could undo it. TV sex was touchier, but the pay was better, which is why George Axelrod, before arriving at his day job writing gags for the small screen, dutifully worked every morning for an hour between eight and nine on a play called *The Seven Year Itch.* Onstage, where there were no sponsors, George knew

his dialogue could be as frank and funny as he could possibly make it. There was no dumbing down or sanitizing on Broadway, so if he wanted to go against everyone's better principles and say the truth, George just might smash the myth that sex and laughter don't go together.

The Seven Year Itch came out of George in one hot spurt— fifteen hours, he said, between Easter Sunday and Fourth of July—and from there, onto the desk of a producer friend of his. By September of '52—around the time *Roman Holiday* wrapped—*Itch* was in rehearsals at the Fulton Theater, where it opened two months later to blow the lid off the seventh commandment (Thou Shalt Not Commit etc.). *The New Yorker* wrote,

> *The Seven Year Itch*, in fact, is concerned with the flesh only to the extent that for most of its cheerful length it goes on about sex in its most specific possible aspect; that is, with an adultery that takes place as nearly in full view of the hopeful audience as the rules of decorum and the ordinances of Manhattan will permit.

Axelrod hit big, he hit early, and he did it the way he wanted to—in full view of the hopeful audience.

Only a few months later, George was sitting in his kitchen when he got the call from Billy Wilder.

It was like getting a call from God, he said later.

George's agent, the wily Irving Lazar—called "Swifty" because that's how fast he made deals—had set the movie up at Fox, and Billy was ready to get to work. *The Seven Year Itch*, Wilder told him, was just his kind of material; funny, bitter,

hot, and unapologetically impolite. George had been told this many times, but hearing it from his idol was like seeing it on a marquee shining forty feet in the air. The next morning, he was on a plane to L.A.

In between writing at 20th Century Fox and eating at Warner Bros. (where Billy's favorite chef cooked Billy's favorite food), Wilder and Axelrod walked around Beverly Hills, shopping and talking, buying bow ties and gourmet snacks, and debating the impossible problem of how to translate Axelrod's sex comedy to the movies without ruffling the stuffed shirts of the Production Code Administration, whose code explicitly stated—and quite definitively—that "adultery must never be the subject of comedy or laughter." At some point or another, every comedy writer in Hollywood had to deal with the PCA, and some, like Wilder, had even become quite successful at it. His films compromised without looking like compromises. From *Double Indemnity* to *Ace in the Hole,* they were masterpieces of bold innuendo and pushed—sometimes invisibly—every envelope to its breaking point. But *Itch* was different; it couldn't cut corners. It couldn't be invisible. If they weren't downstage center with the subject of adultery, there would be no movie. How could the principles of high-minded innuendo work themselves into that? Wilder had purchased hundreds of dollars' worth of bow ties by the time they figured it out.

At first, Axelrod had the idea that he and Wilder would submit the raciest draft they could. His hope was that they could buy themselves some negotiating power by overwhelming the censors, but Billy had been down this road before and assured George that it wouldn't work, especially on this picture, which as a piece of material, was already notorious. This

time, Billy explained, the Production Code Administration—
also known as the Breen Office—was out to make an example
of its power. They would not approve the final screenplay until
all suggestions of the affair between Sherman and The Girl
were eliminated.

There was only one way, then, to show it without showing
it. They had to put it all in his head. Sherman will only *fanta-size* about adultery. Neither Wilder nor Axelrod were happy
with the idea, but there was no alternative. It was an itch they
couldn't scratch. "The bulk of my sex-comedy career," Axelrod
said later, "was done with this enormous handicap: not being
allowed to have any sex. I was trying to write these so-called
sex comedies in the fifties when we had to deal with the Breen
Office."

A WAY TO WINK

Axelrod and Wilder put the script aside, and Billy got to work
on another movie, a romantic comedy that would eventually
be called *Sabrina*. Joining him were writers Ernest Lehman
and Samuel Taylor, author of *Sabrina Fair*, the play they were
adapting. They all worked long, unrelenting hours, and as
they progressed, they found they hadn't progressed at all. Dis-
satisfied with Wilder's changes to his play, Taylor quit, leaving
Lehman and Wilder alone together. Bad idea. Wilder, cranky
on a good day, was having back problems that made him ex-
asperating company. Lehman, a fragile fellow to begin with,
was pushed to the brink, and teetered on the precipice of a
full-blown nervous breakdown. Meanwhile, there were major
script problems; namely, the issue of sex as it related to Sabrina,

who was to be played by the very chaste-seeming Audrey Hep-
burn. Wilder and Lehman went back and forth for months.
Would she be having sex? Could she, under the regulations of
the Production Code? If so, how would they show it?

With preproduction under way in the summer of 1953, they
still didn't have an answer.

But Billy Wilder kept thinking. There must be a way to
wink, a way to show without telling, to imply. If Sabrina
Fairchild was going to make a truly credible transformation
from regular Long Island girl to Parisian sophisticate—in
other words, from purity to sexuality—she was going to have
to have the clothing to show for it. She would need an evoca-
tive costume change. The censors couldn't get them for that,
could they? Not if it was all done in the name of European
good taste and elegance. Why, of course! They'd get an authen-
tic Parisian designer to design Sabrina's authentic Parisian
couture.

That's when the trouble began for Edith Head.

DOES EDITH HEAD GIVE GOOD COSTUME?

The news about the Parisian designer for *Sabrina* would have
been shocking to Edith Head under any circumstances, but in
light of her most recent Oscar for *Roman Holiday,* it was down-
right perverse. Didn't they know who they were dealing with?
After Marilyn, Susan Hayward, and the other top stars, Ms.
Head was undoubtedly the most powerful woman in town.
They couldn't look their best without her.

Edith stayed up all night, got up early, and walked fast. She
didn't like to wait, and she didn't like to keep anyone waiting.

"Good morning, Miss Head."

"Morning."

They all knew her. Joan Crawford wouldn't buy a pair of socks unless she cleared them. Bette Davis insisted on her for *All About Eve,* and Barbara Stanwyck flat out loved her. The whole town thought they were, well, *you know,* but that's what they said about every tough girl in pictures. Either she was frigid or she liked women. But Ms. Head was neither; she was just resilient, like a cockroach.

If they asked, she wore dark glasses, even inside, because she wanted to fade into the background, to give the actresses center stage in their fittings. But the truth was Edith was after inscrutability. There was mystique that way, and more power.

She had been costuming at Paramount since the 1920s, and as long as they kept renewing her contract, that's where she'd die. One day, she'd just keel over on her drafting board and they'd carry her over to the cemetery behind the lot and drop her in. But that would mean she'd have to take the night off.

Without her, they all knew Veronica Lake's neck would look too thin, Loretta Young's too long, and Claudette Colbert's too short. That's why they came to Edith—a single stitch, and she erased all the wrongs. And that's how she got her Academy Awards: *Roman Holiday* was her eighth nomination and fifth win.

She had worked especially hard on *Roman Holiday,* and ingeniously, camouflaging Audrey's many physical irregularities. The list of alterations seemed to go on forever: Edith broadened Audrey's shoulders wide enough to frame her face, she disguised Audrey's spindly neck with jewels and scarves whenever possible, she decided against sleeveless blouses for the

sake of Audrey's too-frail arms, and she selected an especially long dress to keep Audrey's gangly legs from the camera. Because it directed one's eye away from Audrey's problematic torso, the full skirt Edith designed helped a great deal to restore equanimity to the rest of the girl's frame, and with the slimmer belts Edith made especially, she could downplay Audrey's awkward waistline (the slimmest, she said, since the Civil War). Audrey, however, wanted thicker belts, and Ms. Head, despite her misgivings, dutifully consented.

Of course, if it were up to Edith, they would all be Grace Kellys. "She was Miss Head's favorite to dress," said Rita Riggs, Head's former apprentice, "because she was the perfect 1950s beauty. She had the perfect waist, the perfect plucked eyebrows, and she fell right into the mold, the mold Audrey bluntly refused." *Quel chassis:* not an architectural defect in sight.

Where other more exploitative designers would have seized upon Audrey's runway-friendly figure to showcase his or her own talents, Edith congratulated herself for doing what was right for the character. She was a costumer, after all, not a fashion designer. As always, there was shrewd reasoning to this: the more stylized an item of clothing, the faster it would date, and for Edith, who feared (rightfully) the day when her work would no longer be relevant in Hollywood, that was tantamount to the pink slip. Personal vision? Artistic innovation? Please. She knew pictures didn't need any more showmen— that's what the stars were for. What pictures needed were swift seamstresses who could touch up a hem between takes forty-three and forty-four at two in the morning after the director has walked off the set and everyone—including them— has been fired. Trends were for the kids.

So Wilder wanted them to buy what they could have had Edith make for free. It wasn't very nice, but then again, even Edith had to admit there was something of a precedent for shopping out of house. Just three years prior, Christian Dior had been commissioned to costume Marlene Dietrich for Hitchcock's *Stage Fright*. But because they were shooting in Europe and the designer was conveniently at hand, it made financial sense to Warner Bros. and it made their beloved Dietrich very happy. But the business with Audrey on *Sabrina* was another thing entirely; not only was she far from Dietrich in stature, but Wilder's production was based on the Paramount lot in Hollywood. That made Edith Head the obvious, fiscally reasonable choice.

Still, Wilder was convinced she was the wrong person for the job. If she was going to make the transformation convincing, Sabrina needed more than a knockoff. She needed a French fairy godmother. Or father.

THE MEMO

The timing couldn't have been better. If Audrey's schedule had her in Paris that summer, then what if she, not the studio, did the shopping and the shipping? Wilder posed the question to those who wrote the checks. Frank Caffey, Paramount's studio manager, was one such person. His memo to Russell Holman, a lawyer in Paramount's New York office, was the first in a detailed correspondence about exactly how, when, and where Audrey Hepburn was to shop for *Sabrina*. It begins the story of her evolution from movie star to fashion icon—a story that culminates seven years later with a little black dress. Caffey wrote:

*Some weeks ago [executive] Don Hartman and Billy Wilder
in discussing this picture thought it would be very advanta-
geous to ask Miss Hepburn, when she was passing through
Paris, to purchase certain items of wardrobe for use in the pic-
ture. They discussed this with Hepburn and a few days later
Edith Head went to San Francisco and finalized it with her. I
rechecked the requirements today and here is what we would
like to arrange for her purchase:*

*1—Dark Suit. This should be of the type she [Sabrina]
would wear crossing the Atlantic by plane and arriving up-
state New York by train.*

Several blouses, gilets or fronts to be used with the suit.

2—Extreme French Hats appropriate for the suit.

1—Very smart French day dress.

*The above should be bought as Hepburn's private wardrobe,
and in no way should Paramount's name be used as it might
involve screen credit, duty coming into the country as well as
possible holdup bringing it in. It should come into the country
as Hepburn's own personal wardrobe.*

*After selections have been made we would need to have sent
ahead of time sketches of the items as well as sample colors and
fabrics. Hepburn has been requested not to select dead black or
dead white [this Head's suggestion]. We would suggest dark
blue or oxford or charcoal grey [also this].*

Richard Mealand (who spotted Audrey in *Laughter in Par-
adise* years earlier) received the instructions, and added, "I
suggest now, in view of Caffey's letter, that we ask Gladys
de Segonzac [wife of Paramount's Paris head] to make some
selections and let Audrey approve them and pick them up in

Paris. . . . Meanwhile, I can advise Gladys as to what's wanted and she can have adequate time, after the fashion openings, to find the right things, prepare sketches and send samples both to Audrey and Edith Head." Holman saw the advantage to that. "Gladys de Segonzac," he agreed, "being in the Paris couture business, knows clothes better than Hepburn." Caffey took it from there:

> *The selections should be made at Balenciaga's. When Hepburn goes through on July 13th she should complete the selections [tentatively made for her by de Segonzac] or choose new clothes from the same place. Edith Head and Hepburn discussed the fact that after Hepburn had tried on the model or type of clothes that will be selected for this picture, she will on the spot, with Mrs. De Segonzac's help, change the color of the model and possibly the material, as well as perhaps altering collars and cuffs, all to the end that we do not wind up with clothes that will be exactly like the model as the model itself could very easily be turned over to an American manufacturer for making and distribution of reproductions in America. In other words, we do not want to select clothes from the latest Paris collections as is. Obviously we cannot afford to give any screen credit and the clothes as selected and modified by Hepburn should be under the guise of her own wardrobe without reference to Paramount.*

And so it was that in the summer of 1953, before *Roman Holiday* had opened, Audrey Hepburn arrived in Paris for a shopping spree that would not only change her life, but as

a pivotal blow to Dior's reigning New Look, the lives of all women out for a *new* new look.

DIOR'S NEW LOOK

During the Second World War, strict rationing rendered opulence outré, and simplicity politically correct. That all changed on February 12, 1947, when Christian Dior launched his first postwar line, christened the "New Look" by American *Harper's Bazaar*. With his yards and yards of soft sumptuous fabrics, tight fitted jackets nipped in the waist, and full blooming skirts, Dior did away with the brawny shoulder pads and durable wartime fabrics of the early forties. In their place, he reintroduced the hourglass figure and the long-lost bust: all at once, women were allowed to be womanly again. (In fact, the New Look was so lavish, it was briefly condemned by the British Board of Trade.)

Now, to be truly *façonnable,* a woman needed girdles and waist cinchers. For those who couldn't afford Victorian corsetry, there was the practical (but shapely) shirtwaist dress, which, in the words of its master, Edith Head, was "tight enough to show you're a woman and loose enough to show you're a lady." In other words, the New Look was Edith's Look, but by this time it was an old look. What Sabrina Fairchild needed was to look new.

31½-22-31½

It was decided, perhaps by Gladys de Segonzac, that Cristóbal Balenciaga would be too busy with his upcoming collection to

see to the costuming needs of the then-unknown star. She of-
fered instead to make a call on Audrey's behalf to Hubert de
Givenchy, a brilliant young designer (twenty-six to Audrey's
twenty-four) who had worked under de Segonzac at Schia-
parelli before leaving in December of 1951 to establish his own
house at 8 Rue Alfred de Vigny. As a strident Balenciagan aco-
lyte, Givenchy was the ideal runner-up. At Schiaparelli he dis-
covered elegance, but it was Balenciaga who taught Givenchy
to listen to the material, and to design for the person, not the
design. It would always be Balenciaga's voice that told him
what was right and what was wrong, and not just on the gar-
ment, but in his shop: during a fitting, the client's street clothes
were ironed so they would be fresh when she left.

At six foot six, the gentle giant Hubert de Givenchy was
known to friends and regulars as *le grand Hubert*. Since the time
he was a boy, Hubert, who could have been a basketball for-
ward if he wasn't so elegant, valued nothing above simplic-
ity and beauty, even if they came—here Edith would gasp—at
the expense of function. Givenchy never thought about, as he
said, "whether the skirt is wide enough to walk in, [or] how
the wearer will look getting into and out of a taxi," and instead
would, "consider the beauty and artistic value of fashion, not
its utility." One of few exceptions was the white linen smock
he wore in the workroom, which he kept buttoned over his
suit like a chef's coat. All who entered would notice it, a sign
of bygone gentility in an industry rife with the rush of what's
next. Indeed, it was not speed or flash, but fabric that made
Givenchy's head swirl. Fabric, to him, was the stimulus of cre-
ativity. The smell of silk, of a fresh bolt of cotton—these were
the joys of his life. Balenciaga, his master, was the same way.

"Pardon, monsieur," Givenchy heard. He was hunched over his drafting table. "Mademoiselle Hepburn is here to see you."

One can only imagine Givenchy's surprise when, stepping away from designs for his upcoming winter collection, he realized the Hepburn in question was not Katharine, but a five-foot seven-inch, 31½-22-31½ stripe of a girl with short hair, tiny pants, ballet flats, and straw beribboned gondolier's hat that said Venezia.

"Bonjour!" she said.

"Bonjour, mademoiselle," Givenchy replied. "Who are you?"

"Audrey Hepburn!"

"Ah," he said. "Not Katharine?"

"Not Katharine."

With her big eyes and thick eyebrows, she looked to him more like a fragile animal than an actual human.

"Monsieur," she began. "I just made a film called *Roman*—"

"I am very sorry, mademoiselle, but I'm very busy with my new line. If you'd excuse me—"

"Yes, yes, I understand, but—"

"Mademoiselle, I don't have many assistants, and I am pressed for time."

It was no empty excuse. Charmed though he was, Givenchy was simply too busy.

"Please?"

"No, dear, I am sorry . . ."

"Please, please, please?" she insisted. "There must be something that I can try on!"

This could go on, Givenchy thought, for a long time. Better to appease her for the sake of peace and quietude than stand here all afternoon.

So he listened as she described the story of Billy Wilder's new film, which would star Humphrey Bogart and William Holden, and her, of course, in the title role, and how Edith Head was designing the secondary costumes, but that she was sent on a mission from Paramount to purchase only the voguest— and with her own money—for her very own collection, which she would wear for certain scenes—

"Okay," he said, "okay," and led her inside with the proviso that he had not the time to create something new, but she was welcome to peruse the previous season's collection. If she found anything that interested her, Givenchy said, she could have it.

Audrey happily agreed and with her signature efferves- cence, she went straight to work. To those who looked on, she betrayed no sign of the uneasiness she might have felt at having to make such an expensive and indeed perspicacious deci- sion. Although she had experience as a dressmaker—wartime rationing had forced it upon her—here, in the summer of 1953, Audrey was hardly a fashion expert. As countless pre-Givenchy photographs attest, she undoubtedly knew what looked good on her, but when it came to *la mode,* the girl was *naïf.* At the time she sailed into 8 Rue Alfred de Vigny, it's likely she hadn't owned a single piece of haute couture.

Offscreen, Audrey favored skirts, but more often wore slacks (they were more practical, she said). She liked short heels on her shoes (her feet, she knew, were big), and always, wherever and whenever she could manage them, the coziest sweaters imaginable. In short, simplicity set the pace for her wardrobe, as did physical comfort. It sounds obvious (who *wouldn't* want

to be comfortable?), but in this era of straps and bands and pointed bras, the directive was closer to no pain, no gain.

And so, without any aesthetic agenda, willful resistance to the times, or urge to do anything other than what she thought was right for her, Audrey Hepburn set into motion a kind of polite rebellion. As the imposing Hubert de Givenchy looked on, she selected a slim suit of gray wool, which she wore with a lighter chiffon turban; a long white gown of embroidered organdy; and finally, a black cocktail dress held up by two tiny bows at both ends of a wide and narrow neckline (once called a *décolleté bateau,* soon to be renamed *décolleté Sabrina*). With a long V-shaped back culminating in a strip of buttons, the dress featured a snug bodice offset by a ballerina-shaped skirt, and unusually spacious armholes that didn't conceal Audrey's tiny shoulders. Neither, for that matter, did its narrow neckline conceal the collarbones Edith Head had so painstakingly camouflaged in *Roman Holiday,* or the Civil War–sized waistline she attempted to overcome with a long skirt. So artfully did the dress embrace—and even celebrate—Audrey's so-called faults, that when beheld by audiences of 1954, it communicated not just Sabrina's transformation and Audrey's burgeoning influence as a style icon, but the new schismatic potential of what being a woman could mean.

Audrey would become the muse Givenchy had been waiting for; and he, the Pygmalion she needed to bring her to life. Their working relationship would grow over the course of the next five years before reaching its high point in *Breakfast at Tiffany's,* but by then, Audrey and Hubert would be like a needle and thread, symbiotic to the point of total congruity.

MEL

Audrey's life had shot up to full speed, stretching her time and tired body in all directions at once. Where she once moved laterally, working ceaselessly from one day to the next, she was now pushed upward by the very new tasks of growing her star in America and abroad. There were press junkets, studio directives, and temporary accommodations. There were planned introductions, faceless names, and nameless admirers. Merely floating was a thing of the past. Now Audrey flew. Looking below her, behind her, she could glimpse traces of her home in Arnhem, her first meeting with Colette, *Gigi,* and in the distance, James Hanson. They dropped away from her in copper flourishes, like rusted pennies down a well.

In London that summer of 1953, Audrey met the actor-director Mel Ferrer. It was Gregory Peck who introduced them. He had thrown a party in Audrey's honor at his flat in Grosvenor Square. The occasion was the British premiere of *Roman Holiday.*

Audrey was not yet the celebrity she was about to become, but with all of the magazine covers and the buzz about her debut, it was obviously only a matter of time. The night of the party, all eyes were on her.

From his place against the wall, Mel Ferrer watched Audrey's eyes, silently imploring her to look up and see his. Once or twice he caught her trying not to be caught, and she opened up a smile that exploded the room. Describing it later, Ferrer would not be ashamed to say he loved her immediately, nor would

he hesitate to admit he was well aware of his advantage; previously, at the urging of Gregory Peck, he had called Audrey at her mother's. When Audrey picked up the phone, Mel could tell from her enthusiasm that she meant it when she said she loved him in *Lili,* though exactly how much, and in what way, neither of them had any idea.

Here, in person, she drank in the full bottle of him for the first time. He was a gruff and slender man in his middle thirties—over ten years older than she—and had that look she liked. He was direct, shining with stamina, and obviously unafraid of enjoying the attention he so clearly knew was his. Others saw arrogance in Mel, but at that moment Audrey only saw conviction; as someone who didn't have it, she was quick to spot it in others.

In the low light, Mel and Audrey talked of *Sabrina,* which was to begin shooting in September, and of the possibility of doing a play together sometime soon. How fun that would be. They laughed and touched and said goodnight.

THE MOST SOPHISTICATED WOMAN AT THE GLEN COVE STATION

Well into production on *Sabrina,* with the clock ticking and the finish line fast approaching, Billy Wilder and Ernest Lehman were still bickering over the script, which remained, for the most part, unwritten. Cursing at each other into the night, the writers turned out drunken pages on through the morning as the actors arrived for makeup and the lights were put up around the set. There wasn't a scene or line or story point

too small to fight over—nothing escaped their attention—but there was no argument like the one that raged over Sabrina's— and ultimately Audrey's—celibacy.

"Billy wanted Bogie to sleep with Audrey Hepburn," recalled Lehman. "I said we can't do it, no dice, people don't want that, particularly for Audrey Hepburn. She was just a slip of a girl . . . gentle and sweet. She had won the Academy Award for *Roman Holiday*. He was furious at me for insisting they don't sleep with each other. I wouldn't give in on this point." Night after painful night, Lehman and Wilder seesawed through it, first trying the character one way ("What if she—no, never mind . . ."), and then another ("What if *he* . . ."), starting the night at Billy's house, and ending it, broken down and crazy, on the pavement outside of the Beverly Hills Hotel at three o'clock in the morning. They were scheduled to shoot the scene at seven and the only words they had on the page were INTERIOR— LARRABEE OFFICE—NIGHT.

When 4:30 rolled around, they called it quits. Billy had his assistant director cancel Bogie and Audrey's morning call, and Lehman's doctor told them to take a vacation from rewrites. Two weeks prior, Lehman collapsed from overwork and before that, he even had a few hysterical weeping episodes. Far from improving, the doctor saw that Lehman was actually getting worse, and wrote him a prescription for fourteen days without Billy Wilder. But if Billy took time off every time someone told him he had to take time off, he wouldn't have become Billy Wilder, which is why, days later, Billy and Ernie were back at it again, smoking and boozing and shouting at each other over whether or not Audrey Hepburn should be allowed to copulate when Dr. Spritzler arrived to pay a surprise visit on his

patient. Shit. Wilder thought for a moment and then did what for the future writer of *Some Like It Hot* was the only natural thing to do: he leapt into the closet.

(While Billy's in there, it should be known that the matter of Audrey's virginity was not just about keeping her image clean, nor had it to do with any kind of prudishness on Lehman's part, but rather, was born of a very real understanding that like Big Brother, the Production Code Administration was watching them—them, George Axelrod, and everyone else in Hollywood. So Lehman and Wilder weren't just up against each other in the brawl over Audrey's sex life, they were up against the censors.)

In dead silence, Billy waited inside the closet while the doctor examined his patient. A few moments later, Lehman was declared back to normal.

"Well, Doc," Lehman said, sitting up in bed, "then I guess I can tell Mr. Wilder to come out now."

The door flew open and out came the greatest director in Hollywood with a lit cigarette in his hand. He tipped his hat and left.

In the end, Lehman won: Audrey and Bogie make an omelet, not love. Wilder would have to hold off a few years until the Production Code office loosened up before he could make his most challenging statements about sexual freedom, and in fact, so would Audrey have to wait for the right national temperature before she could do the same, quite marvelously, in *Breakfast at Tiffany's*. But here in *Sabrina*, with the help of Hubert de Givenchy, they changed Audrey for good. The designer gave her a style, and the director made her an icon.

After *Sabrina*, Audrey was forever branded, on screen and

off, a young woman who asserts her individuality through her taste—and that, in an age of big breasts in big brassieres, was an altogether novel spin on her sex. ("This girl," Wilder once said, "singlehanded, may make bosoms a thing of the past.") On the surface, Sabrina is a girl who behaves exactly how girls were supposed to—as a Cinderella who longs only (and not carnally) for princes—but with the subversive power of glamour, she, Wilder, and Givenchy, smuggled in some new ideas from the women of the future. Key in that equation is the smuggling: were they to have been overt about it, Audrey would have been shut down by the censors, the critics, and the moviegoing public. Why she wasn't—indeed why she thrived throughout the late fifties and early sixties—was due to the public's understanding of Audrey as a good girl princess.

THE DREAM BEGINS

Only weeks after *Sabrina* premiered in September of 1954, Audrey married Mel Ferrer in Burgenstock, Switzerland. The ceremony was held in a tiny mountain chapel overlooking Lake Lucerne. Audrey wore a white robe of organdy and a halo of white roses.

Returning from their Italian honeymoon, the Ferrers discovered that they would be parents in only nine short months. The baby, Audrey said, "will be the greatest thing in my life, greater even than my success. Every woman knows what a baby means."

At last, this was the happiness Audrey had longed for. Not the kind of happiness that went away, but the forever kind, the one that never stopped renewing every morning and every night.

OSCAR NIGHT

Sabrina was nominated for six Academy Awards. Two of them belonged to Billy Wilder for writing and directing, one of them to Audrey, and another to Edith Head for Best Costume Design.

Amazingly, Audrey and Billy lost. But Edith Head won.

After the envelope was opened and her name was read aloud, Edith ascended the stage at the Pantages Theater to collect her Oscar. Her acceptance speech was two words, neither of which was "Hubert" or "Givenchy." They were only "Thank you." It was her sixth Academy Award.

MRS. MEL FERRER

In March of 1955, Audrey miscarried. Brittle now, and frail, she took to her bed. There she battled a despair so ferocious, it seemed to the few who saw her that despite her soft smiles and reassuring air, she would never fully recover. Somehow, losing a child meant losing the chance to rewrite the wrongs of her own childhood. It was forsaking little Audrey, the tenuous dancing girl of war-torn Belgium. She kept the press from her grief.

What the public saw was presented through the sugary veil of virtue. In the years following, a blissfully happy Audrey could be seen in print throughout the world, praising the virtues of wifedom. Of her life before Mel, she said to *Photoplay,* "I don't think I was a whole woman then. No woman is without love." In a piece entitled, "Audrey's Advice: Have Fun, Let

Hubby Wear the Pants," she confided, "He's a protective hus-
band, and I like it. Most women do. . . . It's so nice being a wife
and having your husband take over your worries for you."

"She was in part attracted to Mel," Audrey's future compan-
ion, Robert Wolders, explained, "because he was like a father
figure to her. Some people say that he misused her trust in
him, but I don't think that's the case at all. If he decided which
parts were and were not suitable to her, I think it was because
she wanted him to. It's true that he took over her life, but she
wanted to be protected and she trusted Mel. In a sense, she did
that with me as well."

Audrey's supplication was so well publicized, that Ferrer,
who already had a reputation for being controlling, came to
be known as a kind of Svengali. The article "My Husband
Doesn't Run Me" took dead aim at these rumors ("She's known
dictators in her early war-shadowed life. And you can take it
from Audrey Hepburn—she didn't marry one!"), but as count-
less Ferrer-Hepburn intimates would attest, the truth was a
little different. To Hepburn biographer Warren Harris, Yul
Brynner said, "Mel was jealous of her success and could not
reconcile himself to the [fact that] she was much better than
he in every way, so he took it out on her." Harsh, yes, but
Brynner's observation matches the general consensus; Mel
Ferrer lagged behind, and it hurt him. "Of course, it's a prob-
lem," he confessed, "when the wife outshines the husband as
Audrey does me."

3

SEEING IT

1955-1958

THE SWANS

Like every fiction, Holly Golightly was a composite of multiple nonfictions. She took her dreams of society from Truman's own mother, her existential anxieties from Capote himself, but her personality, which seemed so intimately hers, would come from the tight-knit coterie of Manhattan divas Truman so flagrantly adored. He called them his swans.

For Capote, they were it: the most glamorous and often the most powerful girlfriends in town. Feasting on daiquiris at La Grenouille or Quo Vadis, or El Morocco or 21, or sunk in a back banquette at La Côte Basque, Truman and his swans could turn lunch into performance art. With one of their gem-covered hands wrapped around his, Capote and his confidante

du jour would be seen—and overheard—lost in the titillating round of who's heard what about who. ("Oh, Tru, you're so bad! Now tell me *exactly* what she told you." "Wellll . . .") They included Oona O'Neill Chaplin, Gloria Vanderbilt, Carol Marcus, and Gloria Guinness, who wore a ring so big she couldn't fit a glove over her hand, and to the seedling Holly Golightly, they were the richest soil.

"I rarely asked anyone to my studio," wrote Gloria Vanderbilt,

> but Truman had wanted to see it, so one day I invited him there to meet my unexpected houseguest, Russell Hurd. He'd been a friend since childhood, with the looks of Charlton Heston and the wit of Noel Coward. Although Russell was gay, we had been in love with each other ever since the days when we tea danced at The Plaza. . . . What I didn't know yet was that Truman had started weaving Russell into a story set in a brownstone very like mine, and that the heroine was a girl whose confidant was a man very like Russell. The girl in some ways was like me, in other ways like Carol Marcus, who was at that very moment on a plane from L.A. to New York, fleeing from her second marriage . . . with no place to land but my studio.

Gloria's apartment, a four-story brownstone on Sixty-fifth between Fifth and Madison, was stocked with flowers, delicacies, and all the compulsory accoutrements of fashionable life on the Upper East Side—compliments of her beau, Frank

Sinatra. It was there that Carol Marcus, single and heartbro-
ken, met Truman Capote for the first time. Lucky for her, he
had an ear for distress. "You have freed yourself," Truman said
to her. "I can see it all now. Your life is just beginning. Now
why don't you sleep with some of these rich men who always
want to sleep with you? There would be nothing wrong with
doing that, and it would solve a lot of your problems."

When it came to heart pain, Capote was a master healer.
One touch of his magic medicine, and he could make any
woman into a friend for life. Two touches, and they would
become swans. In her memoir, Carol Marcus explained ex-
actly how:

At 3:00 every morning that I was in New York, I would
meet Truman Capote at a private club called the Gold
Key Club on West Fifty-fifth Street. The lights were low
and we would sit in big chairs in front of a fireplace and
talk and talk. . . . One night, though, he began talking
about something different. "I knew a girl once, she was
nothing like you. In fact, she was almost a hooker, but I
liked her a lot. She came from the South. I don't know
how she ended up, and I've always wanted to write about
her. But I'd like to do her as you, I'd like to have the things
that I know happened to her happen to you. I want you
to stick around with me a little bit. I'm going to do you as
Holly Golightly." And every morning about 7:00, we left
the Gold Key Club and walked to Fifth Avenue, where
there was man with a cart of doughnuts. We'd buy some
and then continue on toward Tiffany's.

BEAUTIFUL BABE

Gloria and Carol and all the others went through the revolving door of Truman's affection, but Babe Paley, beautiful Babe, had a door all to herself. As swan queen, there was hardly another human being more important to Truman, and as wife of Bill Paley, the broadcasting titan who made CBS, there was hardly a more important wife in the whole of New York.

Had she met Babe, Truman's mother would have been proud of her son for reaching so high, for seeing so much of what she could only imagine. She died in 1954, a year before Babe and Capote met.

They met only a few months before he began to work on *Breakfast at Tiffany's*. The Paleys were off to their Jamaican estate for a long weekend with the David O. Selznicks, when Selznick, who had enjoyed Truman's company in the past, suggested they might have a bit more fun if they brought Capote along. Paley, who thought they were talking about President Truman, agreed and the invitation was made. *Quelle chance!* Capote was used to traveling in fast circles, but weekending with two of the world's media monarchs and their wives was about as fast as it got (outside of Hollywood and royalty). He couldn't pass it up.

"When I first saw her," Capote said, "I thought that I had never seen anyone more perfect: her posture, the way she held her head, the way she moved." By the time the plane touched down in Jamaica, Babe and Truman had become enmeshed in each other's lives. He was her ears, eyes, and sometimes mouth, her escape from the humdrum whir of society,

and a guide through intellectual terrain Babe had never explored. Like Holly would be to the unnamed narrator of *Breakfast at Tiffany's,* Babe was to Truman the crème de la crème of sheer fabulosity. If each of his swans, as Truman would write, was an artist "whose sole creation was her perishable self," then surely Babe was a masterpiece.

Their relationship was perfect. She would lead Truman in and out of restaurants all over the world, like a pet or talking accessory or personal therapist that she couldn't shop, drink, or cry without. And Truman needed her, too. She looked great on him. They looked great on each other. "I was madly in love with her," Truman said to Gerald Clarke. "I just thought she was absolutely fantastic! She was one of the two or three great obsessions of my life. She was the only person in my whole life that I liked everything about. I consider her one of the three greatest beauties in the world, the other two being Gloria Guinness and Garbo. But Babe, I think, was *the* most beautiful. She was in fact the most beautiful woman of the twentieth century, and with the single exception of Gloria, who was sort of neck-and-neck with her, she was also the most chic woman I have ever known." She was voted one of the best-dressed women in America fourteen times over.

Babe was so chic, in fact, and so commanding in her elegance, that once after removing her scarf on her way to lunch, she nonchalantly tied it around her handbag only to discover that within a matter of weeks, women all over New York were doing the very same. She was almost embarrassingly rich, owning over one million dollars' worth of Harry Winston, Cartier, Tiffany's, and Van Cleef & Arpels, most of which, like her $50,000 emerald ring and $75,000 diamond necklace, she

kept locked away in her husband's bank. If she wanted to wear them, Mrs. Paley had only to interrupt Bill at the office ("I'm sorry, darling, but . . .") and he would discharge a limousine and secretary for the pickup. Waiting for the jewels to arrive, Babe would sit in the foyer, drawing L&M cigarettes from a twenty-four-carat gold case, which she smoked, demurely, out of her ivory holder. She burned through two packs a day, but her lips never touched a single cigarette.

She dressed up for her husband. That's why he'd built her a labyrinthine dressing room of hidden closets containing over a hundred drawers, each one lined with pale blue stripes and labeled according to their contents. There were six that held nightgowns alone: silk nightgowns, old chiffon night-gowns, new nightdresses, cotton nightgowns, thin nylon nightgowns, and winter nightgowns. Of course, there were other closets at Kiluna Farm, their eighty-five-acre Long Island estate; the house in Jamaica; and the St. Regis apart-ment where she threw her fabled dinner parties. Naturally, Truman became a resplendent fixture at every one. He coached her through precarious turns in conversation and chimed in at dull moments with a choice anecdote or literary equivoque, which he displayed as precisely as Babe had the baby vegetables.

Everything Babe served she served for Bill, though he was closer to gorger than gourmet. (After the war, Paley met Billy Wilder in Bad Homburg. Using a broken toaster, Billy re-members, they would grill steaks specially granted to them by the general's post exchange, and Paley would shovel them down one after the next. "The Germans have a word," Billy said, *"essen,* which means to eat. They also have *fressen,* which

means to devour. That suited him much better.") Paley was often seen to devastate upwards of eight meals a day, and Babe, as his connection to the kitchen, devoted herself to his satisfaction. She would spend literally days searching every shop in Manhattan from Lexington Avenue to Chinatown in hectic pursuit of le food *juste*.

Pleasing her husband was Babe's number one purpose. At each dinner party, she had at her place a small notepad encased in gold. In it she would note anything that had disappointed or satisfied him, be it about food or books or ideas exchanged. Those who were seated beside her husband were of unique value to Babe, and had been assigned specifically, both in service of her purpose and his amusement. At the evening's end, when her guests were preparing to leave, she would corner them at the door. "Did he mention the olives?" she would ask, pen in hand. "They're new. Did he like them?" Mrs. Paley would write it all down.

She was, in short, everything Truman's mother, and Holly Golightly, had wanted to be. But Nina was dead, and Truman, though he threw himself into the swans, would never find peace. Neither, for that matter, would his beautiful Babe. Though she had New York society's full attention and Truman's fervent devotion, she was down in the depths on the ninetieth floor.

For all of her minks and earrings and vacations and dinner parties, Babe was unhappy. It was her marriage. Love had long since fled the scene (if it was ever truly there to begin with), and whatever warmth their guests had observed in Bill and Babe was, like the green and gold on their Louis Seizes, only a part of the upholstery. Since the beginning, the wife had been

compliant, tending to Bill's directives with the precision of a
star secretary, always sure to put her face on well before he
woke up in the mornings, and keep her differences of opinion
to herself. But it was never enough. At Bill's request, the chil-
dren and their governesses were housed primarily at Kiluna,
where they saw their parents on certain weekend visits and
then only in the moments between guests. When they were
together, Bill instructed Babe not to embrace the children or
even touch them, and she obliged. Babe obliged.

All this she told to Truman. She couldn't speak freely to
most of her intimates, and to journalists, Bill had told her
to confine her remarks to dressing and entertaining, but to
Capote, who poured out his own heart to her like a barrel of
quicksand, Babe was real and candid. She confessed that they
had stopped having sex entirely. Not since the early fifties, she
gathered, had they slept together. It wasn't that Bill was no
longer interested in sex—he openly flirted with many of her
friends (Carol Marcus among them)—it was that he wasn't
interested in *her*. Like his children, Bill's Babe was for looking,
not touching.

Later, Truman told Gerald Clarke that Babe was so unhappy
she had twice tried to kill herself. Once she took pills, once she
slashed her wrists, and both times Truman (he said) had saved
her. More than once, Babe told Truman she had to get out. At
the end of one such talk, sitting with Babe in the Paleys' Man-
hattan apartment, Truman urged her to stay put.

"Bobolink," Truman whispered—it was his pet name for
her—"Bill bought you. It's as if he went down to Central Cast-
ing. You're a perfect type for him. Look upon being Mrs.

William S. Paley as a job, the best job in the world. Accept it and be happy with it."

It was not often that Babe let anyone see her cry, but this was an exception. Truman was an exception.

She told him that she needed to rest, that she needed to think it over. Would he permit her that? Would he occupy himself for a couple of hours while she napped? Yes, he said. Yes, darling, of course.

A couple of hours later, Babe woke up and returned to Truman. Her face was made. "You're right," she said.

And that was that.

Babe was caught. Truman would fashion *Breakfast at Tiffany's* so Holly Golightly wouldn't be.

GEORGE AXELROD DREAMS OF RICH PEOPLE SAYING WITTY THINGS AND SCREWING

The film of *The Seven Year Itch* was released in June 1955. Wilder and Axelrod saw then that their plan to hoodwink the censors—to make adultery a figment of their hero's imagination—ruined the whole picture. "The film version of *The Seven Year Itch*," *Variety* wrote, "bears only a fleeting resemblance to George Axelrod's play of the same name on Broadway. The screen adaptation concerns only the fantasies, and omits the acts, of the summer bachelor, who remains totally, if unbelievably, chaste. Morality wins if honesty loses, but let's not get into that."

George was depressed. His next assignment, an adaptation of *Bus Stop*, only made him feel worse. In one scene, Axelrod

had Don Murray's character—a cowboy who wants to prove how literate he is—break into Marilyn Monroe's room and recite the Gettysburg Address as he's screwing her. Of course, the Breen Office nailed him on it, and made Axelrod rewrite the scene sans sex. It depressed him further.

No wonder he wrote *Will Success Spoil Rock Hunter?*, a play about a writer (named George) who sells his soul to a devilish agent (named Irving "Sneaky" LaSalle). No wonder Fox bought the rights for Jayne Mansfield and scrapped the showbiz setting for Madison Avenue, effectively transforming Axelrod's revenge piece into a movie about a nebbishy ad man that the world believes is sleeping with a large-breasted movie star. It was a theme Axelrod had introduced in *The Seven Year Itch*— about a nebbishy book editor with the hots for his upstairs neighbor (played in the movie by Marilyn Monroe)—causing Axelrod, somewhat ruefully, to label his specialty: Boobs and boobs. Dumb guys and curvy girls.

What the public didn't know, however, was that deep down, beneath his brash, frat house raunch, George Axelrod wanted to be Noel Coward. He wanted to write old-fashioned high comedies of the beautiful rich standing on balconies at midnight uncorking one another with wit and *quelques cuvées de prestige*. But he was too late. America was already at war with its natural urges, and movie wit was paying the price. Now, the slightest whiff of anamorphic tit and the country collapsed into puerile hysteria. In came Jerry Lewis, but for a price: sophisticated romantic comedy—the kind so prevalent in the thirties and forties—became a total anachronism. "In the Eisenhower years," Norman Mailer wrote, "comedy resides in how close one can come to the concept of hot pussy while still

living in the cool of the innocent." It regressed Hollywood's depiction of adult men and women considerably.

So George Axelrod was depressed. What he didn't know was that Truman Capote was coming to his rescue.

TWO YEARS IN THE LIFE OF TRUMAN CAPOTE

In the spring of 1955, only months after he and Babe met on that jet to Jamaica, Capote began to think seriously about *Breakfast at Tiffany's*. He took a cottage on Fire Island with his partner, the writer Jack Dunphy, dug in, but didn't get very far. There were distractions—namely, a piece about an American opera company that planned to take *Porgy and Bess* into the Soviet Union—and Holly was tabled. What he required, if Truman was really to get into *Breakfast at Tiffany's*, was the peace and tranquility he found at the seaside. Only there could he maintain the total concentration he needed to compose a longer piece, which is what *Tiffany's* was turning out to be.

For the next two years, Capote flitted from Russia, to Peggy Guggenheim's in Venice, to his new apartment in Brooklyn Heights, and to Kyoto, where, in 1956, he trapped Marlon Brando into a drunken interview and sold it to *The New Yorker* for a cushy sum. *Tiffany's* waited in a drawer.

THE PRODUCERS

Marty Jurow wore his black hair slicked back and combed neatly off to the side. He wasn't a tall man, but he was rugged and packed a punch. Maybe he got it from Brooklyn, where he

was born, maybe from Harvard Law, or maybe he got it from all those years he spent at New York's top entertainment law firms. One look at Jurow, and the suits on the other side of the boardroom table got the picture: this guy knew the angles. At the age of forty-seven, well before he and Richard Shepherd produced *Breakfast at Tiffany's*, Marty Jurow was already a show business veteran.

At thirty years old, Richard Shepherd was a lithe and dapper up-and-comer. After graduating from Stanford, he landed a first-rate agenting gig at MCA looking after the likes of Marilyn Monroe, Grace Kelly, and Brando. But Shepherd was restless and taking meetings in skyscrapers had lost its appeal. What he wanted was to be out in L.A. making movies from the trenches. He wanted to get his hands dirty. So off he went.

Marty, meanwhile, had decided to do the same. Why not team up? With Jurow's extensive show business experience and Shepherd's immaculate client list, they could really make something of it. Great idea, but there were two things missing: money and material.

Money came first. They got it from Shepherd's father-in-law, producer William Goetz, and formed Jurow-Shepherd Productions. Then they struck a multipicture deal with Paramount and started looking for material. They started to read.

WHAT TRUMAN CAPOTE DOES IN BED

Truman finally got back to the seaside in the summer of 1957. He, Jack, and theatrical designer Oliver Smith rented a massive Victorian house in Bridgehampton and settled down to work. Sailaway—that's what the house was called—stood over the

water on stilts, and when the tide rose, the house did indeed look as if it were being carried off to sea. Truman liked it that way; the crash of the surf was a kind of metronome for him, especially at night when he did most of his work, lying in bed. There, culled from the fan of notebook pages he had spread out around him like a paper quilt, he transcribed *Breakfast at Tiffany's* onto typewritten pages.

The hardest part of writing was getting up the nerve to start, but when he did, Truman gave it a good four hours, dividing his hand between the keys and a cup of coffee, or as the afternoon wore on, mint tea, sherry, and by dusk, a row of tall martinis. Between sips there were puffs of cigarettes. If it got late and Truman needed to rest, he might look to Colette's paperweight. It helped him to slow his mind. "When it's a quarter to two and sleep hasn't come," he once wrote, "a restfulness arises from contemplating a quiet white rose, until the rose expands into the whiteness of sleep."

Truman wrote *Breakfast at Tiffany's,* as he did the bulk of his oeuvre, with a cold, almost scientific precision. He scoffed at impulse, at writers who hadn't mapped out the whole thing beforehand, preferring instead to plan, reconsider, and plan again before he so much as sharpened a single pencil. With *Tiffany's* he intended to evolve his style away from the florid swirls of, say, *Other Voices* and move toward a more measured, more subdued prose style. Out went the likes of "he was spinning like a fan blade through metal spirals; at the bottom a yawning-jawed crocodile followed his downward whirl with hooded eyes," and in came a new technique, literal and direct. The page, he told those who asked, was no longer his playground; it was his operating room, and like a surgeon—like

Flaubert, one of his heroes—he endeavored to keep surprises to an absolute minimum.

He wrote of a nameless narrator, and of a thin, outspoken eighteen-year-old called Holly Golightly. And she does indeed go—from man to man and place to place—lightly (the permanent message on her mailbox reads, "Holly Golightly, traveling"). As he wrote Holly, Truman was discovering that, though she shared many qualities with the women he knew, she was unlike any woman Truman had ever met. She said what she wanted, did what she wanted to, and unlike the swans, outright refused to get married and settle down. It isn't just that she was a wild thing, though she most definitely was, it was that independence was the full mettle of her life, and she earned it by selling herself.

Holly was a high-class call girl, an American geisha. To her, a life without love was an occupational necessity. Try to cage her and she'd fly away, just like she flew away from Doc Golightly, the ex-husband she left back in Tulip, Texas. Freedom is what she's after, and in New York City Holly finally finds it; she cuts off her hair, speaks frankly about fucking, and is unrattled by the fact that the narrator, whom she calls "Fred" after her own brother, is gay. (She even admits to being a "bit of a dyke" herself.)

Though it's never explicitly stated, "Fred" is indeed a homosexual. Truman codified it somewhat, but it's in there for the taking. (Of Fred, Capote wrote, he "once walked from New Orleans to [the fictional] Nancy's Landing," and Holly calls him "Maude" in the gay slang of the day.) That means that he and Holly are bound to one another by their sexually unorthodox dispositions. Unlike Holly and her lovers, they

share an intimacy that isn't tethered to their erotic or financial needs. In other words, they can love each other *freely,* the way no two married people can.

Challenging the sanctity of heterosexual dominion, Capote is suggesting that the gendered strictures of who makes the money (men) and who doesn't (women) might not be as enriching as the romance between a gay man and straight woman. This isn't because he believed platonic relationships were somehow ideal, or because he considered straight people bores, but because in 1958, with wives across America financially dependent upon their husbands, being a married woman was a euphemism for being caught.

Capote isn't whipping out any political pistols here, but he's certainly packing heat. In truth, he was more interested in observing a trend, being, in a sense, a journalist. "Every year," he explained, "New York is flooded with these girls; and two or three, usually models, always become prominent and get their names in the gossip columns and are seen in all the prominent places with all the Beautiful People. And then they fade away and marry some accountant or dentist, and a new crop of girls arrives from Michigan or South Carolina and the process starts all over again. The main reason I wrote about Holly, outside of the fact that I liked her so much, was that she was such a symbol of all these girls who come to New York and spin in the sun for a moment like May flies and then disappear. I wanted to rescue one girl from that anonymity and preserve her for posterity."

Truman finished *Breakfast at Tiffany's* in the spring of 1958 and expected to publish it that summer in *Harper's Bazaar.* But he didn't. They turned him down. Truman Capote, rascal

genius and cause célèbre of the literary world, and they turned
him down.

BREAKFAST AT TIFFANY'S, TRAVELING

Apparently, it was a problem of language. Carmel Snow, the
editor to whom Truman had promised the manuscript, had
been fired, and in her place, the Hearst Corporation had in-
stalled Nancy White, a sort of unimaginative company cog.
She objected to some of Capote's colorful usage ("dyke,"
"hell," "damn"), and most of all, to his heroine's free spirited-
ness. Truman was horrified by White's objections but acqui-
esced, and together they reached a less-colorful compromise.
"The Bazaar is printing it in their July issue," he wrote to his
friend Cecil Beaton, "though they are <u>very</u> skittish about some
of the language, and I daresay will pull a fast one on me by
altering it without my knowledge."

As it turned out, *Bazaar* altered nothing but their inten-
tion to publish. Just as they were about to send the cleaned-
up Nancy White version of *Tiffany's* to press, the magazine
backed out once and for all. No, they said, with a heroine as
openly carnal as Holly Golightly, *Breakfast at Tiffany's* was just
too risqué for their publication. Truman, naturally, was out-
raged and vowed never to associate with *Harper's* again. He
and Jack took off for Greece.

Truman was in Athens when he received the telegram from
Esquire. The magazine offered to buy *Breakfast at Tiffany's*
from *Harper's Bazaar* for the two thousand dollars they'd paid
for it, and put up an additional thousand dollars just to sweeten
the deal. (Truman said yes.) By the time he and Jack returned

to New York in October of 1958, Random House had published *Breakfast at Tiffany's*, and *Esquire*, in its November issue, had serialized the novel in full.

On the whole, the book was well received, but no one was more ecstatic than Norman Mailer. "Truman Capote I do not know well, but I like him," he wrote. "He is tart as a grand aunt, but in his way is a ballsy little guy, and he is the most perfect writer of my generation, he writes the best sentences word for word, rhythm upon rhythm. I would not have changed two words in *Breakfast at Tiffany's*, which will become a small classic." There was, however, a bit of dissent. Several critics found the novel—and Holly herself—disconcertingly slight, and even shallow. "Whenever Capote tries to suggest the inner life of his heroine," wrote Alfred Kazin, "the writing breaks down. The image of the starving hillbilly child never comes into focus behind the brightly polished and eccentric woman about town in her black dress, pearl choker, and sandals."

Was Capote fazed? Hardly. He was too busy sunning himself in the spot- and limelights.

THE REAL HOLLY GOLIGHTLY

After the publication of *Breakfast at Tiffany's*, modish women all over New York began to announce—some with evidence and others without—that *they* were Capote's real-life inspiration for Holly. Thus began what Truman called "The Holly Golightly Sweepstakes."

Just about everyone, it seemed, had biographical ties to the novel, but no claim was nuttier, or less factual, than that of the twice-divorced former Greenwich Village bookstore

owner Bonnie Golightly. She sued Capote for $800,000, charging him with libel and invasion of privacy, claiming that Truman shaped Holly from facts about her life he picked up from "mutual friends." "Besides a broad Southern accent acquired from her Tennessee upbringing," noted a February 9, 1958, item in *Time*, "Bonnie Golightly points to some other evidence. Like Capote's Holly, she lived in a brownstone on Manhattan's fashionable East Side, with a bar around the corner on Lexington. Like Holly, she is an avid amateur folk singer with many theatrical and offbeat friends. Like Holly, Bonnie says: 'I just love cats. The cat thing corresponds, and all the hair-washing and a lot of little things hither and yon.' One bit of Hollyana to which Bonnie makes no claim: 'I've never, absolutely never, had a Lesbian roommate.'"

Upon learning of Miss Golightly's claim, author James Michener wrote a letter to Random House in Truman's defense. "The suit brought by the young woman in New York is patently false," he wrote, "because I happen to know without question that Truman patterned Holly Golightly after a wonderful young woman from Montana. . . ." When Michener showed Truman the letter, Capote instructed him to burn it immediately. "I've been afraid she's going to sue, too!" he cried.

Michener had met the woman in question, a "stunning would-be starlet-singer-actress-raconteur from the mines of Montana," through Leonard Lyons, columnist for the *New York Post*, when she had been hanging out with him and Truman in the fast and wild pre-*Tiffany's* days. "She had a minimum talent," Michener recalled, "a maximum beauty, and the rowdy sense of humor. Also, she was six feet, two inches tall, half a head taller than I, a head and a half taller than Truman."

In the end, neither woman sued; Bonnie was ridiculed back to reality and the Montana-made starlet rode it out only as far as she could. Thanks to her newfound notoriety, the actress transferred some of Holly's aura to herself (which Holly, ironically, had borrowed from her), spun in the sun for her mayfly moment, and then, like Truman's mother, up and disappeared. But was she, or any of the other women who stepped forward, the *real* Holly Golightly? When the question was posed to the book's author, he answered a simple no. "The real Holly Golightly," he said, with a portentous pause, "was a girl exactly like the girl in *Breakfast at Tiffany's,* with the single exception that in the book she comes from Texas, whereas the real Holly was a German refugee who arrived in New York at the beginning of the War, when she was seventeen years old. Very few people were aware of this, however, because she spoke English without any trace of an accent. She had an apartment in the brownstone where I lived and we became great friends. Everything I wrote about her is literally true—not about her friendship with a gangster called Sally Tomato and all that, but everything about her personality and her approach to life, even the most apparently preposterous parts of the book. For instance, do you remember, in the beginning, where a man comes into a bar with photographs of an African wood carving of a girl's head he had found in the jungle and the girl could only be Holly? Well, my real-life Holly did disappear into Portuguese Africa and was never heard from again. But after the war, a man named John La Touche, a well-known song lyricist and writer, traveled to the Belgian Congo to make a documentary film: and in a jungle village he discovered this wooden head carving of Holly. It's all the evidence of her existence that remains."

"Truman mentioned such a woman to me too," remembers Gerald Clarke, Capote's biographer. "But in the version I heard she was Swiss. He even gave me her name. I could never find any of his friends who remembered her, however. Did she exist? Probably. But was she Holly Golightly? I doubt it. If she did exist, I suspect she was just one of the many." Indeed there were many, and as Clarke has witnessed, new ones keep popping up all the time. "A few months ago," he said, "a reporter from *Newsday* called me. She was writing an obituary of a woman who had told her family that *she* was the model for Holly. I had never heard of the woman, but the reporter told me that she was the right age, had been a model, knew Truman, and so on. There were lots of women like that in those days, and my guess is that Holly owed something to any number of them."

At that time, there were few girls in fifties literature quite like her. Though it may not seem so at first glance, lurking beneath Holly's hedonism, a kind of uptown beatnik is crying to get out. She may not wear berets or play the bongo, but she speaks in "hep"s and "crazy"s, cares not a thing for domestic propriety, and like a girl out of Kerouac, is hell-bent on freedom. But not just in terms of ubiquity, of going lightly. It was the American sleepwalk that Holly—and her Beat brethren—were running from. In fact, the term "beatnik," coined by journalist Herb Caen only months before the publication of *Breakfast at Tiffany's,* pinned the suffix "nik" to "beat" after the Russian satellite *Sputnik I.* What could be more anti-American than that? Not that Holly was a polemicist; she'd never get on a soapbox to argue for anything other than having a good old time.

But in her reckless love of individuality, whether she knows it or not, Holly rustles with the fervor of the next generation.

It would be three years until Truman's creation shook loose the complacencies of Babe Paleys across America—and it would take the film for it to happen—but until then, the Holly of the novel would be viewed as a salacious other— not a normal person, but one of the world's weirdos, one of *them*. In 1961, Audrey Hepburn, the good girl princess, would change all that. With the movie of *Breakfast at Tiffany's*, she'd bring Holly home.

4

TOUCHING IT

1958–1960

JUROW AND SHEPHERD MAKE THEIR MOVE

Midway into production on *The Hanging Tree*, Jurow-Shepherd's first movie, Marty Jurow was handed the reader report on *Breakfast at Tiffany's*. The book was still in galleys, so there was no sales record yet, but even a fool could see it wasn't the kind of story that screamed box-office success. "Well-written, off-beat, amusing," the coverage said. "But it is unfortunately too similar to Isherwood's work [*Goodbye to Berlin*], dramatized as *I Am a Camera*. The type of character is the same. Only the incidents and chronology are different, and in any event this is more of a character sketch than a story. NOT RECOMMENDED."

But Jurow was curious. So was Shepherd. "We thought there could be a feature there," he said, "because the story of

how a girl comes from Tulip, Texas, and gets involved with a guy in New York was at its heart a love story and could even become a marketable romantic comedy. It has an opening act in that sense, and ultimately had a potential conclusion if they got together, but we weren't sure. There were problems." Maybe somewhere there was a movie in it. Maybe.

Jurow called Capote's agent, Audrey Wood, to set up a meeting with Truman in New York. Wood let Jurow know there were already a few offers on the table, but Marty couldn't be so sure. Was that a bluff? Was she bullshitting him? Probably not. Even outside of literary circles, the name Capote had serious cachet; his talent had earned him prestige, and his flamboyance made him into a star. In Hollywood, that combination made *Tiffany's* highbrow plunder, and it would earn the one who got the rights a sizable chunk of clout. As Jurow knew, that made *Breakfast at Tiffany's* a good investment, even if they ended up never making a movie out of it. Just having it in their possession would be a victory.

Jurow got on a plane to New York as soon as he could. The trick was to see Capote in person, and waste no time in doing it. Who knew how many executives Truman had already met with or how much they had offered him? Or was it already over? At the very moment Marty took his seat in first class, Truman could have been dangling his pen over someone else's dotted line.

Jurow knew he could handle the negotiation. Though his production company did not yet have the swagger of other, older production outfits, or a fat wad of box-office receipts to flash around like a VIP pass, they did have one very formidable lure: both Marty Jurow and Richard Shepherd were

seriously connected. "I had a good relationship with Audrey Wood since we had met at MCA," Shepherd explained, "and I don't mind saying that Marty and I had represented some very important, very bankable clients from the days when we were agents. Audrey knew that and Truman did too." Should *Breakfast at Tiffany's* get that far into preproduction, Jurow-Shepherd was only a rotary call away from the biggest names in town.

And if that didn't hook Truman, they had other lures. Shepherd said, "The fact that Marty and I were developing Tennessee Williams's *Orpheus Descending* [which became *The Fugitive Kind*], and were willing to go with Anna Magnani, who Tennessee wanted, as opposed to Ingrid Bergman, who wanted to do it with [producer] Sam Spiegel and who would be better for the studio, meant a lot to Tennessee, I'm sure, and I think it's probably why he ended up selling us the rights to his play. My guess is that even though we hadn't produced a lot of movies, Audrey Wood looked upon us as producers who would remain respectful to her writers."

As the senior, more experienced member of the team, Jurow was chosen to go to New York. He had since proven he knew how to be clean in the boardrooms, and if need be, dirty when it counted. Nothing for him was without precedent—or so he might have told himself as his plane took off from LAX—but he had never sat across the table from the bulldog Truman Capote.

Of course, he had heard the stories. He knew that Capote had New York society at his feet, that Bill Paley called him Tru-Heart (others called him the Tiny Terror), and that somehow, by charm, wit, or genius, when it came to seduction, he was an absolute pro. Who would set the terms of the deal

was anyone's guess, but Jurow, as he told Shepherd before the flight, had committed himself to winning the property. He would be the one doing the seducing.

Best, he thought, to steer clear of story discussions. Writers wanted promises about the adaptation, and promises Jurow couldn't make. He could, however, promise to remain "faithful." That one was always up for interpretation. If it came to it, Jurow decided, he would sincerely pledge his commitment to what was written. He would assure Capote that he and Shepherd wanted only to be loyal to his ideas about *Tiffany's*, with, of course, the single (*ahem*) caveat that there are certain very minor things that work on the page that just don't work on the screen. Surely Truman, as an occasional screenwriter, understood that. Jurow knew the way to get what he wanted was to keep the other guy sure *he* was getting what he wanted. If he was a writer, that meant letting him talk and talk. They'll deny it between their gulps of booze, but all writers love nothing more than the sound of their own voice. They crave the spotlight, and Capote more than most. Just look at the way he posed for photographers. Deep down, the guy was nothing but showbiz, and nobody could play that game better than Marty Jurow.

They were to meet at the Colony Restaurant on Madison and Sixty-first. Marty got there early, gave his name to the maître d' and was led to a corner of the room designated for Mr. Capote. The table, Marty discovered, had its own telephone, a select coterie of personal waiters, and as one of them revealed, a private stash of wine reserved just for Truman. Just then, a nasally chirrup shot out from across the room. Marty looked up. There was the leprechaun Truman Capote, bounc-

ing ahead, extending a grin to his admirers, and catching air kisses thrown at him from all ends of the restaurant. Yes, Marty thought, he was looking at a picture of pure showbiz, an entrance staged and costumed to Truman's exacting perfection. If you could measure a man's ego by the length of his scarf, then this one had no end. He had been right to come to New York.

Over the next several hours, as Truman's eyes radared the premises for socialites and celebrities, Marty Jurow listened to the little man's monologue on who he saw and who saw him, and about Marilyn Monroe, that sweet dear baby, who was sent down to earth to make married men crazy and, according to Truman, play Holly Golightly. Here Marty turned on his practiced smile and tried to change the subject. But Truman held on. He told Jurow how he had known Marilyn for something like ten years, that he had met her around the time of her first speaking role, and that they were very fond of each other. Beneath all that sex and glamour, Truman said, Marilyn had something touching about her, something simple. She would be perfect for the role of Holly. ("Don't you think, Mr. Jurow?") She was Truman's first choice.

He and Marilyn were very close, Truman continued, which would make things a lot easier. They were always seen together at El Morocco, either canoodling in a corner or, of all ridiculous things, dancing. So as not to tower over him, Marilyn would kick off her little shoes and twirl around in her bare feet. "It's true!" Truman said, laughing. "It's true!"

Marty listened (incredulous), nodding his head, and when he could, inserted a few words of carefully chosen praise about the book. It wasn't easy to keep Truman on subject, but Marty

made his pitch when the time came, pledging his—and Richard Shepherd's—loyalty to what was written, dropping choice details from the coverage he had reviewed in the cab over. Truman listened, beaming at the morsels of praise he ingested between chews. As Marty went on, it became clear to him that he had Capote right where he wanted him. For the moment.

"You know, of course," Truman said, "that I want to play the male lead."

Marty took a breath. If he stalled for a moment to figure out if Truman was joking, he could buy enought time to calculate his next move. All he needed to see was the slightest tremor turn up at the corner of Capote's mouth. Then Jurow would know that he needed to laugh. But there was no tremor, only silence. Marty was on his own.

"Truman," he said, erring on the side of flattery, "the role just isn't good enough for you."

Truman said nothing.

Marty waited. He'd have to fill the silence.

"All eyes will be on Holly Golightly," he added, "through every frame of this picture. The male lead is just a pair of shoulders for Holly to lean on. You deserve something more dynamic, more colorful."

Did that work? In the hush that followed, Jurow had no way of telling. If Capote smelled the bullshit—and God knows it was getting thicker by the second—it would all be over.

"You're right," Truman said. "I deserve something more dynamic."

The next day, with Paramount's approval, Marty closed the deal for $65,000.

MARILYN

On the plane back to Los Angeles, Marty found himself seated next to Marilyn Monroe. At that time, only months away from the release of *Some Like It Hot,* Marilyn had achieved breathtaking fame, and a level of sexual and commercial desirability few other Americans had (or ever would). She had heard all about *Breakfast at Tiffany's* from Milton Greene, her photographer-cum-producer-cum-partner-cum-confidant, and though she had not read the book, she was interested in playing Holly. It was something Marilyn said she'd have to discuss with Paula Strasberg, her personal acting coach and, along with Greene, career adviser. She said she'd talk it over with them, but what she really meant was she'd have to get their permission. She was, as Truman said, very much the little child under all that creamy come-hither; weary enough to know human iniquity, but too timid to defend herself against it. "I've never had a home," she once confessed to Truman. "Not a real one with all my own furniture." There was more than a little Golightly in that.

But Jurow wasn't convinced Marilyn was right for *Breakfast at Tiffany's.* Holly had to be sharp and tough, and as anyone who saw Marilyn could sense, she was about as tough as a tulip. It was difficult to imagine a personality like that living like Holly, all on her own in the big city.

And there were the very practical facts of film production to consider. Marty knew that Marilyn was notoriously irresponsible, and to a producer, that meant expensive. He'd heard

stories about her on *The Seven Year Itch*. Wilder said dealing
with her was a kind of hell, like pulling teeth. His picture fell
nine days behind schedule (at $80,000 a day), and not just be-
cause of Marilyn's chronic lateness, but because of her strange,
almost pathological block against remembering dialogue (she
might require up to forty or fifty takes to complete a single
line). "It's not that she was mean," Billy said. "It's just that she
had no sense of time, nor conscience that three hundred people
had been waiting hours for her." Jurow didn't want that on his
hands; and yet, he knew Marilyn could sell tickets. So maybe
she'd bring in more than she'd cost them. Wilder thought she
was worth it, but with a big proviso: she couldn't always hit
the right notes. One minute she had the precision timing of
Judy Holliday, and the next she was mugging like crazy.

Days later, Jurow got a phone call. It was Paula Strasberg.
"Marilyn Monroe will not play a lady of the evening," she told
him. Case closed.

Maybe. "I remember it this way," Shepherd said. "We both
knew Marilyn was interested, but neither of us really saw her
in the part. Because she was at one time a client of mine, I was
the one who had to call her and tell her we were going to go
with someone else. It was beyond question one of the hardest
calls I've ever had to make. But she took it fine. 'Okay,' she said.
And that was it."

Before they could consider any other actresses, Jurow and
Shepherd needed a great script, something so good that every
doubt an actress would have about the raciness of the project
would be washed away the moment she started reading. But
before the script could be great it had to be good, and consid-
ering the difficulty of the adaptation, just converting Capote's

novel into movie terms—a story with three acts, relatable protagonists, and a concrete romance—would be a challenge for any screenwriter, no matter how experienced.

In January of 1959, Jurow and Shepherd set out to find one.

THE GAG WRITER

Since the day his wife gave him the novel, well before he got the news of Capote's deal with Jurow-Shepherd, George Axelrod had been dying to adapt *Tiffany's*. The book had all the elements he was drawn to: wit, a progressive sensibility, and sophistication up the wazoo. Just about everything Hollywood thought George wasn't.

Like most other successful actors, directors, and writers in pictures, Axelrod was typecast by his success and unable to break free. Executives considered George capable of writing his particular kind of movie—the lowbrow *The Seven Year Itch* kind—and nothing else. He had cornered the market, and now the market was cornering him.

It's a testament to his enthusiasm that he went ahead anyway and pitched the idea to Fox. That's when George found out that Jurow-Shepherd had beaten him to it. From there he went directly to Paramount, eager and hopeful that if the book had already been optioned, he might be able to finagle himself into the job. But Jurow and Shepherd flat out turned him down. Not uptown enough, they said. *Breakfast at Tiffany's* was going to be a class picture, not a yuck job.

If they were making a comedy with Jayne Mansfield or Marilyn Monroe, then, yes, they'd get George, but that wasn't what they wanted for *Breakfast at Tiffany's*. Worse than that, as

a screenwriter he was a real liability. After *The Seven Year Itch*, the name Axelrod was such a red flag to the protectors of the Production Code that putting his byline on a script about a call girl might just shut down their production for good. So, no: Jurow-Shepherd needed to tread lightly, which is why they were after as genteel and well mannered a writer as they could get. George Axelrod was not that writer.

THE SERIOUS WRITER

They went with Sumner Locke Elliott. He was what they meant by a serious writer. The producers contracted him to fly out to L.A. for a week's worth of story conferences, from which he would produce a sixty-page dramatic outline. If they deemed the outline satisfactory, Elliott would proceed into the screenplay; if not, the contract stipulated the deal would be finished without any future commitments. In Hollywood parlance, it was called a cutoff. Elliott signed.

THE GAG MAN GAGGED

Axelrod called Capote. They had only met a couple of times.

"Truman," George said, "they won't use me. They don't think I'm serious enough."

"Well, bullshit," Truman said. "They don't know how to do it, *you* know how to do it."

But Capote's hands were tied. He told Axelrod that he was not at all involved in the film's adaptation or production—that he had sold the option on the novel and that was that. And in any case, he was trying to write a book about the massacre of

a Kansas wheat farming family. It was very unlike him, yes, but he couldn't resist the appeal of inventing a whole new type of literature, and he had reason to believe it would be his masterpiece.

George was right back where he started.

THE SERIOUS WRITER GAGGED

Until now, Sumner Locke Elliott had been a novelist, playwright, and a prolific TV writer with almost three dozen credits to his name. But in ten steady years of working in the business, he had never seen one of his feature scripts produced. That may have been tough on the writer, but it was all right by Shepherd and Jurow, who lowered their payment accordingly. From their perspective, the fact that Elliott was a gay, New York–based writer only sweetened the deal and hinted at the possibility of cultivating that certain Capote something. At least in theory.

Upon receiving Elliott's treatment in April 1959, a distressed Richard Shepherd wrote a memo to Paramount studio chief, Y. Frank Freeman, including the following:

Suffice to say we are all immensely disappointed in Elliott's efforts. Disregarding its length and its peculiar physical format, we are most disturbed by its episodic, disjointed, fluffy and even ephemeral tone. Elliott, to our way of thinking, has seriously failed to capture the warmth, the zest, the humor, the beauty and, more important, the basic heart and honesty that is Holly Golightly. The young man he has written is petty and unattractive in character, borders on the effeminate, which we

all detest, and as is the case with Holly and the whole piece, is almost totally devoid of the humor and contemporary flavor that is absolutely vital for this picture.

Most important, however, a dramatically <u>sound</u> <u>story</u> <u>line</u> and point of view is either non-existent or certainly not clear. Capote's book provides a marvelously wonderful character study of a fascinating girl, surrounded by almost equally interesting people and locale.

Our task has been and continues to be one of converting this character study into a <u>clear-cut</u> <u>dramatic</u> <u>story</u> <u>line</u> with an even clearer audience <u>point</u> <u>of</u> <u>view</u>.

We spent considerable time and effort in story conferences with Elliott with the primary objective of making certain that the dramatic line and point of view in his treatment would be clear. Somehow, as is so unfortunately often the case, the result did not equal the expectations.

All of us are convinced that we are correct in assuming that the boy and girl get together at the end of our story, that Holly's problem, which is the principal one, is in some way resolved through the understanding, love and strength of the boy. This requires a completely different kind of male character than has been given to us by Elliott and a far more solid construction of the dramatic elements of the piece.

We therefore are of the singular opinion that a different man should be put on the job. One with infinitely more experience in dramatic construction, with a contemporary understanding of these people to say nothing of an appreciation for comedy that is not so perfumed. Our gamble on Elliott in the hopes of getting a proper script on the more economical basis

*did not pay off. There is some consolation, however, in the fact
that we protected ourselves with a proper cut-off period.*

Elliott was off the movie, leaving Jurow and Shepherd with
no script and one hell of a tough adaptation.

THE PITCH

Only days later, George got a call from his agent, Swifty Lazar.
Elliott was out, he said. They thought his script lacked piz-
zazz, not to mention a clear story line, and Jurow-Shepherd
was looking for a replacement. The production company was
anxious to move forward, he said, and fast. Was George still
interested?

Was George still interested?

Yes, he was still interested.

Hold on, Swifty said. It wasn't that easy. It wasn't in the bag.
Jurow and Shepherd, the agent explained, were now looking
at some very experienced, very "respectable" writers. Their
new list included some of the most accomplished in the busi-
ness: Betty Comden and Adolph Green (*Singin' in the Rain*),
Charles Lederer (*His Girl Friday, Gentlemen Prefer Blondes*),
Samuel Taylor (*Sabrina, Vertigo*), Julius Epstein (*Casablanca*),
Ernest Lehman (*Sabrina, Sweet Smell of Success*), the redoubt-
able Kanins (*Adam's Rib*), and of course, George Axelrod (*Boobs
and boobs*). The writer they hired would bypass treatment and
go directly to screenplay, meaning if he or she could pitch
Jurow and Shepherd an idea they liked—a romantic comedy—
with a clear-cut dramatic story line and less effeminate male

lead, then, for the right price, the gig was theirs. All George had to do was figure out the right angle, go in for a meeting, and knock 'em dead. Swifty hung up.

Axelrod was almost ready. He had been thinking about *Tiffany's* for so long, and knew the trick was to make the picture more of a traditional romance, structurally speaking. To do it, he'd have to invent a stronger conflict, some impediment to the love story, which the lovers had to overcome to be together. Otherwise, the movie would be over in one scene; they'd meet, get coupled, and that would be it. So what would keep these two mutually attracted people apart? If Axelrod couldn't answer that, his story would go the way of Elliott's, and it would be back to boobs for him.

If Axelrod were writing for Doris Day and Rock Hudson the problem of finding the conflict would come ready-made. The guy wants to get the girl into bed and she wants to stay out of it—until they get married. And when they finally do, the movie ends. But in Holly Golightly, who isn't guarding her virginity like it's Fort Knox, Axelrod had to grapple with a heroine who was anathema to the genre. If only he could lick the conflict, he could easily be at the forefront of a new kind of romantic comedy. Not one about 1950s people who shrink from sex before marriage, but one about modern people who embrace it.

Axelrod would have to flip the paradigm. Where Doris Day struggled with abstinence, Holly would struggle with promiscuity. Thus commitment, not desire, would be at the heart of Holly's conflict—that much Axelrod could bring over from the novel—but what then would prevent the newly heterosexual male from running away with her? If she slept with every-

one, why wouldn't she sleep with him? The most obvious answer was the one right in front of George: the same thing that prevents *her* from running away with *him*. He's a gigolo, too. *That's* it. And he can't afford to pay for a night with her, and she can't afford to pay for a night with him, and when they do finally get into bed together after he's just slept with his sugar mama, he's just too tired to make a move. Ergo they just lie there. So their conflict? Leaving a steady life of fiscal security for one of love. Going from being "owned" to being free. Making the late fifties into the early sixties.

It was three o'clock in the morning when George Axelrod turned to Joan in bed and said, "I've got it! I know how to do *Breakfast at Tiffany's* as a movie!"

At last, Axelrod would pitch a sex comedy *with* sex. It probably wasn't something that Paramount would be immediately comfortable with, but if Jurow wanted uptown, this was it: a contemporary romantic comedy for the modern generation.

AUDREY'S RETREAT

On May 20, 1959, just weeks after Audrey's thirtieth birthday, the Ferrers announced they were expecting once again. But tragically, while shooting *The Unforgiven* in Mexico that June, Audrey miscarried a second time. The emotional burden, she said, was unbearable, the worst of her life. "I blamed God," she said. "I blamed [director] John Huston. I was a bundle of anger and recrimination. I couldn't understand why I couldn't have children. Mel and I were so much in love."

She retreated to her home in Lucerne, and with the encouragement of her physicians, began to consider returning to

work. Most scripts, however, didn't appeal to her. Despite pro-
testations from her agent, former boxer Kurt Frings, Audrey
turned down the (quite prestigious) leading parts in both *West
Side Story* and *Cleopatra.* Only *No Bail for the Judge,* the film
Alfred Hitchcock announced would be his next, piqued her
interest. But she had reservations about the material. The role
of Elizabeth—a British barrister who sets out alone to acquit
her father of murdering a prostitute—was quite blatantly at
odds with her traditional persona, which, in the years since
Sabrina, had maintained its conservative stance.

Audrey was still very much the party-less party-line girl. In
1956, aiming to take on a "serious" part as a dramatic actress,
she played Natasha in the woefully stilted *War and Peace,* which
earned her good reviews, but did nothing to her status quo.
Funny Face, released in 1957, pointed her in the right direction,
as did Billy Wilder's *Love in the Afternoon,* released the same
year. But both films paired Audrey with considerably older
men (Fred Astaire and Gary Cooper, respectively), which kept
her star securely hitched to the idea of adolescent love-worship
and romantic fantasy, and the boat went unrocked. As Sister
Luke in *The Nun's Story,* Audrey did battle once again with the
opposing forces of duty and desire, and for a time, it looked
like rebellion. But she can't have her church and eat it too.
"How can I be a good nun," she asks, "if I can't get the Congo
out of my blood?" Like Princess Ann of *Roman Holiday,* Sister
Luke must divest herself of one in order to have the other. "I
think I've been struggling all these years, Reverend Mother,"
she says, nobly. "In the beginning, each struggle seemed dif-
ferent than the one before it. Then they began to repeat, and
I saw they all had the same core: obedience without question,

without inner murmuring. Perfect obedience as Christ prac-
ticed it, as I no longer can." The urge to resist ethical mandates
is there, and is indeed compelling, but Audrey's conviction
to reverse them is not. *Green Mansions* followed in 1959, and
a year later, she played the denim-skirted Rachel Zachary in
John Huston's western *The Unforgiven*. The spirit of her indi-
viduality remained problematic in each.

All the more reason, Frings advised Audrey, to expand her
repertoire. Taking *No Bail for the Judge,* he said, would allow
her to grow in new, darker, more challenging directions; and
with the added benefit of working for Mr. Hitchcock, she
wouldn't have to worry as much about public approval. They
understood his name meant quality, no matter how perverse
his films.

Audrey saw Frings's point and agreed to the picture. But
after signing the contract, she learned that Hitchcock and writer
Samuel Taylor had added a new scene, what looked alarmingly
like a rape scene, and Audrey wanted out of the picture. In a
cleverly timed announcement, she made public—only seven
months after her miscarriage—the news of yet another preg-
nancy. This time, Audrey said to the press, nothing, not even
Alfred Hitchcock, would endanger her baby. Children were "in-
dispensable for a woman's life and happiness." Films were far
from her mind.

"I'm told the pregnancy transported her," her son Sean said,
looking back. "All she wanted was to be a mother and have a
family. Here it was and she wasn't going to let anything stop
it." Robert Wolders agreed. "She loved family more than her
career," he said. "That was far more important to her than
movies."

ROMANTIC COMEDY

After hearing George Axelrod's pitch, Marty Jurow made it clear to Paramount that he was not interested in vetting other writers. George was it.

Hours later, Shepherd cabled Swifty in Europe for the price on Axelrod (Joan Axelrod said, "They offered him Rhode Island and a piece of the gross"), and in a week—this was vintage Swifty—the papers were signed. George would write a first draft screenplay in fifteen weeks, followed by two weeks of consultations with Jurow and Shepherd, four weeks of revisions, and then two additional weeks of consultations on the rewrites followed finally by three weeks for second revisions. For all this—a combined total of twenty-six weeks of work—he would receive $100,000.

Now all George had to do was write the damn thing. Plied with long cigars and a few vodkas (neat and chilled), he put some kind of an outline down on paper, and in the loosest possible form. Too many details at this stage could kill the energy he needed to save for the screenplay itself. In the meantime, he'd turn those scene ideas into scenes, scribble them down on notepad paper, cut away the slack, and then, when he got the feeling he had something good, something that couldn't be said better, he'd transfer them to his Olivetti, which stood proudly on his desk beside his favorite photograph—a shot of him and Marilyn on the set of *Bus Stop* squeezing the hell out of each other.

He took out Capote's brittle edge and replaced it with soft-focus pluck. Out went the bitchy exchanges between Holly

and Mag Wildwood. Out went her illegitimate pregnancy and miscarriage. Out went the scene when she saves the narrator from a rogue horse and out went her flight to Brazil with Jose and eventual disappearance in Africa. Anything of the know-how and resilience Capote instilled in his heroine was now out of step with the new Holly, who Axelrod was turning, quite deliberately, into a cockeyed dreamer à la Princess Ann in *Roman Holiday* and Sabrina in *Sabrina*. Playing up the Tulip, Texas, girl was a good move, strategically speaking; not only did it cater to Audrey's screen personality, but as a discretionary precaution, it also would help the audience forget that their lead was turning tricks in her spare time. Better a bunny rabbit, George thought, than a shark.

He added a scene in which Holly and Paul (formerly the narrator, or "Fred") try to get a Cracker Jack ring engraved at Tiffany's. In its subtle satire and whimsy, the scene represents the kind of high comedy Axelrod wanted in the script (it remained his favorite scene in the picture). In utilitarian terms, the scene develops the embryonic love story, tightening the emotional connection between Holly and Paul. We see they've formed a conspiratorial bond crucial to the translation of *Breakfast at Tiffany's* from one kind of story to another— character study to romantic comedy, homosexual to heterosexual, platonic to erotic.

Axelrod finished the script in July of 1959. He two-finger typed the whole thing.

A month later, Jurow-Shepherd submitted it to the Production Code Administration for review. "Most sex comedies involve men cheating on their wives," George said about his script. "Well, I'm striking a blow against the double standard."

Exactly how hard he struck, and whether or not the blow was acceptable in the first place, was now under the jurisdiction of a man with the deskbound name of Geoffrey Shurlock— Hollywood's new moral watchdog.

A LITTLE MORE THIGH

Since his appointment in 1954, Shurlock followed a slow but intentioned process of moral realignment in Hollywood, instigating the Production Code's first major rewrite in the twenty years since its inception. The new Code was less a symptom of a new loosening in America's values than it was—like all changes in Hollywood practice—about the bottom line: selling tickets. In the 1950s, Hollywood was in the midst of an industry-wide panic over the threat of TV, and tried every trick in the book (CinemaScope, 3-D, AromaRama) to lure people from the comfort of their living rooms. An increase in moral latitude was one such trick, and with the ascension of Geoffrey Shurlock—a man in the business of doing business—producers and directors with an eye on a dollar and a hand up a thigh saw an opportunity to force the door. Push too hard, however, and one loses his picture's popular appeal. Alexrod knew this. After the debacle of *The Seven Year Itch,* he knew the idea was finesse, to push without looking like you're pushing.

DOING IT FOR MONEY

It was a game of red-tape limbo, but by this time, Axelrod was something of a pro. He preemptively booby-trapped the script, overemphasizing Paul's sexual activity in a bait-and-switch

effort to reroute Shurlock away from Holly. (Richard Shepherd had seen this move before: "I knew certain writers who would specifically try to lead the Code offices astray by putting something in there that they knew was going to be too hot, just to lead them off the scent.") There were a few Golightly morsels calling out to be nixed (on "Page 15," Shurlock wrote, "Holly should be wearing a full slip rather than a half-slip and brassiere"; later, she must specify that her marriage to Doc had not ended in divorce, but had been *annulled;* and her scenes of undressing must be "handled with extreme care to avoid an attempt to exploit any partial or semi-nudity"), but these were relatively minor in comparison to Paul's provisions, which Shurlock outlined with exacting care and detail.

One scene in particular—eventually cut from the finished film—stood out from the rest. Intended to follow the brief exchange between Holly, Paul, and a new character—called 2E, her apartment number—outside their brownstone, the dubious scene lays out Paul and 2E's sexual arrangement quite clearly, and it reveals in the process an aspect of Paul's backstory taken directly from Axelrod's own. "I couldn't bear the idea of you . . . prostituting yourself . . . sitting in a little cage in Hollywood," 2E says, "writing movies that would make us both cringe when we saw them later. . . . Let me be your Hollywood, Paul . . . your own personal, tender, loving Hollywood. . . ."

PAUL
And what do you get out of it?

2E
Satisfaction, darling. Just satisfaction. And

maybe the feeling of pride, when the book is
finally done, of seeing the dedication page
that says: 'For 2E, Without whom . . .'

During this, she has very gently begun to unbut-
ton his shirt.

 PAUL

And that's all?

 2E

Well, almost . . .

She draws him to her and kisses him. When they
break she very gently pushes him away from her
and toward the bed.

 2E

It's not so bad, is it? Really?

 PAUL

I suppose there are tougher ways to earn a
living . . .

 2E
 (softly)

You <u>bet</u> there are, darling. You just bet
there are.

She begins to unbutton her blouse.

Cut! Hold it right there. "The relationship between 2E and Paul as presently described is unacceptably blunt," Shurlock wrote. "In this regard, we call your attention to the following unacceptable details: she has begun very gently to unbutton his shirt . . . [and she very gently] pushes him away from her and toward the bed."

There was more. Later, after the off-screen event takes place, Holly is on the fire escape, looking in at them through the window. From her point of view, we see "Paul is asleep in bed. In the single light from the bed lamp we can see that he is smiling benignly in his sleep." That too had to go. So did the following seemingly harmless piece of business: "2E, dressed for the street, is coming out of the bathroom. She moves about the room, straightening up. Emptying ashtrays and clearing away glasses." Shurlock wasn't objecting to cigarettes and alcohol, but to the suggestion that 2E and Paul spent *time* in the apartment before he fell asleep. With that bit of ligature, Shurlock knew that the audience could draw conclusions about the event preceding Paul's bedtime; without it—and without the adverb "benignly"—Holly would be watching nothing more precarious than a man asleep in his bed.

Cuts of this sort continued in other forms throughout the script. They might have whitewashed their affair beyond all recognition and obscured the story entirely if it weren't for Jurow-Shepherd's secret weapon, waiting like a Trojan horse at the gates. Confronted with Shurlock's order to slash various indispensables—lines of Holly's like "Three hundred? She's very generous . . . is that by the hour?" and "I was just trying to let you know I understand. Not only that, I approve"—the producers could argue that, in the face of Capote's homosexual

rendering of the narrator, it was essential they take certain pains to maintain the viewer's sense of Paul's "red-blooded" heterosexuality. Otherwise, they would leave themselves vulnerable to sexual deviance of another kind. Better that than *that*. Shurlock, after all, had explicitly warned against it: "There should be no attempt," he wrote, "to give Mr. Smith [a character cut from the film] the mannerisms usually associated with a homosexual." He'd fallen right into George's trap.

INT. MR. SMITH'S DOORWAY—(DAY)

As Paul climbs the stairs, Mr. Smith, two flights above, opens his door and calls down.

> **MR. SMITH**
> Roger? Is that you Roger?

> **PAUL**
> No, it's me . . . Paul . . .

As Paul comes up the stairs, Mr. Smith eyes him curiously. He's seen him somewhere before— but where?

> **PAUL**
> Sorry to bother you, old man, but you see I used to live in this apartment . . . before you took it and I'd heard you've done such fabulous things with it that I . . .

 MR. SMITH

You're very kind, but I'm really just get-
ting started . . . I haven't even put up the
drapes . . . actually when you rang I thought
you were someone else . . .

 PAUL

Roger?

 MR. SMITH

Yes. Actually, Roger's <u>bringing</u> the drapes.

With homosexuality explicitly off-limits, Axelrod's evoca-
tion of Paul would have to err on the side of hetero just to be
safe. George used the opportunity to insinuate something
bolder.

In the moment after Paul and Holly step into their brown-
stone (after they steal Halloween masks), they share a lin-
gering, almost awkward silence. In George's draft, Holly
is the first to speak. She says, "I just thought of something
that neither of us has ever done. At least not together . . ."
(Sex, *naturellement*.) But the line was cut, as was the decision
to set it upstairs in Paul's apartment because, in Shurlock's
words, "this story cannot handle an affair between Paul and
Holly." Shurlock's summary of the final screenplay read,
"Paul's novel, which has Holly for its heroine, is accepted
and he and Holly celebrate. ~~They end up spending the night
together~~. Paul realizes he has fallen in love with Holly and
breaks with 2E."

The battle over Paul and Holly's sex life was a battle too crucial for George to lose, but by September 1960 it was all over. Shurlock had spoken: Paul and Holly would not be sleeping together.

Without sex, George feared, *Breakfast at Tiffany's* would come apart. His vision of a sophisticated high comedy, of a picture that said the truth about adults in and out of bed, would slop into a tawdry mess of phony urges. He'd be back to *The Seven Year Itch*. Back to *Bus Stop, Rock Hunter,* and all the rest.

That is, unless Jurow and Shepherd could cast the picture right. If the right actress—and it wasn't Marilyn—could find a way to lend this whitewashed Holly some subversive carnal knowledge, then he'd get away with it. They all would.

A LONG SHOT

If Jurow and Shepherd were to go by Capote's description of Holly, they'd have to find a skinny girl with a "flat little bottom," "hair sleek and short as a young man's," and "a face beyond childhood, yet this side of belonging to a woman." And there was another consideration: the producers knew that as alluring as Capote's creation was, their Holly would have to be a whole lot gentler. That's the only way they could move this material through production.

Whomever they cast couldn't discharge sex like Marilyn, nor could she be young and innocent without provoking cries of Lolita. Furthermore, as a "good" call girl—not the Elizabeth Taylor kind that gets killed off at the end of *Butterfield 8*—Holly couldn't be too seductive. Not alluring enough, however, and the character would have no call-girl credibility at all.

How to do it? Strike a middle: cast Holly *just a little* against type. Find an actress who wasn't automatically associated with sex. Then make her sexy.

There were a few names. Jurow and Shepherd entertained the possibility of Shirley MacLaine, but she had already signed on to *Two Loves* at MGM. There was some talk of Rosemary Clooney, and even Jane Fonda, but casting her at twenty-three would raise too many eyebrows. Then who would it be? In 1960, the biggest women at the box office were Doris Day, Elizabeth Taylor, Debbie Reynolds, and Sandra Dee. None were right.

It was a long shot, but they would go for Audrey Hepburn.

5

LIKING IT

1960

GETTING TO FIRST BASE ,

Of course, Marty Jurow knew Audrey Hepburn would never go for Holly. And yet it wasn't the rejection that was the hard part, it was making the offer. You couldn't just call up Audrey and offer her the part. You had to call Frings, her agent. Then you had to wait for him to call you back. *If* he called you back. Then you had to convince him that it was worth presenting to Audrey, and you'd probably have to do it quickly before he got another call from a more notable producer with a more reasonable offer. Jurow would have been lucky to get that far, and in fact, most producers would have considered a minute of Frings's attention equal to an hour of anyone else's, but Marty aimed higher. He would cut out the middleman and go straight to Audrey herself.

Tiffany's would be a delicate pitch, and Frings could mangle it in translation. He could fail to summon compelling enthusiasm when the moment came, or what's worse, forget about it in the wake of other projects that took priority in his mind. And Jurow wasn't going to wait around for that. If Audrey was going to turn down *Tiffany's,* she was going to have to turn him down in person. At least then he would know that they had tried everything.

THE SEDUCTION

"Mr. Frings is in a meeting right now, can I take a message?" "Mr. Frings is in with a client, he'll have to call you back." "Oh, hello, Mr. Jurow. Yes, I did give him your message. Can he reach you at the office?" "I'm sorry, Mr. Frings has gone to lunch." "Yes, he's *still* at lunch, Mr. Jurow. Would you like to leave a message?"

Finally, they spoke. It was Frings himself who told Jurow it wasn't going to happen, that his client would not be playing a call girl, and thanked him for his interest. But Jurow wouldn't leave it at that.

"Frings was pretty sure Audrey wouldn't do it," Shepherd said, "so he didn't want to bother her with the script, but I guess Marty caught him on a good day. Who knows? Marty could talk." With Frings's go-ahead, Jurow and George Axelrod went off to pitch Audrey in person. Jurow would present the case, and Axelrod, in the likely event that Audrey resisted, would be stationed to turn her around. As a writer, he was better positioned to defend the nobler points of Holly's char-

acter, and if need be, he could even make accommodating changes right there on the spot.

Marty began his trip with a stopover in New York. He met Y. Frank Freeman and Barney Balaban, Paramount's top executives, at Dinty Moore's, a Broadway hangout with a honey of a bar. They knew where Marty was headed—and they let him know they weren't optimistic—but seeing him in person so eagerly explaining his angle made the whole venture seem to them more ridiculous than ever. What Jurow was endeavoring, they said, was a reckless expenditure of energy and resources. But Marty held out. "What if she said yes?" he asked. "What if we're all wrong?" Then he'd be a hero. He would be remembered as the one who did what Hitchcock didn't have the guts to do: the one who got up, went over, and told Audrey exactly why she needed to do the movie.

With Axelrod at his side, Jurow flew to the south of France where Audrey had joined Mel, who was hard at work on a movie. There, for about a week, Jurow and Axelrod tried to persuade a very pregnant Audrey Hepburn that far from damaging her career, Holly would only expand it. But as expected, Audrey blocked their every move. She told them she wanted to be with her family. She wanted to stay at home and raise the baby. And anyway, Mel had made up his mind about Capote's book long ago. "Audrey's reluctance was wrapped up in Mel's feelings that she shouldn't take the part," Robert Wolders recalls. "Before either of them read the screenplay, when *Breakfast at Tiffany's* was just a book, he had trepidations about her playing the part of the call girl, especially after he had heard that Marilyn had been up for consideration for

the part. He didn't quite think it would be good for Audrey's image."

"Oh, Martin," Audrey said to Jurow. "You have a wonderful script"—pause—"but I can't play a hooker."

There were two ways to take that one. Either Jurow could insist that Audrey had underestimated herself as an actress, or—and here is why he brought Axelrod with him—he could suggest they entertain the possibility of certain small rewrites that downplay the hooker angle in favor of that *other* side of Holly, the wholesome Tulip, Texas, side. He went for Texas.

"We don't want to make a movie about a hooker," he assured her, "we want to make a movie about a dreamer of dreams."

To drive home his point, Jurow went so far as to suggest that if Audrey didn't see Holly as the cockeyed romantic she truly was, then maybe she was the wrong choice for the part after all.

That got her.

Okay, Audrey said, if she took the part—*if*—she couldn't play it as written. What about sugaring some of the innuendo in the script, like this whole collecting fifty dollars for the ladies' room business? Couldn't they change it to "Powder Room"?

Axelrod knew he hadn't flown across the world to say no to Audrey Hepburn, so he kept his mouth shut and let her work it out for herself. "She kept fighting to have the character softened," he said later, "making the actor's fatal mistake of thinking they are going to endear themselves to an audience by doing endearing things if the character is tough. Humphrey Bogart never made that mistake, and they loved him for his toughness. You should have loved Holly Golightly for her toughness . . ." Axelrod gave in, but he knew he had to;

the moment Audrey asked for the change, it was as good as granted.

She said she'd think about it. Jurow and Axelrod thanked her and left.

GETTING TOGETHER

Privately, Audrey was more direct. She told Frings the part frightened her, and not just because of what Holly did in the powder room, but because of what the role demanded of her as an actress. Were she to accept, Audrey knew that this time she couldn't trade in on charm alone, nor could she sing and dance the part away like she did in *Funny Face*. She wondered if she could even express the blank look of integrity people said she mastered in *The Nun's Story*, a performance, she thought, that owed as much to Fred Zinnemann's clever cutting as it did to her "work." That wasn't acting, it was a magic trick. But playing Holly was a different thing entirely. Actually playing an extended drunk scene, getting into an absolute rage, and evincing a deep depression (the "mean reds," as the script said) were simply out of her range.

All this she poured into Frings, and Frings listened, nodding, yessing, and that's-true-Audreying, waiting until her excuses ran out before he began his speech. Holly isn't anti-Audrey, he explained, but the first step toward the new Audrey. The year 1960 was upon them.

Frings knew that if his client wanted to stay prescient, she would have to dip a toe in uncharted waters. If after accepting the role she wanted to assure the public that she was only *playing* a character, and that she wasn't to be confused with

that wild girl up on the screen, then they would use the press to make it so. That might even make her seem more of an actress and earn her higher esteem with the critics. "Look at the transformation!" they would write. "Look how far she's come!" (Did he mention they were offering $750,000?)

Naturally, Frings continued, he would make sure she was well taken care of. They'd get director approval.

CHANGING PARTNERS

At the moment, John Frankenheimer was going to direct *Breakfast at Tiffany's*. A highly accomplished television director, Frankenheimer had his name on nearly thirty teleplays for *Playhouse 90* by the time he got *Tiffany's*. So stellar was his reputation, that when he was brought on, it didn't worry Jurow and Shepherd that he had directed only one theatrical feature (*The Young Stranger* in 1957). As a hot, young New York director—and a particularly resourceful one at that—he seemed a perfect fit for the material; hopped up like a kid, but sturdy as a pro.

For three months, he and Axelrod worked on the script, casting and recasting the parts in their minds. In between discussions of their problematic second act, they came across a *New Yorker* review of the Richard Condon novel *The Manchurian Candidate* and agreed that it was everything the studios were afraid of—everything, in other words, they wanted to see in a movie. But first came *Tiffany's*.

It was around that time that Frings called Jurow with his verdict. It came in the form of an ultimatum. "Audrey will do the picture," he said to him. "But not with Frankenheimer."

Frings's list of approved directors—A-list only—included

Wyler, Wilder, Cukor, and Zinnemann, but no Frankenheimer. "Pressure was brought to bear," the director said, and "that was that." He was off the picture.

BEACHSIDE INTERLUDE

Meanwhile, Truman Capote, vacationing with his lover Jack Dunphy along the Spanish Mediterranean, was apprised of Paramount's casting decision. They were way off the mark, he thought, but there was little he could do about it now. Privately he would scoff, feign apathy, or affect whatever pose earned him the most admiring glance, but now, with Audrey Hepburn in his midst, it was time to play the diplomat. The birth of Audrey's son Sean, on July 17, 1960, gave him the perfect opportunity.

> *Dearest Audrey,*
>
> *With two such parents, I'm sure it must be a most beautiful little boy, wicked-eyed but kindly natured. My life-long blessings on the three of you –*
>
> *May I say, too, how pleased I am that you are doing "B. at T." I have no opinion of the film script, never having had the opportunity to read it. But since Audrey and Holly are both such wonderful girls, I feel nothing can defeat either of them.*
>
> *I am spending the summer here (until the end of Oct.), and then going somewhere in Switzerland—the point being that I am working on a new book, and plan to stay abroad until I've finished it.*
>
> *Please give my love to Mel.*
>
> *Mille Tendresse*
>
> *Truman*

Had he stayed abroad to write that new book, *In Cold Blood,* Truman would have been away for six straight years.

MR. AUDREY HEPBURN

At her home in Switzerland, surrounded by her husband and new, nine-pound baby boy, Audrey Hepburn could rest, at last, knowing she had achieved nothing short of her life's purpose. "With the baby I felt I had everything a wife could wish for," she said, years after she gave birth to Sean. "But it's not enough for a man. It was not enough for Mel. He couldn't live with himself just being Audrey Hepburn's husband."

He grew angry. "It's true that Mel was puritanical in his outlook," said Robert Wolders. "Audrey Wilder told me that after they made *Love in the Afternoon,* the cast was at a restaurant, and Audrey spilled something on her dress and said, 'Oh, shit, I'm so sorry!' and Mel was so angry with her for using an expletive that he walked out. He just walked out." A woman shouldn't say such things.

AUDREY'S NEW MAN

Back in Hollywood, every director on Frings's list was called, and every one was either uninterested or otherwise engaged. Billy Wilder was already into *One, Two, Three,* Joseph Mankiewicz had just settled into the idea of doing *Cleopatra* (God help him), and the others passed outright, leaving Jurow, Shepherd, and Frings no choice but to enter the second rank of proven, but not yet prized directors.

That's when Shepherd suggested Blake Edwards, the direc-

tor of, most recently, *Operation Petticoat*. Shepherd admitted the picture itself was nothing special—a frivolous maritime sex comedy with a few standout slapstick moments—but it was one of the highest-grossing films Universal had ever had ($8 million), and what's more, it starred Cary Grant. Though he was, artistically speaking, a midlevel director in 1959, the fact that Edwards successfully managed Grant made him very attractive to Kurt Frings, who worried about Audrey Hepburn, who worried about Holly Golightly.

Though *Roman Holiday* was almost a decade in the past, Audrey still very much relied on the firm hands of strong directors to help shape her natural personality into full, textured performances. But with more experience came, paradoxically, more insecurity, and each director found he had to work harder on Audrey than the last. "My mother was very Victorian," she said later in life, "and brought me up not to make a spectacle of myself." But had she gotten used to it? Was performing any easier? "It gets harder and harder," was her reply. "I really die a million deaths every time. My stomach turns over, my hands get clammy. I do suffer. I really do. I wasn't cut out to do this kind of thing, I really wasn't."

By proving to Frings that he could handle a star of Cary Grant's magnitude, Blake Edwards earned himself the job of a lifetime. "It was really a big step up for Blake, a huge, huge step," said Patricia Snell, Edwards's wife at the time of *Tiffany's*. "It was like the beginning of a whole other world. They liked *Operation Petticoat* and the *Peter Gunn* series on television, which he had created. That was really an amazing show at that time. Audrey saw it and the studio saw it and they thought that he might be the one to do this. But he was a young director

and something of a risk. He had a new approach to everything. He had a new style."

Through the late fifties and early sixties, *Peter Gunn* was the epitome of cool. Where most hard-boiled PIs were as burned out as the hoods they trailed, Gunn was an Ivy-league playboy closer to James Bond than Philip Marlowe and introduced network audiences to the next thing in soigné. With the aid of his cinematographers, Edwards developed a highly cinematic look for his show, complete with severe chiaroscuro (not the regular dull grays), eccentric angles, and disorienting camera moves. Adding to the hipness was Henry Mancini's chart-topping theme, which used modern jazz at a time when most TV was scored with a more formal orchestral sound. Jurow and Shepherd wanted that hip feeling for *Breakfast at Tiffany's*.

Blake was working on a picture called *High Time* when they called in May of 1960. No matter what they told him, he knew they were taking a chance.

BING CROSBY IN A DRESS

Blake Edwards, a pipe lodged in his mouth, settled down in his director's chair stationed squarely behind the camera and took a long, slow look around the set.

What a mess. *High Time,* a moronic "teenage" comedy with Bing Crosby, was undoubtedly the most useless picture he'd ever made. What the hell was the studio thinking? The scene they were setting up called for Bing to dance around in a pink taffeta hoopskirt, but that wasn't the problem (actually,

it was the funniest thing in the picture); the problem was the story, the dialogue, the acting, dealing with Bing himself, and the inexorable reality that no matter what he did or how smart he was about it, there was no way Blake could clean up the mess. What do you do with a movie about a fifty-year-old widower who decides to go back to college, hang with jive talkers, pledge a frat, rally for the big game, and romance a French professor on the school hayride? All the world's whip pans, flashy dissolves, and state-of-the-art postproduction effects—if Blake used them (and he did)—would only make him look like a plastic surgeon cutting up a corpse.

Okay, so he wasn't yet Billy Wilder, but why did he say yes to this shit? Right: he was making money. But that was about all he was making.

High Time was proof positive that the industry was panicked about the new generation. Who were these kids? They had sex, they did drugs, and like everyone else, they went to the movies. But what did they want to see? In 1960, no one in Hollywood had a clue: the year's top films were *Swiss Family Robinson* and *Psycho*. Meanwhile, the success of foreign films by Bergman, Fellini, and—if you wore a beret—Antonioni were challenging the home court advantage. Should the studios get artier too? Ordinarily, getting young people to the movies was a cinch for Hollywood because kids wanted to see what their parents saw. Way back when, families used to go to the movies *together*. That's what Mickey Rooney was for. Shirley Temple, Depression-era antitoxin, was a box-office queen from 1934 to 1939. But this strange generation of youngsters—"teenagers" they were called—was impossible to pin down.

High Time was one of Fox's attempts to bridge the widening generation gap. They cast rock 'n' roll sensation Fabian, circulated posters heralding Tuesday Weld "the new teenage crush," and dropped Crosby in for the folks. With the right combination of antic revelry and a new Mancini tune for Bing (he sings, "love, like youth, is wasted on the young"), *High Time* would be a film families could enjoy together. But what teenager wants to go to the movies with his mom?

Blake didn't have an answer. He just went to work and thought about *Breakfast at Tiffany's*. He agreed with Axelrod that departing from Capote's novel was a wise choice, if for no other reason than he thought a faithful adaptation would frighten people. "It was too cynical," he said of the book. "You touched on subjects that I believe people would be afraid to dramatize—the homosexual influence of the leading man, [and] the sexual relationships of Holly that were so amoral."

Edwards was right, in a way. People would be afraid of a faithful adaptation. But one look around him and Blake could see that, with Hollywood in the middle of an identity crisis, filmmakers, if they were smart about it, could push all kinds of moral and artistic envelopes. Look at what Hitchcock did in *Psycho*. Killing off Janet Leigh in the first half hour? Making us empathize with Norman Bates, a perverted, matricidal, part-time taxidermist? Maybe Hollywood was saying bad guys weren't so bad anymore—maybe a lot of things weren't really so bad anymore. Like Natalie Wood in *Splendor in the Grass*, who wants to have sex with her boyfriend *before they're even married*—or engaged—and right there in the backseat of car. But rather than think her loose, we think maybe she's right to act "wrong":

DEANIE LOOMIS (NATALIE WOOD): Mom, is it so terrible
to have those feelings about a boy?

MRS. LOOMIS (AUDREY CHRISTIE): No nice girl does.

DEANIE: Doesn't she?

MRS. LOOMIS: No nice girl.

DEANIE: But Mom, didn't—didn't you ever, well, I mean
didn't you ever feel that way about Dad?

MRS. LOOMIS: Your father never laid a hand on me until
we were married. And then I—I just gave in because
a wife has to. A woman doesn't enjoy those things the
way a man does. She just lets her husband come near
her in order to have children.

Blake Edwards was still a year away from seeing *Splendor
in the Grass,* but he had seen *The Apartment,* that year's winner
for Best Picture. Billy Wilder's story of the white-collar schle-
miel who falls for a suicidal girl was everything midcentury-
American cinema was not, and proved that it wasn't safe for
the romantic comedy to be just cute any longer. Now it had to
be truthful, too. "With that film we became grownups," critic
Judith Crist said. "This was not an age of innocence anymore.
Suddenly we had the ability to come edging out in the open
with sex. It was getting to be the sixties." You could see it on
the screen and you could hear it on the radio.

JAZZ

By this time, Henry Mancini was fluent in the unspoken lan-
guage of Blake Edwards. They had been regular collaborators
for several years, and now that Mancini had signed on to score

High Time, he split his days between the recording stage and Blake's set.

"Hey, Hank," said Blake one day during *High Time.* "It looks like *Breakfast at Tiffany's* is going to go ahead at Paramount. We've got a meeting with Jurow and Shepherd—they already know you're the one I want."

Mancini read the script in preparation for the meeting. At just about every page turn, he saw opportunities for the sort of jazzy sound he was becoming known for. Blake was right to see that Hank Mancini and Holly had non-conformist cool in common: she with her hepcats, and he with his swingin' big band sound. By 1960, Mancini had already moved away from the more traditional symphonic approach of his predecessors. Of course, there had always been jazz in movies, but it was generally back-alley brass drenched in rotten sex. It was never pop like Mancini was pop. It was never fun.

One musical passage in Axelrod's script—which included lyrics Axelrod lifted directly from the book—caught Mancini's attention.

The CAMERA PULLS BACK and we see Paul typing furiously. He is about halfway down a page. A stack of completed pages rests proudly at his elbow. His concentration is intense. He is, for example, totally unaware of a SOUND that drifts lazily up through his open window. It is Holly, SINGING and ACCOMPANY-ING herself on the guitar. The song is a

plaintive prairie melody, the words of which
seem to be: "Don't wanna live, don't wanna
die, just wanna go a-travelin' through the
pastures of the sky."

Mancini, should he get the job, would have to supply the
music. But there was a problem. When Mancini met with
Marty Rackin, Paramount's head of production, Mancini
could see that the executive was clearly uninterested in hear-
ing his ideas. He had a totally different kind of songwriter in
mind for *Tiffany's,* one who wrote in the elegant Broadway
style. This was to be a New York picture, he said, and Holly
was very much a Manhattan girl, so she'd sing a cosmopolitan
tune. What Alexrod had written in the script was just filler.
Rackin wanted something hip that placed Holly squarely in
the in-crowd. Mancini, he said, wasn't that songwriter. He'd
just supply the score. Not the song.

The meeting was over.

CASTING

Blake Edwards did not want George Peppard in his movie.
What about Tony Curtis? he asked the studio. What about
Steve McQueen? Tony Curtis wanted the part, and having
been cast in three of Blake's previous pictures, he thought
his chances were good—but he didn't make it. Mel Ferrer, he
was told, didn't want his wife playing opposite him ("Who
knows why?" Shepherd said. "That was just the way Mel
was."). So Tony was out, as was Steve McQueen, who was
still contracted to CBS's *Wanted: Dead or Alive.* Thus the name

George Peppard was thrown in once again. Trying to keep an open mind, Blake went with Jurow and Shepherd to see Peppard in *Home from the Hill,* and from the moment the actor first appeared on the screen, Blake knew he had been right all along. "After coming out of the film," Edwards remembers, "I dropped to my knees on the sidewalk to the producers and begged them not to cast him." But it was two against one. Peppard was in.

Virginia Mayo read for the part of 2E and performed satisfactorily, but she was turned down. By her own admission, she was not right to play a wealthy New York socialite. That's when Shepherd's wife, Judy, suggested they consider Patricia Neal instead. Blake loved the idea. Though she hadn't appeared in films since Kazan's *A Face in the Crowd* three years prior, Neal was, as far as Edwards was concerned, the intuitive choice. With her high-toned cheekbones, cabaret swagger, and that throaty purr, Neal was what you'd call born to play it. There was, however, one condition: Neal would have to dye her hair red so as to stand apart from the dark-haired Audrey. Fine, she said, great (though she couldn't wait to dye it back). Neal signed the contract in September. They didn't even test her for the part.

As for Jose da Silva Pereira, Holly's Brazilian suitor, it was unlikely Blake could do any better than the Marquis José Luis Cabeza de Vaca de Vilallonga. He had come recommended by Audrey and Mel who had spotted him two years earlier, inveigling Jeanne Moreau in *The Lovers,* but Vilallonga—as he would be listed in the opening titles—did not begin his career as an actor. He was a writer, and a scandalous one at that. In 1954, after an attempt at journalism and an aborted

stint of horse breeding, Vilallonga offended the Spanish military censor with the publication of his novel *The Ramblas End in the Sea* and was promptly exiled. (Paramount publicity ate it up. They wrote, "He received word from Spain that he was to be sentenced for 178 years in prison for his repeated attacks on the Franco dictatorship.") Vilallonga spent his exile as a part-time foreign correspondent and occasional actor, dabbling in small parts in France and West Germany until he was spotted by Hollywood and offered a contract. He turned it down, but years later, at Audrey's request, he agreed to do *Tiffany's*. It would be his first Hollywood movie.

"Casting Buddy Ebsen as Doc Golightly was due to Blake," said Patricia Snell. "We all thought the idea was off the wall, that he was too old, but Blake said, 'No, he'll be perfect.' And he was." Throughout his career, Edwards's eye for latent talent would produce many brilliant feats of casting, but few were as unforeseen, and indeed impactful as his feeling for Buddy Ebsen. Beginning in the mid-1930s, Ebsen had made a name for himself as a song and dance man, twinkling alongside the likes of Eleanor Powell and in *Broadway Melody of 1938*, a young Judy Garland. Then, in the 1940s, he practically disappeared: a contract dispute at MGM and World War II service in the U.S. Coast Guard all but removed him from the picture business. When he finally returned, Ebsen found himself in midlevel parts in B-westerns with titles like *Silver City Bonanza* and *Thunder in God's Country*. It wasn't John Ford; it was work. From there it was TV until the lightbulb went off over Blake Edwards's head in the summer of 1960. There was no question as to Buddy's strength as a performer, but could he act? *Really*

act? Blake put his money on "Yes." He called Ebsen out of the blue and told him that if he took the part, he would bet him a case of champagne he'd be nominated for an Oscar.

Less of a gamble was the casting of Holly's cat, or rather, cats. Since cats, unlike dogs, seldom perform more than one trick at a time, more than a dozen were required for the film. Said trainer Frank Inn, "I have a sitting cat, a going cat, a meowing cat, a throwing cat—and so on, each one a specialist, and all the same color, you'll notice." All twelve cats were practically identical—"thug-faced," as Truman described them in the novel, with "yellowish pirate-eyes"—but only one would get star billing. On October 8, the production held an open cat-call at New York's Hotel Commodore, at which twenty-five orange-furred hopefuls appeared freshly preened and plucked. After an arduous round of auditions and callbacks, the twelve-pound Orangey, belonging to Mr. and Mrs. Albert Murphy of Hollis, Queens, was named the winner. "He's a real New York type cat," Inn declared, "just what we want. In no time at all I'm going to make a Method, or Lee Strasberg type, cat out of him."

YUNIOSHI

Late in the year, papers announced that the part of Mr. Yunioshi, Holly's upstairs neighbor, had been given to the renowned Japanese comic Ohayo Arigatou. Though he had never worked in pictures, Mr. Arigatou (they said) was possibly the funniest foreign comedian since the great Cantinflas and had gotten the part by reciting "Casey at the Bat" in compound fractured

English. In December of 1960, a Paramount press release con-
firmed that Arigatou had leased his family's geisha house,
whose name translated to "Have Happy Time Here Boy," and
soon thereafter, Arigatou was spotted at the World Series,
rooting for Pittsburgh from the bleachers, where, sadly, he had
lost every cent of his advance. He cabled Jurow and Shepherd:
"I BROKE WIRE 36000 QUICK." Thankfully, at 360 yen to
the dollar, the request was only for $100. The producers paid
it posthaste. Despite the reimbursement, Arigatou called Para-
mount collect with the news that he would not be coming to
work.

"No work yet," he said. "Study part. I Methodist actor—
Lee Stlassburg Methodist actor. Take time. No hully.

"Meantime, build theater in Yokohama. Put name in rights:
Ohayo Arigatou, in *Bleakfast at Tiffany's,* with Audrey Hepburn
and George Peppard.

"You want to hear me say 'Clasey at Bat'? Now? Say good. I
baseball fan, gleat actor. I go now. You tell bosses I come when
leady, not before, got to start new theater, put name Arigatou
in rights."

Jurow and Shepherd were in trouble. Because Arigatou
had refused to be in Hollywood for his makeup tests and
English lessons, the production had stalled—for how long
it was impossible to say—leaving the producers no choice
but to appease the Asian Cantinflas. They would honor his
demands for a bigger part. At Arigatou's request, Axelrod
wrote in a Japanese sword dance complete with exploding
firecrackers. And that did it. At long last, Arigatou appeared
in Hollywood.

Well, kind of. In *Tiffany's* final, and most controversial pre-production publicity coup, it was announced that a "sneaky" reporter (fictionalized by publicity) had nudged his way onto the set to get a look, once and for all, at the Japanese comic genius Paramount had been waiting for. Imagine the reporter's surprise when he discovered that all along, since the very beginning, Arigatou had been none other than Mickey Rooney himself!

Of course, no one really "discovered" anything. There never was an Arigatou in the first place. The whole thing was just a bit of eye-grabbing hogwash, a hoax cooked up by studio salesmen to arouse curiosity in the unsuspecting readers of the world. And they were prepared for something of a backlash (though they had no idea how offended the offended would be). To appease their potentially uneasy Japanese audience in the wake of the Rooney-reveal, Paramount issued conciliatory press releases confirming that Mrs. Katsuma Mukaeda, wife of the cultural information director of the Japanese Chamber of Commerce in Los Angeles, was to act as Rooney's coach and the film's technical adviser.

Considering she was up against the long-standing antic rapport of Rooney and Edwards, it's easy to understand why Mrs. Mukaeda had little influence on the portrayal of Arigatou. More than just former roommates, Blake and Mickey had been longtime collaborators, comedians with vaudeville DNA. Artistically, they were a Venn diagram with considerable overlap, like a couple of swells hocking a side-by-side act from Fresno to the Great White Way. Mrs. Mukaeda had no chance.

THE SOUND OF TULIP

Henry Mancini, meanwhile, was despondent. It was true that his talents as a songwriter were unproven, but based on the success of "The Peter Gunn Theme," Mancini knew he was up to the task. Lyrics or no lyrics, Broadway or Texas, a tune is a tune, and he could write them. So what if his name didn't mean standards? This was an opportunity he wasn't ready to pass up. Writing scores for the movies had never been the most lucrative aspect of composing for Hollywood, but attaching one's name to a song, which might go on to numerous recordings and return substantial royalties, was another matter entirely.

Hank called his agent. He told him he wanted to negotiate, to go back in there and raise a little hell. Mancini expected to hear knuckles cracking in preparation, but all he heard was silence. Though cautious, his agent's point was a good one. From Capote to Audrey to Blake, all was in place for a major motion picture. Take what you got, he told his client, and don't go around looking ungrateful. Still, that didn't cut it. Far from settling him, the promise Hank's agent saw in *Breakfast at Tiffany's* only encouraged Mancini that he was right to push for the song. Rather than go back to Rackin himself (Mancini was humble to the point of being shy), he applied to Blake, and respectfully asked him, as a friend, to go see Shepherd and Jurow instead. If they heard what he came up with and liked it, then great, they'd put it in the movie and trust that Rackin would come around; if not, not. All it would cost them was time. Blake obliged, and to Mancini's great delight, so did the producers. "Marty and I believed the song absolutely should

not have been about New York City," Shepherd said. "It was about this girl from Tulip, Texas, and needed to sound like it."

Here was Hank's shot. He'd write for Audrey. He'd write directly into her range.

HUBERT DE GIVENCHY UNDRESSES EDITH HEAD

Ever since *Funny Face* in 1957, Audrey's film contracts had contained a nonnegotiable standard clause stipulating that Givenchy design her costumes. Where everything else in her movies, from art direction to editing, would be handled by whomever the studio or the director had installed to carry out its mandates, this one crucial point was left to the jurisdiction of Audrey Hepburn.

Once again, Edith Head would be backup. Though she wasn't happy about it, Edith understood there was a pragmatic element to hiring a European designer for a European shoot like *Funny Face*. But *Tiffany's* was a New York movie. Why get a Parisian designer? Not only was it impractical, it didn't click with the character. What would Holly Golightly be doing with high fashion clothing? Where would she get it? How could she even afford it? Patricia Neal's costumes were to be designed by Pauline Trigere, but Trigere was a New York designer, Neal *lived* in New York, and moreover, she was playing a ritzy character who in reality would very likely shop Trigere. All that was beyond reasonable. But Hubert de Givenchy?

Edith had a point. With location shooting becoming more and more common in the Hollywood of the late fifties and early sixties, it made sense that films shot in Paris would have actual Parisian clothing. Rare—indeed singular—was the case

when a European house would design an American picture actually set in America. It meant that teaming Givenchy and Audrey on *Breakfast at Tiffany's* was without precedent. Consult Edith's credit for the scar: her title reads "Costume Supervisor." Head's biographer, David Chierichetti says, "The 'Costume Supervisor' credit was a weird, one-time-only credit for Edith. She was a very, very powerful woman, and even though she did very little on the picture, the studio wanted to maintain some good feeling and gave her this kind of conciliatory credit. Of course, Edith was a master diplomat, perhaps a better diplomat than she was a designer, and stayed quiet when she knew she should, but she was aware that it was taste, not necessity that barred her from the picture. That hurt her terribly."

She would provide some of Holly's plain clothes as well as George Peppard's changes, and, naturally, would supervise the additional costuming needs of the various ancillary players, but Audrey's gowns—truly the film's stylistic centerpieces—were all Givenchy.

It fell to Blake Edwards to approve Givenchy's designs, but he knew—as far as couture was concerned—he was in over his head. He was not about to deny the inspirations of an acknowledged wunderkind, let alone the megawatt star who considered him a spiritual sibling. "I was sort of inadvertently thrown in with some of the truly great fashion people in the world," he said, "and suddenly I was looking at wardrobe to be approved by Audrey Hepburn. And, of course, I'm not stupid, I'm not going to say 'Well, gee, fellas, I don't really know about those kinds of things.' It gave me an education. How wrong can you go?"

AN OCTAVE AND ONE

For a full month, slouching on the rented piano he kept in the garage, Henry Mancini agonized over the song. What had he gotten himself into? Over and over again, he replayed, again and again, Audrey's voice in his head. He caught *Funny Face* on TV a few nights earlier, and with the short range—her range—of an octave and one, tried riffing on Audrey's rendition of "How Long Has This Been Going On?" *I could cry salty tears.* . . . Everything he tried died on the second or third note. *I could cry.* . . . But for lack of an alternative, he stuck to it. *Cry salty . . . cry salty tears.* . . . But the stucking didn't stick. Nothing did. If Mancini didn't deliver on this, what would he say to Jurow and Shepherd, or to Blake, who'd had faith in him, who stuck his neck out? Even worse, what would he tell himself the next time he sat down with a pipe at the piano? "You'll do it, Hank"? There were only so many times his wife, Ginny, could say it to him. Only so many more times he would let himself go on to her about what kind of song this girl would sing. Was a Broadway-style melody actually the right choice for "travelin' through the pastures of the sky"? That didn't seem to fit with the private moment on a fire escape. But maybe the blues would. *Where have I . . .* Maybe like a jazzy-pop thing. Or a country thing. Was that what was in her heart?

This was a time when Holly would cut through the pretense and show, for the length of a song, who she really was beneath all the sophistication. Right: *beneath* the sophistication. Whatever that sounded like, it had to be simple.

And then—as these things tend to happen—it came suddenly. Three notes: C, G, F. It was promising. Not a song, but a beginning. Staying within the range of an octave and one, and being careful to keep the melody all in the same key— much simpler that way—Mancini turned out the next several notes, all on the white keys. They didn't sound bad—actually, they sounded *good*. At first, he went ahead carefully, mindful of not leaping too far beyond his flow, and then, as he gained momentum, proceeded half consciously. Now it was all falling out of him. A moment later it was automatic—he was taking dictation. As if they knew just where to go, as if they had been there many times before, the remaining notes obediently assumed their place on the page. Twenty minutes later, the composer looked up from the piano. The song was written.

The next day, Mancini made a record of it and took it in to Edwards. Blake loved it. Then it was to Paramount to play the tune for Shepherd and Jurow. "Hank brought a 78 record up to our office," recalls Shepherd, "and he said, 'Let us know what you think of it.' He just laid it down and left. Marty and I listened to it and we thought it was terrific."

"Who do you want to write the lyrics?" they asked.

"Johnny Mercer," was the reply. Mancini didn't even have to think about it.

WHAT JOHNNY MERCER DOES IN BED

Mancini had always wanted to write with Johnny Mercer, but that guaranteed nothing; so did everyone else. With a credit list that included, in part or in full, songs the caliber of "Too

Marvelous for Words," "That Old Black Magic," "Come Rain or Come Shine," and "Hooray for Hollywood" (which he wrote ironically), Johnny Mercer would have been any composer's first choice, but fortunately for Mancini, the admiration was mutual.

For the past two years, Mercer had been longing to collaborate with Hank. The track that hooked him came off the *More Music from Peter Gunn* album. "Joanna" it was called, and after he heard it, Johnny Mercer did what he had been doing since his first crank of that Victrola in the parlor of his boyhood home smack-dab in the sweet spot of the South, Savannah, Georgia. That is, he put words to it. A born singer, all Johnny would have to do is stand by his own vocal instinct and wait for the humming to come out right. When it did, it was brisk and fragrant, with a lyric pitched on the outskirts of town and country, fancy but idiomatic, like Holly Golightly herself.

But by 1960, Mercer had been supplanted by Elvis, the national pelvis. As hearts sank to groin level and doo-wop regressed popular song to shoobiedoobies, the premium on Mercer's signature dropped to an alarming low. Not only was rock 'n' roll in the way, but like Mancini, more and more composers were insisting upon writing the songs in their movies, which relegated dyed-in-the-wool words and music men like Mercer to the bygone era. Setting lyrics to a waltz, he said, was a pointless venture, commercially speaking. At that moment in music history, when the day's chart-toppers included Fats Domino and Paul Anka, he was right to think no one would record a waltz, but Mancini (and necessity) prevailed, and Mercer, who loved Capote's book, and who wanted an excuse to collaborate with Mancini, said yes.

Often, Johnny would compose lying down. Stretched across a bed or along a couch with his eyes closed, Mercer would cycle words and images through his mind all without the help of paper and pen. It looked like sleeping to those who saw it, and indeed earned him the epithet lazy, but anyone who knew of Mercer's prolificacy had to have thought it less like snoozing than dreaming. Sometimes he'd surface with a fractured image that he'd take down with him the next time he submerged, and sometimes he'd come up with a lyric in full, a deep-sea diver with a sack of gold.

Mercer's gentle southern demeanor only fanned the legend of his laziness, for to greet him in person, one would surely be overcome by the kind of lullaby sensation perfected by the expert porch sitters of his kin. As a young man, he, like Holly, left home for New York, and since then, whether in sleep or dreams, had never been far from the nostalgic pull of Dixie. It made Mercer a good man—sometimes a drinking man—but it also allowed him to harmonize with Mancini. Together, they were kindness incarnate, and they melted as easily as butter on mashed potatoes.

When Johnny called Hank to tell him he had lyrics, he said, to Hank's bewilderment, he had not one version to show him, but three. That afternoon, Mancini was scheduled to lead an orchestra through a benefit dinner at the Beverly Wilshire, so he told Mercer to turn up at the hotel ballroom at about four o'clock. There was a piano in there, he said, and it would be deserted. And that's how it happened: when four o'clock rolled around, in came Johnny with an envelope full of papers, and in came Mancini, crossing the darkened room to greet him. Hank took his seat at the piano on the bandstand and Mercer,

standing beside him, pulled out version one, which began with the lyric, "I'm Holly . . ." But Mercer wasn't so sure about it. They tried his second version, threw it out, and then tried his third. "Blue River" it was tentatively called, because, as he told Mancini, there had been other tunes with the same name.

"I have an optional title," Mercer added. " 'Moon River.' "

That was fine by Hank. So that afternoon, Johnny inserted "Moon" for "Blue," and for the first time, sang,

> *Moon River,*
> *Wider than a mile:*
> *I'm crossin' you in style*
> *Someday.*
> *Old dream maker,*
> *You heart breaker,*
> *Wherever you're goin',*
> *I'm goin' your way.*
> *Two drifters,*
> *Off to see the world,*
> *There's such a lot of world*
> *To see.*
> *We're after the same*
> *Rainbow's end,*
> *Waitin' 'round the bend,*
> *My Huckleberry friend,*
> *Moon River and me.*

That was it. There was no doubting it. In his lyric, Mercer had harnessed an assortment of poignant, multilayered frictions. Taken one way, the song tells of simple affection, the

pure and wide-eyed kind between two friends; but on the flip side, it's laden with the weariness of heartbreak. It was the musical equivalent to the casting of Audrey Hepburn in the part of Holly Golightly. When she sang it on the fire escape, wearing only jeans and sweatshirt, no audience would begrudge her the little black dress.

THE LITTLE BLACK DRESS

Centuries ago, black dye was affordable only to the very rich. In the seventeenth century, the wealthy abandoned darkness for color. And in the Victorian era—where contemporary ideas about black originate—it was worn almost exclusively by those in mourning. As the shade of death, black seems the most intuitive choice. But in the game of courtship, color aids seduction. Traditionally speaking, it's feminine, and the more eye-catching women are, the more easily they can lure. Consequently, those without color—say, dressed in all black—can go about almost unnoticed. Where the rainbow is conspicuous, their darkness acts as a kind of camouflage, masculine by contrast, and allows them to watch without being watched. It's the choice of someone who needs not to attract. Someone self-sufficient. Someone more distant, less knowable, and ultimately, mysterious. Powerful.

It is a man's look. So what happens when the tables are turned and the woman wears black? In the nineteenth century, when women would often stay in all black for years after their husbands' deaths, it was a surefire sign of widowhood. To the men passing by, it signified the wearer's knowledge of sex. It meant experience. No wonder the flappers of the 1920s were

so drawn to it. In aerodynamic tubes of black satin, the Jazz Age teenies made their statement loud and clear: "We don't care about what Mom and Dad cared about. *We're* out to have a *good* time." Chanel took the opportunity to capitalize on the new modernity, and the little black dress turned up everywhere. Not only was it fashionable, but when the 1930s came around, it was very practical. It didn't seem right to dress decoratively the way it had before the crash of 1929, and so, in its subdued functionality, the black dress became a gesture of political correctness. It was hip to be square. And after the war, when Dior swooped in with his New Look, black was dressy again. With the world back on its feet, people didn't have to feel ashamed of going all out anymore, and certain intensely fashionable women—mostly in Europe—stuffed themselves into black hourglasses and took to the boulevards.

But when the domestic resurgence of the fifties broke through America, color was once again the emblem of femininity. Just look at the movies: only the bitches wear black. There is Margo "Fasten your seatbelts" Channing in *All About Eve,* Norma "I *am* big" Desmond in *Sunset Blvd.,* and before them, back when film noir saw all its curves in shadow, there was Rita Hayworth as Gilda. Even before they even open their mouths, we know these ladies are going to be two big handfuls of heat-packing trouble—and it's black that tells us so. On men, it's par for the course (Cary Grant should wear nothing else), but when it's seen on women, black's symbolically charged intimations of power, sexual knowing, and reversals of traditional passivity make it the color of choice for all those women the movies think we should be worried about—and in most cases they're right, we should be. So, to Jane Wyman and

Doris Day: wear pinks and blues. Be decorative. Be floral. As women, it's what you're supposed to be.

Hubert de Givenchy got Axelrod's script in the summer of 1960. On page 1, he read, "The cab door opens and a girl gets out. She wears a backless evening dress and carries, in addition to her purse, a brown paper bag." Black might not have been such a distinctive choice were it some degenerate wearing the dress; indeed, it would have been the obvious move. But seeing how this was a dress to be worn by Audrey Hepburn—and not at night, but in the very early morning—it was unusual to say the least. Because it's Audrey—wholesome, wholesome Audrey—there is irony in her endorsement of a color heavy with unchaste connotations. More than merely quirky, the contrast is sophisticated. Black on Audrey Hepburn gives her an air of cunning—just as anyone who turns something outré into an asset appears somehow masterly. That's the essence of glamour.

It's true that Audrey had worn black before—quite memorably, in fact, in *Sabrina* and *Funny Face*—but this particular instance brought her down from the penthouses and onto the pavement. "Remember," says costume designer Rita Riggs, "it was natural for Sabrina to shop at a French house in *Sabrina,* and *Funny Face* was set in the Paris fashion world, but *Tiffany's* was all New York, about a girl who knew nothing about European fashions. And she's just a poor girl from Texas—a moll! There's no real way of explaining how Holly would get that dress. At that time, only the very wealthiest American women would have European trousseaus. A regular girl couldn't afford that. So *Breakfast at Tiffany's* was a breakthrough in that sense. We hadn't seen that before."

"Givenchy and Audrey gave us a very realistic, very accessible kind of class," said designer Jeffrey Banks. "All of a sudden, in *Breakfast at Tiffany's,* chic was no longer this faraway thing only for the wealthy. Of course, part of that had to do with who Audrey was and the kind of person she represented to people, but it also had to do with Givenchy. Unlike Balenciaga, he was a naturalist. He was about showing off the body as it was, not reshaping or idealizing it. He felt you didn't need to use a lot of accessories or embellishment and based dresses on the shape of women as they were, not as he, or the culture, wanted them to be. That was a kind of first in fashion and it took glamour from the remote and unattainable and made it practical. After *Tiffany's,* anyone, no matter what their financial situation, could be chic everyday and everywhere."

The little black dress was easy to emulate: any young woman in 1961 could make one or even afford to buy one (and did they ever). Of course, they didn't all get Givenchy's LBD, but that didn't matter; because of its simplicity, *any* little black dress would do the trick—as millions would soon see, that was the beauty of it. What's more, its simplicity wasn't just pragmatic, it was an assertion of self. Pure understatement radiates confidence—individual personality as opposed to a prefab femininity. "I don't need to embellish to be commanding," it says. "I don't need a fashion megaphone to make myself heard. I just need to be me." It's what Audrey had been doing since *Roman Holiday,* but here she added a touch of girl-on-the-go. This was New York City.

Its efficiency and simplicity made the LBD a natural for the workingwoman, and Givenchy's take, unlike Chanel's, was skimmed, narrow, and attentively sculpted, which gave the

dress a severity not common to looks of the day—as well as a quiet allure. Banks explains, "Givenchy was a master of understanding the backs of dresses. He knew how he wanted a woman to look as she's walking away from you. If you look at the neckline of Audrey's long black dress from the front, it looks just like a sleeveless dress, but if you look at the back, if you look at the way he cut in a sort of halter shape that followed the shape of the jewelry, you'll see that it's quite daring for its time."

"I was in Paris for the fittings," recalls Patricia Snell. "It was amazing. Givenchy came out with all of Audrey's outfits; her hat, and her little black dress, and her everything. He was the kindest man, the gentlest man, and so tall. You couldn't believe how a man so tall could move with such grace. It was truly unbelievable to see him. And he handled the fabric with such love, it was like he was carrying a newborn baby. He even looked at the dresses like they were babies—his babies. I can't say I knew then that these dresses would change fashion, but I must say, they jolted me. None more than the black one."

MOON RIVER AND . . . ?

After Mancini played "Moon River" for Blake Edwards (whom it left speechless yet again), they ran it over to Jurow and Shepherd. It didn't matter that the producers were in the middle of something; Blake and Hank wanted to be there when they fell off their chairs. They weren't disappointed. The moment the recording ended, whatever hesitation Marty Jurow or Richard Shepherd, or Rackin had about Mancini's capability was now a detail in history. They were all in agreement. This was it. The

new question of talent, or rather, facility, was about their lead-
ing lady. Could she sing it?

The room was uncertain, but Hank pressed for Audrey,
explaining that he had written the music to "Moon River" spe-
cifically with her range in mind. Technically, he said, she could
pull it off, no sweat. Admittedly, she was no great singer, but
she had done it in *Funny Face* and, Hank argued, she would do
it again for *Tiffany's*. His plea, however, was met with raised
eyebrows—and none were raised higher than Audrey's. When
she heard she was in the running to sing, she said she was
completely against it. The thought of singing now frightened
her. Since *Funny Face,* she believed her voice had thinned con-
siderably, and what with the risks she was already taking in the
film, it seemed too much of a stretch.

For a brief period, there was some discussion about Marni
Nixon (Audrey's vocal surrogate for *My Fair Lady,* three years
later), but all that ended as soon as Blake made up his mind. This
song's dramatic function—to give voice to the authentic Holly—
couldn't succeed if it wasn't authentic Audrey. He claimed what-
ever weakness audiences perceived in her vocal ability would
actually enhance the feeling of a regular, down-home Holly.
Never one to say no, Audrey gave in, and without a moment
to lose, she was rushed into guitar lessons and rehearsals with
a vocal coach. She was far from sure that she was the right
person to sing "Moon River," but there was no stopping what
had already been set in motion. The first day of filming, the
morning of October 2, 1960, was fast approaching.

6

DOING IT

OCTOBER 2, 1960–NOVEMBER 11, 1960

FIFTH AVENUE, SUNDAY, OCTOBER 2, 1960, DAWN

Audrey was worried. They all said she could do it, that playing Holly would be a challenge, but that like everything else, it would come naturally to her. Naturally, they said naturally. In *Roman Holiday*, they said she was so lovely and natural, and then gave her the Academy Award. But that wasn't acting, not like the Patricia Neal kind that made you really think and really feel. Now there, she believed, was a *real* actress. Pat could play anything, but Audrey, sitting in a yellow cab, waiting for Blake Edwards to call action, just had intuition. Intuition and luck.

Audrey missed her ten-week-old baby, Sean, whom she left with the nanny back in Switzerland, and she began to wonder if she was wrong about leaving him in the first place. This was the longest she had ever been away from him. He would be

fine, she assured herself, though it was difficult to forget the recent string of high-profile kidnappings back home (she and Mel had taken severe precautions not to publicize the name of their nanny or her whereabouts). No amount of cigarettes could ease her tension, but she was desperate and smoked on anyway, sometimes shakily, like a gambler with a bad hand.

The street was empty, like one of those tumbleweed roads in a western movie. A crowd would be gathering soon.

It was all so nonsensically difficult, down to the Danish pastry in the bag beside her. How would she eat that thing? Audrey didn't want to be troublesome, but she despised Danishes, and asked Blake if he wouldn't mind if she were to walk up to Tiffany's with an ice-cream cone instead. But he said no. Of course, he was completely justified. This was breakfast after all, and who would believe that?

But really, who would believe any of it?

"Okay, quiet," she heard. "Quiet please . . ."

A man approached the cab and asked Audrey if she was ready. Yes, she told him, she was, and braced herself.

She waited.

Outside, the sun was not yet up. The street, if you were to paint it, would be one long stripe of gray, with little yellow dots for the lamps. In this light, they looked like a string of diamonds hovering above the sidewalk, a necklace Fifth Avenue wore when it woke up.

"They're rolling . . ." Audrey heard, and a second later, the second A.D. cued the cabbie, and they were off. The scene had begun.

Up the avenue they went, up past all the storefronts Holly

knew well, and had visited, if only to look, so many times before. It was a miraculous sight; one of the world's busiest streets cleared of all activity, and just for her, just for this. They wouldn't have many takes (the sun would be too bright soon), and even though it was a chilly Sunday morning, the people of New York would begin to pour out quickly. And there was also Soviet Premier Nikita Khrushchev. He'd be appearing on Fifth at 7:30. They'd have to be done by then.

Audrey couldn't rush it, though. If Tiffany's was, as she says in the script, the place where Holly and things went together, she would be wise to linger at the window and take it very slow, savoring it the way one would a moment of total satisfaction. Better that than run up the street like some kind of hungry animal.

What she had to do now was try to forget that she wasn't anyone's first choice, and that Capote was dissatisfied (some said), and that no one seemed to know how much Holly was, well, *whatever she was.*

She had to stop all this worrying. She had to forget about her fights with Mel, whom she missed as much as she was glad to be without. It wasn't something Audrey had put words to, even privately to herself, but she was certainly beginning to feel it. Was it really true love? Or was it grown-up love, the kind they don't make movies about?

One by one the city blocks fell away, and as the cab approached 727 Fifth Avenue, it slowed beside the curb and came to a stop. Audrey stepped out of the car and shut the door behind her. Rather than approach right away, she paused on the very edge of the sidewalk and looked up at Tiffany's.

THE SOUTHEAST CORNER OF FIFTY-SEVENTH AND FIFTH, HOURS LATER

It was cold that morning.

Blake wore a wool cardigan over his black turtleneck, and over that, a long corduroy jacket with the collar turned up. His crew cut and footballers jaw leant him a lean, manicured look, not unlike Mel's. Audrey knew he was sensitive to her anxiety, not just about Holly, but about acting in general. From the few rehearsals they had had, she could see his working style was open and collaborative, more like a party than actual work. Unlike Billy Wilder, who came to the set knowing exactly how, when, and where every line should be delivered, Blake met the shooting day with an open mind and a listener's attention.

Blake, after all, wasn't her first choice. She had wanted someone with a little more experience. But all that was beginning to change. He was receptive to her minor suggestions, he didn't really like to shoot take after take, and he wasn't afraid of improvising a little. In fact, when the time was right, he encouraged it. Audrey liked that. She wasn't at ease with the idea of just making stuff up, but she agreed with Blake that there was little chance of keeping a funny scene funny if it wasn't always on its toes. It was a belief, Audrey saw, that Blake was deeply committed to, and it applied as much to his actors as it did to his crew. If they weren't kept laughing in the long stretches of wait-time between setups, they were likely to deflate the momentum and kill the scene. To keep them alert, Blake arranged for a craft service table that was simply not to

be believed, worked to end the day's shooting at a reasonable hour, and devised a steady stream of practical jokes directed at cast and crew alike. But not all the jokes were light and effervescent. Audrey nicknamed Blake Blackie, for his black sense of humor. Like Mel, her director had a morose streak, but Blake's was a lot funnier. Was it wrong to keep comparing them? Of course, she didn't do it consciously, but she kept doing it. Maybe it was because she was lonely.

Wearing Hubert's dress was of some consolation, almost like having him there beside her. An armor of love, she thought. Two armors, actually: one little black dress for standing still at the window, and another for walking around the outside of the store. She had to alternate because the standing dress was so tight, she couldn't move in it. But the walking dress had a long slit down the side. She could walk around in it without inching ahead in baby steps like a geisha.

People were already collecting in pockets of two and three, and a short time later, what began as a small crowd had transformed into a gawking mob. On all sides of Fifth Avenue, production assistants upheld a great barricade of several city blocks, dictating to the people behind them, as if they were actors, how and when to move and speak. Despite them, Audrey shot the scene without too much fuss and all before the sun came up.

128.54 CARATS

Before moving on to the next scene, Audrey was photographed inside Tiffany's wearing the famous Schlumberger necklace. Until now, the necklace had been worn by only one other

woman, Mrs. Sheldon Whitehouse, a senator's wife, who wore it on the day she chaired the Tiffany Ball in 1957. Set at the very center of the necklace was Tiffany's canary diamond, at that time the largest yellow diamond in existence, measuring one square inch of 128.54 carats. Though Audrey wouldn't wear the necklace in the film, it would appear briefly and only under glass in the Cracker-Jack engraving scene, the scene they would shoot that afternoon. "Do you see what I mean how nothing bad could've happened to you in a place like this?" Audrey was to say to Peppard. "It isn't that I give a hoot about jewelry, except *diamonds* of course. Like *that*." If only they could hurry it up.

Audrey was taking one for the team. After six long months of back-and-forth negotiations with Tiffany & Co.'s head, Walter Hoving, a fastidious man not renowned for his amenability, Marty Jurow was finally granted permission to shoot inside the store. Unfortunately, Audrey was the barter. Sure, Marty had explained to Hoving, it would be a logistical challenge and an insurance nightmare to let an entire crew set up among some of the most valuable jewel cases on the planet, but from the promotional angle, it was a golden opportunity for Tiffany & Co. Just put Audrey in the Schlumberger necklace and shoot away. Photo ops galore. You couldn't buy better advertising.

They were the first film ever to shoot inside Tiffany's.

Audrey's smile was as convincing as she could possibly make it considering the ungodly hour, her waning strength, and the swarm of ingratiating corporate stiffs surrounding her. But this also was part of the job. So was all the handshaking.

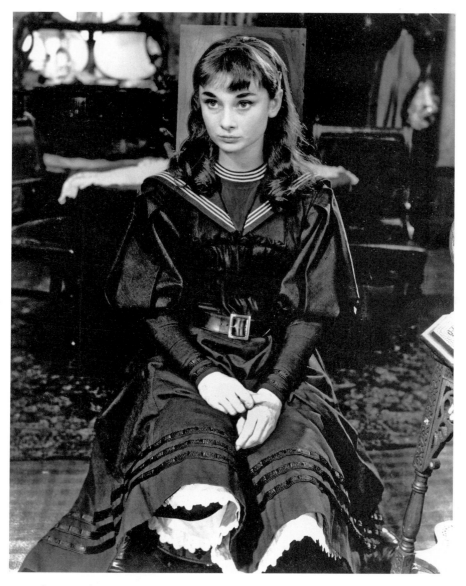

Audrey Hepburn, age twenty-two,
onstage as Gigi.

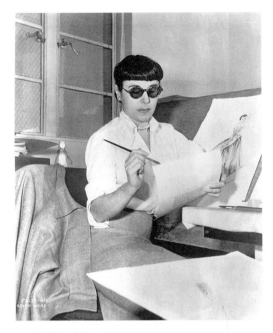

(Left) The redoubtable Edith Head in a publicity portrait staged to her exacting taste.

(Below) Billy Wilder, Audrey, and Hubert de Givenchy review the designer's sketches for *Love in the Afternoon.*

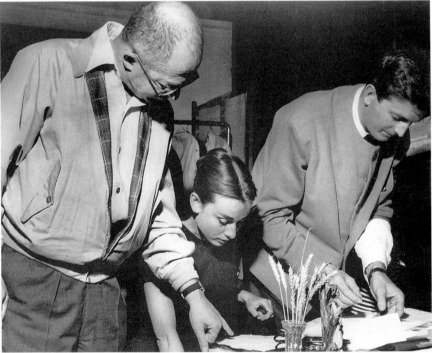

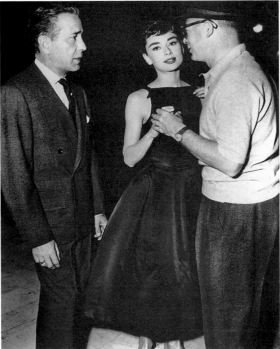

(Above) Humphrey Bogart, Audrey, and Billy Wilder between takes on the set of *Sabrina*. The black cocktail dress is the very one she picked up from Givenchy's studio in the summer of 1953.

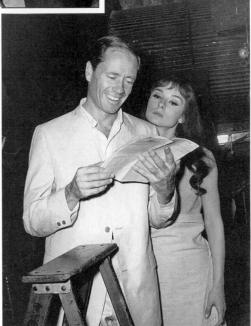

(Right)
The Ferrers, 1959.

Truman Capote in a publicity photo taken for the publication of *Breakfast at Tiffany's*.

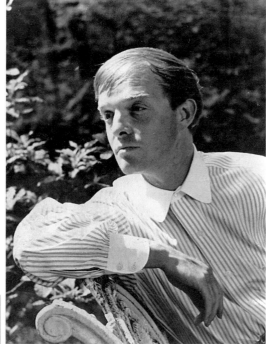

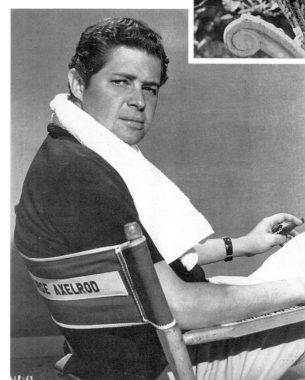

George Axelrod, breast man.

Producer Richard Shepherd, sitting in the middle of Fifth Avenue on the first day of filming *Breakfast at Tiffany's*, October 2, 1960.

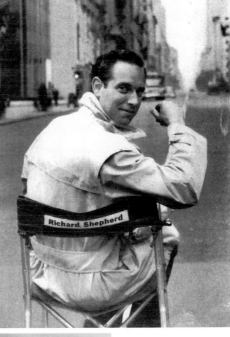

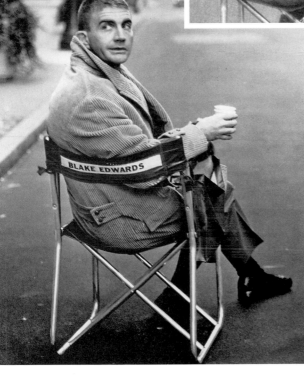

The Director.

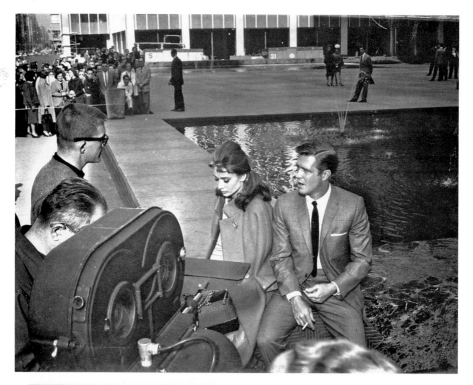

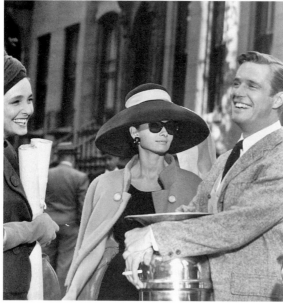

(Above) Just after lunch on the first day of shooting, Blake Edwards resumes production on the northeast corner of Fifty-second and Park.

(Left)
An uncharacteristically pleasant off-camera moment between Patricia Neal and George Peppard.

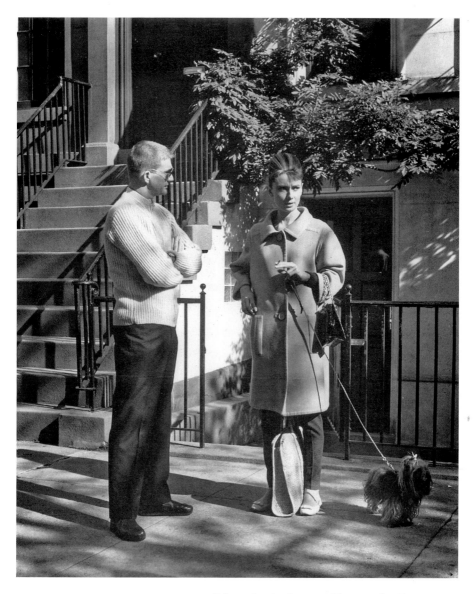

Edwards, Audrey, and her terrier Famous,
outside Holly's brownstone on East Seventy-first.

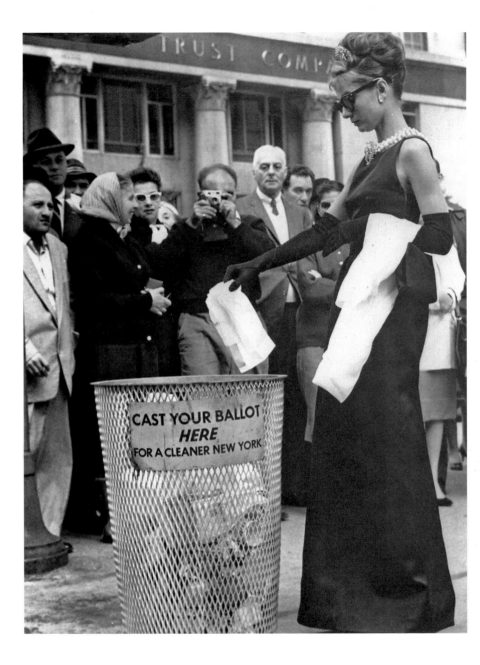

Indeed there was very little to being a famous actress that actually had to do with acting. A great portion of it involved this kind of thing with photographers and journalists and visiting executives. "Audrey, turn so we can see the diamond!" "Audrey, look over here!" But in its way, this too was a sort of acting.

Someone brought in a little table set with breakfast, and she was told to sit down beside it. The long cigarette holder they kept on a prop table was brought over to her. She thanked them, and a bulb flashed. "Audrey, turn back over your shoulder!" How much more of this? "Yes, like that." "Now pick up the Danish!" "Good! Fabulous!" She was good at being fabulous.

THE DIAMOND IN THE SKY

Director of photography Franz Planer surveyed the interior. Scattered around Tiffany's he counted a number of genuine store clerks, as well as an equal number of professional extras dropped in to appease the union. They all walked slowly so as not to trip on one of the heavy, interlocking cables curled on the floor like giant strands of black spaghetti. The gaffer did his best to hide them under carpets and behind cabinets, but a certain amount of protrusion was inevitable.

It was impossible to foresee all that could go wrong. There was weather, illness, second thoughts, and at least a dozen egos to contend with. When one of these elements came into contact with another, something had to give. That forfeit—a piece of scenery, a shard of light—which had most likely been

the product of some high-paid specialist's labor and ingenuity, would take a toll on their spirit. It could even disenfranchise them from the production altogether.

But Planer could roll with the punches. He had been shooting since the early years of the century—over a hundred and fifty films by the time he got to *Tiffany's*—but he got the job because he was beyond question the world authority on how to light Audrey Hepburn. *Roman Holiday, The Nun's Story,* and *The Unforgiven* were all his, though, ironically, he took pains to avoid working with major stars. Planer didn't want to be typecast a glamour photographer. He favored instead more of a poetic realism, one that, as *Tiffany's* opening shots attest, combined documentary and stylization in gentle, veiled proportions. He was an empirical artist, a hybrid physicist and painter, and his Oscar nominations for *Roman Holiday* and *The Nun's Story* only further the point: Planer could balance romance and reality. He could shoot the soundstages and the streets.

Because the sun itself looked bluish on Technicolor film, Planer had Tiffany's windows and revolving glass doors gilded in yellow filters and directed his gaffer to direct his electricians to set up thirty-two spotlights with yellowish gels throughout the interior. As always, he was fighting time, natural light, fire code regulations, as well as the restrictions placed on him by the location. It made setting up the shot— deciding exactly where those thirty-two spotlights were to stand, the precise angle at which they were to be turned, and the intensity of the light—a matter of epic complexity. And it took time. A long time. The room's natural brightness altered as the hours passed, and with the change in ambient light came the necessary renegotiations, which required more

conversation, manpower, and ultimately time. While they figured out their next move, the earth continued to rotate, and the light changed again.

The pressures were enormous. Aesthetics aside, if the shot looked wrong, if it was too dark or too bright or too red, everything that went into it would be undone. All people would see was the error, and it would be Planer's error, and then what would they do? Reshoot? But did they have time? How much were they over budget? Planer would ask Blake who would ask Shepherd who'd ask Jurow who turned to Marty Rackin who conferred with Frank Freeman who asked to see the rushes and have the plan for reshoots explained to him so he could assess the financial consequences before he made his decision. If in the end the executives said no, Franz Planer would be furious. The shot! What about the shot? He'd turn to Blake. Was everyone against him? No, Blake would assure him. Everyone was against everyone.

ACTION!

Audrey was barely cognizant of the bustle around her. Blake and Planer were in the corner pointing at the ceiling, Shepherd was glad-handing Walter Hoving, and armed guards numbering into the dozens were stationed throughout the store, keeping their eyes on the extras (and the jewels). But Audrey's uneasiness, which had mounted steadily through the publicity shoot, had only grown in these moments before they shot her first scene inside the store. With several faulty runthroughs of the first scene behind them (Audrey had been stifled by the hurried pace of the dialogue), Blake finally called

quiet. He could have continued rehearsing until he felt she was absolutely ready, but the day had been long already and he didn't want to wear her out. Now was the right time. They would try it for the camera. Just the wide shots, though. The close-ups would be shot weeks later, on the soundstage at Paramount.

Blake asked Audrey if she was ready to go. She said she was. The trick, as Edwards was beginning to realize, was to catch her at just the right moment—after she warmed to it and before diminishing returns. Blake had to find that sweet spot and harness it.

Audrey stubbed out her cigarette and took her place beside George Peppard. She didn't know him well, but already she could tell he thought more of himself than she did of him. Someone must have told him he was the star of the picture.

"Quiet!"

Audrey braced herself, concentrating.

All was silent.

Blake called action. She began, "Isn't it wonderful . . ." when a scream came from off camera.

Audrey, Blake, and the two dozen others looked up.

"Cut!"

Planer was on the floor. An untethered length of cable had dealt him a 220-volt shock. In the end he would be fine, but the shock sent a booming ripple through the entire set. Repairs, insurance, and the standard legalities would mean further delays, which would mean more stress for everyone from the production assistants to Audrey Hepburn.

After everything settled down, Blake weighed his options. It was getting late, they still had a Park Avenue location ahead

of them, and he had a headache. What time was it? An uncon-
scious weighing of the producers' money against the actors'
emotion split his headache in two. He would have to keep
everyone happy until he got the all clear. Now his headache
had a headache. Audrey lit a cigarette.

"Okay, everybody," announced the assistant director, "here
we go again . . ."

Cigarette extinguished. The wardrobe supervisor brushed
a fleck from Audrey's orange coat. A makeup girl appeared out
of nowhere and lunged at her face with a brush.

"Take your places, please . . ."

Audrey got up from her chair. The girl followed her as she
rose, dabbing at her cheeks all the way to her mark beside
Peppard.

"Thank you, *everyone* . . ."

"Ready?" Beat. "Roll camera . . ."

The camera operator threw a switch. "Camera rolling . . ."

The soundman, his eye on the dials, waited until the camera
was running up to ninety feet a minute. "Speed!"

The loader dropped a slate in front of the lens. "Scene 126,
take 3," he murmured, clapped his board, and ducked out of
the shot.

". . . And . . ."

There was a pause. Blake surveyed the location and the
actors and leaned forward in his chair.

". . . *Action!*"

Audrey and George started walking.

"Isn't it wonderful?" she said to him. "Do you see what I
mean how nothing bad could've happened—"

"Cut—reset—one more time, please!"

Something had happened. Sliding in and out those interlocking diamond displays couldn't be easy for the camera operator, especially with the weight of millions of dollars of jewelry hanging over his head. They tried it again.

Upwards of ten takes later, Blake had the scene where he wanted it.

"Lunchtime everyone! Thank you!"

Cue the journalists:

"It's true we've left sex ambiguous in the script," said Audrey, who had hardly a moment to herself since dawn. "Too many people think of Holly as a tramp, when actually she's just putting on an act for shock effect, because she's very young. Besides, I know Truman Capote very well, and much of what is good and delicate about his writing is his elusiveness."

"When the cast is right," remarked Edwards to the *New York Times,* "and the script as brilliant as this one is, I just go on the set and do what comes naturally. Axelrod followed the novel, but he added a plot, a love story, for commercial reasons—I don't mean for money, but for audience approval. And even Capote is happy about the script. He wrote the producer that we should watch the two-foot cigarette holder and not come too close to *Auntie Mame,* but he thought we had Holly right, and that was the main thing. I couldn't agree more."

Truman was not happy about the script, and he never came to the set. He was still in Europe, traveling with Jack.

LUNCH

"At about 12:00 that first day we broke for lunch," recalls Shepherd. "Then we went across town to Park Avenue to shoot the

scene in front of the fountain. By then, it was late enough in the day that crowds had gathered to watch the shooting. The weather was gorgeous, the scene was going great, and about 2:30, Blake said, 'That's it! Wrap!' And I said, 'Wait a minute! What are you talking about? We still have all day!' I was young, back then, and I wanted to be a hero at Paramount, so I pulled Blake aside and told him to keep shooting. Well, Blake was so pissed off that a producer would say that to him in front of the whole crew. He was *so* mad, but I was sticking to my guns. When we got back to the hotel, my wife said, 'Blake wants to see you.' I said, 'Well, let him come and see *me!*' Anyway, he came down to the room and was obviously very upset. I said, 'Want me to order anything?' He said, 'Just coffee.' So I ordered coffee and then he started lambasting me. 'Dick,' he said, 'I know when an actor has done enough for the day. They've been shooting since three in the fucking morning.' And then he said, 'Never do that again in front of the whole crew.' As he's saying this, I'm pouring the coffee and listening to him, and Blake starts to laugh. I have no idea what he's laughing at until I look down and see I've poured the whole pot of coffee all over the table. That's how nervous I was!"

NEW YORK

The next week was spent location shooting throughout Manhattan. There was the exterior of Holly's brownstone at 169 East Seventy-first, between Third and Lexington avenues. There was the scene between Doc and Paul outside the bandshell in Central Park; the exterior of the Women's House of Detention on Tenth Street; the steps of the New York Public

Library on Forty-second and Fifth; and the miscellaneous places that would provide the ellipses in the "Things We've Never Done" montage.

L.A.

And that was it for New York. Just one week and they were all relocated to Los Angeles. The rest of the film would be shot at Paramount.

Audrey reportedly arrived with thirty-six pieces of luggage and reunited with Mel and baby Sean. They moved into a house on Coldwater Canyon and began to live as a family once again. Audrey plunged into knitting.

GEORGE PEPPARD, IN METHOD AND MADNESS

When asked if she was a Method actress, Audrey responded, "Of course, all actors have a 'method' in order to be even vaguely professional. Mine is concentration—no, first instinct, then concentration." At a time when "Method acting" was printed with quotes, graduates of New York's Actors Studio were viewed by the old guard as narcissistic acolytes of a system that had turned them from just plain actors into two-bit amateur psychologists. Many of them fell in love with their new rock-star status and jumped on the bandwagon without the skill to stay aboard, but others, like Brando and Montgomery Clift, were powerful enough to transcend the bad-image problem, and with the help of what became the next wave in realism, even reverse it.

Alas, the actor George Peppard was not among them. He

belonged to the Method in attitude only, and on the set of *Breakfast at Tiffany's*, everyone—including George himself— paid the price for it. Where Audrey aimed to please, George aimed to pronounce. Where she took direction, he resisted. "I must say there wasn't a human being that Audrey Hepburn didn't have a kind word for," reports Shepherd, "except George Peppard. She didn't like him at all. She thought he was pompous." When she wasn't around, he referred to her as "the Happy Nun."

By the time Edwards's company reached Los Angeles, Peppard's working style had become so bold, and his confidence so firm, that the cast, and even his director, had begun to turn away from him. Even Jurow developed a grudge against Peppard for casting himself as the film's star. But none had it harder than Patricia Neal. "I had done scenes with George at the Actors Studio," she said, "had a very good time, and I adored him, but years later, when I got *Breakfast at Tiffany's*, something happened. I was thrilled when I heard we were going to be in it together, but it wasn't long until I saw that since I last saw him he had grown so cold and conceited." George's new way of working perhaps accounted for the change, instilling in him his character's animus toward 2E. When misapplied, the Method has been known to foul up off-screen relations in the name of "I *am* my character," which would help somewhat to explain Peppard's new demeanor, but his attitude didn't end there. A certain amount of friction came from script disputes, which according to Neal were a part of Peppard's campaign to lasso the spotlight. "He didn't want my character to make his character look bad," she remembers. "My character was dominant, you know, and before George got to the script, I had a

really excellent part, but he didn't want that, so he fought to have my dialogue cut, cut, cut. Much of it he actually managed to get cut because Blake had no choice but to give in, but luckily he didn't get away with all of it."

Apparently, Peppard felt his nascent star status granted him certain behind-camera benefits unavailable to other, regular actors. Years after their divorce, Elizabeth Ashley would refine the point in her book. "George was never one of those actors who believes his job is to take the money, hit the mark and say the lines and let it go at that," she wrote. "He felt that as an above the title star he had the responsibility to use his muscle and power to try and make it better, and that has never stopped in him. He was unrelenting about it, to the point where a lot of directors and executives came to feel he was a pain in the ass."

It's true that Patricia Neal's character was fuller in the shooting script than in the final cut, but exactly how responsible George Peppard was in the thinning of 2E is anyone's guess. Scenes and parts of scenes can be excised for any number of reasons, and while senseless ego is often one of them, it doesn't fully explain what goes on behind closed doors. At the end of the day, what Blake cut of 2E, he cut for the sake of his production. Whether it looked like defeat, improvement, or compromise undoubtedly varied with what (i.e., who) got slashed, but as the director of a major motion picture with major conflicting allegiances, Edwards's reasoning was always multidetermined. He was as much an on-set regulator as a behind-camera storyteller. When, for instance, Neal suggested that they might play a scene with Peppard sitting on her lap—an interesting suggestion, appropriately condescending to the actor's character—Peppard recoiled in absolute horror. He said

he would never do anything like that. Yes, interjected Neal, but would *Paul*?

"On one occasion," said Patricia Neal, "Blake and George almost had a fistfight. We were trying to block a scene and George wanted to change everything that Blake had planned, and George got so terrible that Blake almost hit him. I got them to stop, but I think George got his way. I hated him from that moment on." Ultimately for Edwards, handling Peppard was easier—and more complicated—than it looked to cast and crew. "I liked George," he mused, "he was such a ham, so vulnerable really. He was an ex-Marine and all that stuff, and I'd tease him unmercifully. And he'd try and tease me back but didn't have the wit for it. As a consequence, I always thought he was a piss-poor actor."

United by a common struggle, Patricia Neal and her director developed a strong working relationship. "I loved Blake," she said. "We got along *splendidly*. He had a fabulous sense of humor. Once I did something wrong and he wanted to torture me, and he made me do it again, and again, and again, and again, but he was so funny about it, I practically forgot I was being tortured. That was a gorgeous man, a delicious man. He'd take me home for dinner with his children and his wife and we all had just a marvelous time. I can't tell you how much fun he was—*great* fun—and a beautiful director, too."

The bond between Patricia Neal, her husband—the author Roald Dahl—and the Edwardses was not available to Peppard, presumably marginalizing him even further. "I think the problem with George," offers Patricia Snell, "was that he came to the film thinking that everyone thought him really terrific. Soon people discovered that he had no social grist with things.

He was difficult. He didn't always seem to try hard enough. And Roald didn't like him either. That kind of colored a lot for Pat Neal." Mysteriously, news of Peppard's alienation made its way to the press. Met with accusations of stubbornness, "forgetting his lines, ignoring appointments, and passing up old friends," the actor explained himself to a reporter from *Screen Stories*. "My whole world fell apart in one day," he confessed. "First, the couple who had been running our house for several years announced they were divorcing, and quit. Then, my six-year-old son came down with the measles, and quarantine laws barred me from going home to Chula Vista. I dislike living in Hollywood, so checking into a local hotel every night had me running around in crazy circles."

AUDREY & MEL & BLAKE & AUDREY

In the evening, after the day's shooting had ended, Edwards was accustomed to rehearsing Audrey for the next morning's scenes. Ideally, run-throughs would give her the confidence to make spontaneous but informed choices before the camera, when her anxiety was at its highest. Her instincts, Edwards observed, were impeccable, and each evening's rehearsal would end upbeat, on a note of mutual understanding. In New York, the process went smoothly—Audrey would come to the set the next day ready to apply what they had arrived at the evening before—but ever since they got to Los Angeles, Blake noticed that their headway wasn't carrying over into the shoot.

Between one day and the next, Audrey was changing her mind—or, more likely, having it changed for her. She had not the confidence (or the bad manners) to revoke

Edwards's notes on her own, suggesting to Blake that Mel was counterdirecting her at home. Of course, there was no way for Edwards to be certain that Mel was staging a subtle mutiny, but he had his suspicions. Like most everyone else on *Tiffany's,* Blake saw what the press didn't: the Ferrers as they truly were.

Mel was not shy about openly reprimanding Audrey. They all saw it. Some thought that he even enjoyed it. Jurow overheard the critical remarks Mel made about his wife's clothing and demeanor the few times he'd appear on the set to take her to lunch. "He was very tricky with her, you know," Patricia Neal recalls. "He wanted her to do things as properly as she could, and boy she did! He invited us to supper once after shooting, and we had our drinks, had our supper, and then *left*. She had her bedtime and he wanted her sticking to it."

One evening after the day's shoot, at a Japanese restaurant with various members of the cast and crew, Audrey made the mistake of putting her elbows on the table. Mel was seated next to her, and when he saw this, he picked up a fork, slipped its prongs under her elbows, and said—in a voice loud enough for all to hear—"Ladies do not put their elbows on the table." It was the sort of oppressively awkward moment that can only be met with silence. Audrey was stricken, and the table, mortified. Nothing was said. She simply removed her elbows and put her hands in her lap.

Audrey seemed to have a bottomless reserve of the benefit of the doubt, and the more she gave to Mel, the less she had for herself. But she wanted the marriage to work. So if he said it was right, then it probably was. That meant that if she saw

it another way, or felt differently, she was probably wrong. Of course it wasn't always like this. Once upon a time she didn't have to work so hard at love. Having a family was enough. Well, now she had it, and Mel had given it to her. So why was there a problem? Was she not satisfied to be satisfied? Maybe Mel was not the only one at fault for what was happening. Maybe she had pushed him to it. But couldn't that mean he pushed her to push him?

Audrey's willing selflessness depleted her, and her neediness kept her coming back. It was a bad combination, especially when it was paired with its exact opposite: a narcissistic man who only took, got hooked on taking, and took some more.

Blake sensed a needy side to her and attributed it to a kind of daughterly instinct. She was long without a father, he reasoned, and Mel fit the bill. The trouble was, he fit it too well and she needed it too much. "I don't know whether her men had a lasting effect on her career," Blake said many years later, "but I'm quite sure they had a lasting effect on her personal life. She put up with terrible things. I don't think she had the fun she was capable of having."

Edwards knew that the only way he could help Audrey overcome the wide gap she perceived between her true self and Holly Golightly would be to persuade her to go only to him, not her husband, for direction. She'd have to trust Blake, and him alone. If she couldn't manage that, she'd have to have faith in him instead. But that faith would be impossible to maintain if after hours, Mel continued to fill her mind with new ideas—even if they were good ones—about her performance. So Edwards gave Audrey an ultimatum. Either choose him, or find another director.

Audrey got it instantly. From there on out, she and Blake were in perfect sync. As the shoot progressed, Blake found he didn't need to hold his hand out to her anymore. She was doing it on her own. Buddy Ebsen saw it up close. "No two takes are identical," he would write of Audrey's working style. "The 'nowness' of one minute ago is gone forever and can only be played back—never duplicated. In one's delivery the timing varies by split seconds, or the weight of the word switches by audible milliseconds." Rehearsing with Edwards gave her conviction and the permission to use it. "You know," she said, "I've had very little experience, really, and I have no technique for doing things I'm unsuited to. I have to operate entirely on instinct. It was Blake Edwards who finally persuaded me [to become Holly]. He at least is perfectly cast as a director, and I discovered his approach emphasizes the same sort of spontaneity as my own." Audrey was truly maturing on the set of *Breakfast at Tiffany's*. She was gaining control.

It was a new feeling, one Audrey had never known as an actress. On *Roman Holiday*, Wyler simply didn't direct her that way. The closest he came to shaping a performance was calling out "let's do it again." And he did—over and over. Billy Wilder was a better communicator, but he was abrupt and allowed no room for experimentation. His lines had to be read as written, with a certain inflection, and he shot until he got it. Then there was Fred Zinnemann, who directed Audrey in *The Nun's Story*, her greatest performance to date—and one built largely in the editing room. Of course, Audrey gave him his material, but it was Zinnemann who created her character's elaborate texture of thought and feeling. Strategically placed point of view and reaction shots did the trick. It was a triumph

of implication, of cinematic finesse. But she and Blake worked *together* to make the performance. Holly, in effect, was their offspring.

The seamless synchronicity that held Blake and Audrey together could have led one to wonder if their relationship had progressed beyond the professional. "I can assure you that there wasn't any of that," Robert Wolders said. "During the making of *Tiffany's*, Audrey's marriage to Mel was quite intact. I'm quite definite about that." However, when asked point-blank if there was any kind of romance between himself and Audrey on the set, Blake responded with characteristic gallantry. "In those days," he answered, "everyone fell in love with Audrey."

THROWING A PARTY TO SHOOT A PARTY

When she arrived at Paramount's Stage 9 in early November of 1960, Audrey was drawn into a party that had been in full swing for days.

For all of the verbal refinery Axelrod gilded into the script, Blake maintained that *Breakfast at Tiffany's*, if it were to satisfy the second half of the hybrid genre "romantic comedy," would have to have bigger laughs, and more of them. That's how Mickey Rooney—for better or for worse—got Mr. Yunioshi, and that's why Blake decided to turn Holly's swingin' cocktail party into an all-out slapstick extravaganza.

"The general party was only indicated [in the screenplay]," Blake recalls, "and I had to improvise it on the set and I had a good time doing it. I asked the casting office to hire only actors—no extras. I said that there must be a lot of

unemployed actors around—not important names, not the usual background faces that you see in films. I wanted real actors because I didn't know who I was going to give things to and I wanted to be sure that they could handle it." Convincing the studio to pay actors upwards of $125 a day when extras charge a great deal less was not an easy sell for Blake, but luckily he came out on top. Edwards got the go-ahead from the moneymen, and with the bulk of production behind him, prepped and shot one of the most expensive party scenes to date. It took him the better part of November 2 to November 9 to get what he wanted, but it would last only thirteen minutes on film.

First to arrive on the scene was choreographer Miriam Nelson. Blake had summoned Miriam (or "Minimum," as he called her) to help him fit into place the precarious human puzzle that lay ahead. To make this thing fun and frenzied was one thing, and Blake had the gag muscle to do that on his own, but to make it frenetic and legible required the hand of someone who specialized in physical control. As Blake's choreographer on *Bring Your Smile Along, He Laughed Last,* and *High Time,* Minimum was just that someone, and in those early days of planning, she was also an extra pair of eyes and ears. "Blake wanted to dream up some crazy things to do at the party," she said. "I think he wanted somebody to come and play, someone to try things with. That's when he was discovering all sorts of things to do, like putting the telephone in a suitcase, and having Marty Balsam kissing a girl in the shower, and all that other wild stuff. Because I was a choreographer, I helped him with some of the staging. There were no dance numbers, but we discussed stuff like who should go where and when. It

looks crazy when you watch it, but these actors had to hit their marks, and be in the right position for the dialogue to play. So that's what we did, right there on the stage before we shot. Blake worked like that, you know. Very spontaneous. Very collaborative. He thrives in the company of collaborators. One idea turns into the next and before you know it you're in the movie."

That's how it went for Nelson. "After we finished working that day Blake said, 'Well, you oughta be in the party scene . . .' So the next day, he gave me an entrance, and then he teamed me up with Michael Quinn, who he asked to wear an eye patch, and he said, 'Go in and have an argument.' Halfway through the argument, he said to the fella, 'Lift your eye patch and just keep arguing.' So we did, and neither one of us knew what the hell we were saying. We were just making it up as we went along." And like any real party, people got tired, but rather than fight it, Blake used it. "When we were shooting," Nelson remembers, "I had on my own gold brocade suit, and matching gold shoes. After a while, those shoes began to hurt me, so in between takes, I would take them off and just hold them. Blake saw this and said, 'What's the matter with your feet?' I said, 'Well, these shoes hurt.' He said, 'Then don't put them back on. This is that kind of a party. Just carry your shoes.' So that's what I did the rest of the scene. I kept ripping up my hose so they had to keep replacing them."

Blake had thrown a party to shoot a party, so that out of accident—or you might say, out of reality—he could glean from the mini story arcs that were occurring naturally all around him. Like Miriam Nelson, actress Fay McKenzie was given one of her own. She said, "Blake came up to me and said,

'Hmmm . . . What am I going to do with you, Fay?' And he was thinking, and thinking, and then he said, 'I know! Fay, you're always laughing. I'm going to put you in front of a mirror and you can laugh your head off!' So then we shot the scene, I returned to being an extra in the background, and a few days later, I said to Blake, 'Hey, she could have a crying jag, you know.' He said, 'Do it.' That's how that happened." Unbeknownst to McKenzie, Blake had gone to great lengths to make her laugh. Beside him at the camera, he had stationed actor Stanley Adams, who was wearing one of the combustible hats worn in a previous scene by Helen Spring (Holly accidentally lights it aflame; a turned-over glass puts it out). When McKenzie was ready to go, Blake called action, cued the fire on Adams's head, and Fay—as she was told to—burst out laughing. Asked about this practical joke years later, Fay replied, "Blake didn't know this about me, but I am terribly, terribly nearsighted. I had no idea that he was trying to do anything to make me laugh."

Joyce Meadows, who dances through the party in a white dress, had her bit foisted upon her. "At one point during the shoot, George Peppard reached out and pinched my butt and I let out a huge scream—a *real* scream. That surprised me! Blake didn't tell me what was going to happen, so of course he must have told George on the sly. But I don't know if he told George to pinch me specifically, or just anyone. That's the way it was. You never knew when something was going to happen." "It went like that for the rest of the week," Faye McKenzie said. "Blake would just kind of walk around on the set and you could see him thinking up shtick that he was going to do. Of course, the scene was written by George Axelrod, but everything in it was *pure* Blake Edwards."

And what's a Blake Edwards party without a face-first pratfall? Such was the task of actress Dorothy Whitney, who as Mag Wildwood, was told to fall directly past the lens without lifting her arms from her side. ("Timber!") Not an easy directive for even the most gifted physical comedian, this piece of clowning was murder on Dorothy Whitney, who all but crumpled under the pressure to get it right and do it fast. Kip King, who played the liquor delivery boy, saw everything that happened to her. "Blake had tremendous difficulty in getting Dorothy to fall. That also was really, really, really, difficult for us to watch because we saw her so scared, and he was relentless with her. She would say, 'I can't do it, I can't do it.' Her reflexes wouldn't allow her to fall onto the mattress, but Blake needed that shot, and time was running out, and he went on and on until he got it. 'Okay,' he would say to her. 'Relax. Just relax. Now let's do it again.' I think it was upwards of thirteen takes. It was embarrassing for all of us to watch. He was losing his patience and began to look almost punitive. This was a different Blake. People were so stunned they didn't talk about it afterwards."

For the next seven days, Blake led his partiers through 140 gallons of tea and ginger ale, in addition to cold cuts, dips, and sandwiches, over sixty cartons of cigarettes, and over $20,000 worth of production costs later, at last he had the party he wanted. "People were everywhere," said Joyce Meadows. "Blake had planted us in practically every room throughout the set and signaled us with his hand when and where to move about. He would say, 'Okay everybody, when the music goes on, I want this group of people to cross into here and mingle with this group over here.' But as far as our personal move-

ments were concerned, that was up to us. He didn't give the party people specific notes, but at the beginning he said, 'You're all a regular part of Holly's life. This is not a down-home party, but a typical Golightly party, so don't let anything surprise you. No matter what happens stay in your characters and stay in the scene.' From there, he gave his notes to the first A.D. who'd say stuff like, 'You guys are doing great. Just keep up the conversation. Let's do it again.' You know, A.D. stuff. Blake had to save most of his energy for the dialogue scenes. You could tell that the actors were very precious to him. He would talk to them very privately and, it seemed to me, very intimately. You saw him talking to Audrey and Peppard and Marty Balsam, but you never *heard* him say anything. When he'd walk up to them, he'd put his arm around them and he'd take them to one side of the room and talk."

"Blake makes everyone feel wonderful and appreciated," Fay McKenzie said, "and has goofy things happening on the set. He wanted us to just have a good time, really. A lot of times that doesn't work, but he managed to do it. His sets were like parties, so it's no wonder that he's so good at writing and directing parties in the movies." If this was going to look like a real party, then it had to evolve like a real party, and that meant bringing in a bee smoker—used by beekeepers to calm the bees—to enhance the smoky ambiance to a suitably thick end-of-evening cloud. On the last day of the shoot, Edwards replaced the ginger ale with champagne. But be warned: The trick to playing drunk, he told his cast, was to play the scene with the intention of seeming sober.

Audrey, though, drank very little. The alcohol would soften her focus, and focus is what she needed to keep up with Blake.

Wearing a beehive hairdo piled high and streaked blond with peroxide, she worked as fast as she could, digesting the director's notes with startling fluency. Edwards would assign her a move, line, or a gesture, and she would apply it right away, in a single take. Between setups, while Blake disappeared for his twenty-minute miracle naps or health food lunches, she could be seen reminiscing to a cluster of attentive players. Audrey was viewed by some as distant—in these cases, probably just taking a moment to herself before the scene—but as countless have testified, the generosity she showed to her costars was bottomless. "Everybody loved Audrey," recalls Miriam Nelson. "She was so sweet and unassuming and nice to everybody. Some stars go to their dressing rooms between takes, but she didn't. I remember a group of us had gathered around her while they were relighting the scene, and she told us about the blitz in London. And she also told us that her mother always wanted her to have an extra pair of white gloves in case the gloves she was wearing got dirty. I remember that."

"Everything you have read, heard, or wished to be true about Audrey Hepburn," said Richard Shepherd, "doesn't come close to how wonderful she was. There's not a human being on earth that was kinder, more gentle, more caring, more giving, brighter, and more modest than Audrey. She was just an extraordinary, extraordinary person. Everyone should know that."

When she wasn't on camera, Audrey might be spotted in her little elevated on-set trailer, watching the production from above. "It was like a little box two feet up in the air," remembers Kip King. "It had a bed and a few cabinets. I talked to her standing at the door of the dressing room, two feet below her.

I was doing stand-up at the time and was trying to get her to laugh. She would smile and was always very kind. I think if she was Snow White, I was one of the dwarves. You know what I'm saying? There were human beings and there was Audrey Hepburn." Joyce Meadows would also hang around beneath the trailer. "When Blake yelled cut," she said, "the second A.D. walked over to the tall ladder beside me and yelled up, 'Audrey! Get your butt down here! You're in the next scene!' And there she was, watching the whole thing from her trailer. 'Ahhhhh!' she screamed. 'That's right. That's me, isn't it?' I looked up and here comes this woman who looked like a toothpick dressed in black coming down the ladder to join the crowd. One thing about Audrey: she had none of that star stuff. You didn't have to say 'Miss Hepburn.' And Blake was just as sweet. At the very end of the shoot, when I was all through, I walked out the stage door, and Blake rushed up and said, 'Joyce Meadows.' I turned around and he said, 'Thank you for making it a beautiful party.' I said, 'Thank you, sir.' I was surprised he even knew my name."

"The party scene was such a smash," said McKenzie, "Blake and my husband [screenwriter Tom Waldman] decided it might be a good idea to do a whole movie like that. That's how the movie *The Party* came about."

Here in the party scene was an opulent sweep of visual humor. All the surprises, gags, stunts, and reversals that had beckoned to Edwards from the silent films he adored were splayed out in kooky munificence, advancing one after the next like toys on a conveyor belt. But unlike the slapstick of Edwards's masters, Mack Sennett and Leo McCarey (directors of

The Keystone Cops and Laurel and Hardy), Blake's revisionist spin had a satirical edge. Each punch line—from the eye patch, to the phone in the suitcase, to the couple in the shower— was pointedly drawn from Holly's central theme; that the way things appear is not always the way things are. For as Holly's agent, O. J. Berman says, "She's a phony. But she's a *real* phony." More than simply jokes, Edwards's party gags implicate all those present in the charade, gently mocking everyone too hip, drunk, or fashionably blasé to notice what is made obvious to Paul Varjak—that these nuts may be glamorous, but they don't have a clue. It's the cosmopolitan façade cut down to size, and in Edwards's comedic terms, it's sophisticated slapstick.

No one is less conscious of it than Holly Golightly, who lights a hat on fire, but notices nothing. Nor does she notice the empty frivolity of the life she leads, her true feelings about coupledom, or the man who wants so badly to love her. These are the thematic cornerstones of Edwards's *Breakfast at Tiffany's;* Capote's *Breakfast at Tiffany's,* by contrast, takes as its central preoccupation Holly's never-ending search for belonging. That's what Tiffany's is to her, and significantly, she never gets inside. But that is most certainly not the case with Blake Edwards's picture. In the movie, the director's personal interest in phoniness forms the basis of *this* Holly's story, which, because it is a romantic comedy, will resolve in love. But before it can end happily, all of the many lies, betrayals, and masks (literal and figurative) must be stripped away. So how to end it? What if all the glamour and society élan of the picture's first half came down to, say, a dark and rainy alley? Or if the image of the cage with which Edwards began the party scene was somehow . . . inverted . . .

THE END

But Axelrod's ending called for nothing of the sort. What's more, the scene wasn't really that dramatic. It didn't crescendo. It didn't sweep you up. It just ended:

EXT. STREET—(DAY)

Paul stands watching the departing car. The rain has stopped now and patches of blue are beginning to show between the clouds. At the corner the limousine stops for a light. Suddenly the door opens and Holly jumps out. She is running back toward him across the wet sidewalk. In a moment they are in each other's arms. Then she pulls away.

HOLLY
Come on, darling. We've got to find Cat . . .

Together they dash up the block and into an alley in the direction Cat had gone.

HOLLY
(Calling)
You cat! Where are you? Cat! Cat! Cat!
(To Paul)
We <u>have</u> to find him . . . I thought we just met by the river one day . . . that we were

both independents . . . but I was wrong . . .
we do belong to each other. He was <u>mine</u>!
Here Cat, Cat, Cat! Where are you?

*Then they see him, sitting quietly on the top of
a garbage can. She runs to him and gathers him
in her arms.*

<div align="center">

HOLLY
</div>

(To Paul, after a moment)
Oh, darling . . .
 (But there are no words for it)

<div align="center">

PAUL
</div>

That's okay.

*They walk in silence for a moment, Holly carry-
ing the cat.*

<div align="center">

HOLLY
</div>

(In a small voice)
Darling?

<div align="center">

PAUL
</div>

Yeah?

<div align="center">

HOLLY
</div>

Do you think Sam would be a nice name for
a cat?

As they continue to walk up the street—

 FADE OUT
 THE END

That was it. But Blake couldn't hear the music swell, he couldn't see Paul and Holly pushed to the brink of their passions and beliefs, and without that eleventh-hour twist, the whole mechanism would just sputter to a halt. What it needed was some kind of imperative, the feeling of high tension followed by a crucial snap. Holly's mask ought to be ripped off her face.

All right, Blake thought, this is a scene about Holly's change of heart. She was once an independent, a free spirit, and now she wants to belong. The business of naming the cat comes to represent that transformation, sure, but this isn't *Lassie;* it's a love story between a man and a woman, so why play the climactic scene between her and an animal? Play it instead between the two of them, and that line about belonging, put it in Paul's mouth.

 PAUL
 You know what's wrong with you, Miss Who-
 ever-you-are? You're chicken, you've got no
 guts. You're afraid to stick out your chin
 and say, "Okay, life's a fact, people do fall
 in love, people do belong to each other, be-
 cause that's the only chance anybody's got
 for real happiness." You call yourself a

free spirit, a "wild thing," and you're ter-
rified somebody's gonna stick you in a cage.
Well baby, you're already in that cage. You
built it yourself. And it's not bounded in
the west by Tulip, Texas, or in the east by
Somali-land. It's wherever you go. Because no
matter where you run, you just end up run-
ning into yourself.

Now there's drama. Now there's a question in the air. Will
she go with him or won't she?

The new pages were dated September 14, 1960, written six
weeks after Axelrod's final draft. In the big speech, the scene's
centerpiece, Blake recapitulated the image of the cage, which
he featured in the first shot of the party sequence. He added
the rain, changed the limousine to a taxi, and they shot it in
December of 1960.

But they also shot the original ending—George's ending.
That way, in postproduction, Blake would be able to see which
one worked better. The final decision was his. And anyway,
George was back in New York. "Blake shot both endings," says
Patricia Snell, "but he picked the one he wanted. There wasn't
much George could do about it during the production, but
when it was done, he put his three cents in." What happened
to the footage of Axelrod's ending—the ending that survives
only in print—is a secret kept by the Paramount vaults, if it's
kept anywhere at all. Perhaps it's gone for good. Perhaps not.
Maybe it's mislabeled thirty feet under ground, and by some
archival magic will turn up accidentally in years to come. But
it's not likely. The cutting room floor is a graveyard.

THE CAT IN THE ALLEY

"As a woman," film critic Judith Crist said in 2009, "if I could chop down my reactions, I would say that *Breakfast at Tiffany's* was a progressive step in the depiction of women in the movies, perhaps unintended by Axelrod and Edwards. The woman in me really likes Audrey Hepburn because she is successful at what she's doing, she's sort of in charge of herself, and is a realist beyond being so cute and attractive. That appeal—a woman's appeal—comes from the very basic idea of the gamine, and not just the gamine's physical being, but the idea of her cleverness. Marilyn didn't have that, but Audrey did. As a gamine, shrewdness was available to her. So she's a call girl, but we let her have it. There's even something very appealing about it. We won't admit it, but don't we, really, all secretly admire her for it? Because she gets away with it? Because she's so imperious, and at the same time is slightly, shall we say, immoral?

"If I could chop down my reactions one step further," Crist continued, "that's the added pleasure for me as a critic, and it's at the heart of why *Breakfast at Tiffany's* is perhaps one of Audrey Hepburn's classier achievements. Her previous performances are beautifully embodied, but marked by intelligence, breeding, and middle-class grace—all qualities already familiar to us in Audrey. But not Holly Golightly. She was an impostor. That's why she's a multilayered character—Audrey's *first*. Not only that, but—and here's the woman in me again—a multilayered woman who isn't punished for her transgressions. When Bette Davis played the bad girl, she paid for it. That was the thirties-forties morality. Then there were things

in the fifties like *Love Me or Leave Me* with Doris Day, which was the beginning of redemptive "wrongdoing," but its excuse was biography. *Breakfast at Tiffany's* was different. It was one of the earliest pictures to ask us to be sympathetic toward a slightly immoral young woman. Movies were beginning to say that if you were imperfect, you didn't have to be punished. But what's clever about the way they ended *Breakfast at Tiffany's*—this is, of course, my own feeling—is that you don't get the sense that the two of them will last forever. About George Peppard's character, I remember thinking, 'Well, he's not long for it. Just because you're going to give the cat a name doesn't mean that the cat isn't going to go back to the alley.' You see what I mean?"

THE RAINCOAT

"Edith did the raincoat Audrey wears at the end of the picture," Patricia Snell recalled. "I was on the set the day they shot that scene, and Audrey knew that I had loved the raincoat and wanted to give it to me, but Edith had made it so difficult for Audrey to even get the raincoat that I didn't find out until years later when Blake said, 'Do you realize what Audrey went through to get you that raincoat?' I said, 'No, I didn't.' You see, Edith Head didn't want anyone giving costumes away. They made about six of them, you know, because you never know what's going to happen on a set. But she finally got it and wrapped it in a box and, boy, I was so thrilled to get it. I love it."

THE KISS

Two dressing rooms were assembled for Audrey, especially for the final sequence—one for taking off her wet clothes, the other for putting on dry ones. They were labeled "Wet Hepburn" and "Dry Hepburn." When it came time for the kiss, Blake held out for eight takes, each one straining Peppard's neck more than the last. To give the camera the best view of the leading lady, the actor had to tilt his face just so, and the awkward angle, he claimed, threatened his look of rapture. (And the cat, meanwhile—a very, very wet cat—was stinking up the joint. That didn't make things any easier.) But they did it again (and again) with Audrey ducking into "Wet" and emerging from "Dry," and at long last, with the warmish studio rain pouring down around him, Blake Edwards had the last shot he wanted. High-angled and wide, his camera tilted down on Paul and Holly ensorcelled in a kiss. *Breakfast at Tiffany's* was now a love story. Jurow and Shepherd—their fretting about star and subject officially behind them—had their old-fashioned happy ending in the can. Axelrod had his high comedy, Blake his lowbrow elegance, and Audrey Hepburn, who said she couldn't do it, had done it.

7

LOVING IT

1961

ONE OF BENNETT CERF'S DINNER PARTIES

In the days leading up to *Tiffany's* release, Joan and George
Axelrod ran into Capote at one of Bennett Cerf's dinner par-
ties in New York. As Joan told it,

> Truman was there and curious about how George felt
> about it [the movie]. George said, "I'm very happy with
> it, but I don't know how to break this to you. . . ."
> Truman said, "What? What?"
> "They're not going to stick with the title."
> Truman said, "What?"
> "They're not going to stick with the title."
> Truman said, "What? They're not going to use the
> title . . . ?"

"I pleaded and begged but, Truman, there's nothing I can do about it. They're calling it *Follow That Blonde*."

Truman fell for it hook, line, and sinker. George caught him at his own game. The moment Truman got it, he turned bright red. I've never seen him be so embarrassed, because this was something he thought he was beyond. Nobody could play a joke on *him*, nobody could lead him down that sort of garden path. He was totally furious.

He always liked George, but he was never really friendly with him after that and I think it had to do with that story.

ONE OF BILLY WILDER'S DINNER PARTIES

Meanwhile, George and Blake were riding a few postproduction bumps of their own. Though he swallowed Blake's ending without too much bitterness (it was sentimental, yes, but he agreed it was probably wise to give 'em what they paid for), Axelrod objected to the liberties Edwards took with the party scene. As the film's director, it was Blake's call, but with the question of authorship at stake and reputations on the line, it was going to take more than prerogatives to ease Axelrod's mind. "What Blake did with the cocktail party upset George a lot," said Patricia Snell. "Blake just took it and ran with it and I'm not sure it's what George had in mind. It wasn't his."

Neither, for that matter, were Mickey Rooney's scenes. They incensed George. "Each time he [Rooney] appeared I said, 'Jesus, Blake, can't you see that it fucks up the picture?' He said, 'We need comedy in this, and Mickey's character's

funny.' But Mickey's character is a) not funny in that film, and b) he has nothing whatsoever to do with the goddamn story. I got Audrey to agree to re-shoot the last scene, which was the only thing she was in with Rooney, so I could cut out all the Rooney stuff. However, Blake kept it in."

"From there on," adds Snell, "the relationship between Blake and George was difficult. They never really [pause] . . . we were socially their friends, we would go to their parties, and they would come to ours, but Blake and George just never quite connected after that. We would see them every Friday night at the Wilders' dinner parties, and on the surface they remained friendly but, you know, that's the game people play in Hollywood." Had Axelrod been a producer on the picture, he could have kept a handle on his interests, but it was too late for that. All he could do now was smolder in silence.

After the fracas with Blake on *Tiffany's*, Billy Wilder convinced Axelrod to finally pack up the kids and move to L.A. "Look," he said to George, "the time has come. You cannot sit in New York, see the finished product, then raise hell about it. If you want to be involved in the making of a picture, you've got to be out here to do it." Billy was right. He could either stay a New York writers' snob in New York or become a New York writers' snob in L.A. where he could keep an eye on his scripts. That's what George was doing with *The Manchurian Candidate*, which he and Frankenheimer had been talking about since the early days of *Tiffany's*. This time, he'd do it right. If they made it the way they should, the way he wanted to, *The Manchurian Candidate* would be the bleakest political satire America had ever seen. George became a coproducer.

MANCINI IS READY TO SCORE

With the studio system on the outs, big changes were happening in Hollywood. The Production Code Administration was loosening its strictures, a new morality was coming to the fore, and motion pictures, formerly mass entertainment, were on their way to becoming art. Classical modes were fading fast, and Henry Mancini, whose sound struggled to keep apace with the classical giants, was on the crest of the change. Now that the studios had canceled their own orchestra budgets, Mancini was allowed unprecedented access to unconventional instruments—the sort audiences wouldn't normally hear on a traditional movie sound track.

It was the dance band sound that thrilled Mancini, but he wasn't ready to forsake the old-guard conventions entirely. What he would do in *Breakfast at Tiffany's* was combine both traditions, the symphonic and the jazz, and redeem the latter by the former. But rather than use the full-blown orchestras of scores gone by, Mancini reduced the number of instruments to an ensemble small enough to foreground the guitars, harmonicas, and cha-cha beats.

At that time, most film scores weren't thought of as popular music. They were considered musical accompaniment, with little value apart from the picture. But Mancini had something else in mind. He wanted to make popular music—and he did. Weaving into *Breakfast at Tiffany's* self-contained jazz themes of ideal radio-playing (and album-selling) length, he became the first film composer to score big with the buying public. Not only did he reconceive and rerecord cues especially for

the sound-track album, Mancini advertised his catchy melody throughout the picture. He made "Moon River" a major thematic recurrence in *Breakfast at Tiffany's*, which only helped the tune, and the album, climb their way to the top of the charts.

After Audrey saw the film with the finished score, she wrote:

> *Dear Henry,*
>
> *I have just seen our picture—BREAKFAST AT TIFFANY'S—this time with your score.*
>
> *A movie without music is a little bit like an aeroplane without fuel. However beautifully the job is done, we are still on the ground and in a world of reality. Your music has lifted us all up and sent us soaring. Everything we cannot say with words or show with action you have expressed for us. You have done this with so much imagination, fun and beauty.*
>
> *You are the hippest of cats—and the most sensitive of composers!*
>
> *Thank you, dear Hank.*
>
> *Lots of love,*
> *Audrey*

Too bad that Marty Rackin, who had reservations with Mancini from the word go, completely disagreed.

THAT FUCKING SONG

Breakfast at Tiffany's had just previewed at a little off-road theater near Stanford University, and Audrey, Mel, Blake, Jurow,

Shepherd, and Henry Mancini were piled in a stretch limo headed back to Rackin's suite in San Francisco.

For the most part, the preview had been a success. The proof was in the response notecards the audience had filled out; none of them seemed to indicate that there was any serious problem with the picture. The only real issue seemed to be the picture was running just a little too long, but other than that, the company ought to have been riding high for the forty-five-minute trip back into the city. And yet, not everyone in the caravan was at ease. Mel's jealousy was as high after a good preview as it ever would be, and as Fay McKenzie observed, this one was no exception. "After the preview," she said, "when everyone was telling Audrey how great she was—and she was, so wonderful—Mel said to her, [terse] 'I liked your hat.' He said it loud enough for everyone to hear and it made us all so uncomfortable. But Audrey just about laughed it off. I think probably to put us at ease."

When they got to the hotel, Marty Rackin was the first to speak.

"I love the picture, fellas," he said, tapping out his cigar on an ashtray, "but the fucking song has to go."

He was standing in front of the fireplace, with one long arm stretched across the mantle. They were all seated before him. No one spoke.

"The song had been an issue for Rackin for some time," said Shepherd. "It wasn't about Audrey's voice, it was something else. He wanted to use the music of a guy like Gordon Jenkins, whose album *Manhattan Tower* had been a bestseller a few years earlier. But by that point we were all against it. After the screening in San Francisco, the only thing I wanted

to change was the Mickey Rooney stuff. I had told this to Blake on several occasions, but he stood by it. He thought he was funny. But he could have gotten the same laughs from a Japanese actor. It disgusts me to think about it. And Marty [Jurow] didn't like it either. But we never went to the mat about it. That night, in Rackin's suite, it was obvious to all of us that he was way, way off base about 'Moon River.' Having been a studio head myself, I can only say that I think you're often inclined, instinctively, to comment, even when you don't have anything to say. Rackin was in that position."

In Warren Harris's biography of Hepburn, Mancini says, "Audrey shot right up out of her chair and said, 'Over my dead body!' Mel had to put his hand on her arm to restrain her. That's the closest I ever saw her to losing control." But Mancini was mistaken; hostility, it's safe to say, was not in Audrey Hepburn's repertoire. What's more likely is that she protested silently or with a few tactful phrases, especially if Blake Edwards, who set the tone for the group, was himself keeping it all inside. "I looked over at Blake," Mancini reports in his autobiography. "I saw his face. The blood was rising to the top of his head, like that thermometer when I put a match under it. He looked like he was going to burst. Audrey moved in her chair as if she were going to get up and say something. They made a slight move toward Marty, as if they were thinking about lynching him." Clearly, Mancini's accounts are at odds.

It turns out it was Shepherd who saved the song. "I said, 'You'll cut that song over my dead body!' And Rackin heard that. The issue was resolved that night."

The song stayed. Swell music, fade out, the end.

Kind of.

THE KOOK

Despite all the precautions taken by the production, from casting to scoring, to ensure that Holly would appear proper and well behaved, it's hard to forget all the evidence to the contrary, from Capote's novel to Givenchy's dress, that suggests Holly is a wild thing at heart. Though the picture ends when she kisses Paul in the rain, we cannot forget that to get there, she has forsaken her family, abandoned her husband, gone out with a lot of rich foreign men, and, worst of all, had a really good time throughout.

Paramount's Publicity Department knew this, and they were afraid. Afraid that all the euphemisms would be lost on ticket buyers, that they'd believe Audrey Hepburn had made an indecent movie and stay home in front of their TVs, where they were safe. To reassure the unsure, they built a campaign around "kook."

Derivative of cuckoo, "kook" was one of many pieces of fifties slang to give nonconformist eccentricity a positive spin. There was also "insane" and "mad," as well as "crazy," which had been in circulation since the crazy twenties, and as one might expect, made the idea of difference—a wildly pejorative concept in midcentury America—into an emblem of cool. Good jazz was *craaazy*. So was rock 'n' roll. But by the end of the fifties, kookiness had been appropriated into the mainstream; Madison Avenue spluttered it across print and radio, the TV show *77 Sunset Strip* borrowed it for hepcat Gerald Lloyd Kookson III, and the musical comedy *Bye Bye*

Birdie saw a throng of moist teenagers rioting under signs of "Birdie You're Really The Kookiest." But what did it mean exactly?

Careful to make clear the distinction between a Beat kook—which the studio urged readers to acknowledge Holly was *not*—and a fun kook—the kind nervous parents might enjoy—Paramount publicity whitewashed the term of its seditious connotation. Their press releases were quite clear about the distinction:

Let's face it, now: what is a "kook"?

"Kook" is a word frequently employed by the offspring of this bewildered generation.

"She's a 'kook,' and all that jazz," they say. But what do they mean, dad?

At the moment, the only authenticated, self-styled kook is Miss Audrey Hepburn who claims to be one as Holly Golightly in Jurow-Shepherd's Breakfast at Tiffany's.

Holly Golightly keeps a fish in a birdcage. Holly Golightly takes breakfast on the sidewalk of Tiffany & Co. on Fifth Avenue. Holly Golightly wears clothes designed by Hubert de Givenchy of Paris. Holly has a cat whose name is "Cat."

But what's a kook?

Kook is not, as everybody associated with Breakfast at Tiffany's knows, a beatnik term. Couldn't be. The star is Audrey Hepburn, not Tawdry Hepburn.

Once on the set, an interviewer caught Audrey in the middle of knitting a sweater for Mel. She was quick to reassure the reporter—as he is quick to reassure his readers—that Holly was not the sort of part they might think it was. "When you publicize this unusual role," she was supposedly overheard saying to Blake, "please make it clear that I do not play a trollop; I play a kook." The British version of *Photoplay*, a well-circulated film fan magazine, reminded girls that there was no cause for alarm:

> If you're an Audrey Hepburn fan—who isn't?—you may have some difficulty in picturing her as a New York playgirl. Miss Hepburn, an elegant thoroughbred, just doesn't look like the type of girl who would live strictly for kicks. Yet here she is, turning out the performance of her life, in a new picture, *Breakfast at Tiffany's*, as—what the Americans call—"a real kookie dame!"

Just in case the point wasn't clear enough, Paramount issued regular statements to the press underlining the not-so-subtle facts of the Audrey-Holly discrepancy, facts such as these:

> Since Miss Audrey Hepburn has never played any part that has suggested she was anything but pure, polite and possibly a princess, a hard look at Miss Golightly is in order.
>
> Miss Golightly is not, according to critics, an exact prototype for the excellent Miss Hepburn. Miss Golightly is, said *Time*, "A cross between a grown-up Lolita and a teen-age Auntie Mame." She is, *Time* goes on, "an

expense account tramp . . . who by her own countdown has had only eleven lovers."

At the same time, regarding this surprising waif, now to be re-created by Audrey, other critics found that Holly Golightly was more to be pitied than censored. The *New York Times,* reviewing Capote's book and Holly Golightly, found them "A Valentine of love." The *Washington Sun-Star* called her "unforgettable."

So don't worry, moms. *Breakfast at Tiffany's* is just a simple love story about a simple fun-loving girl.

THE POSTER

Before he got the call to design the *Tiffany's* poster, Robert McGinnis illustrated paperback book covers, romances mostly. His women were typically slender, idealized, but with a hard edge that made them more elegant than voluptuous. "I preferred the more intelligent look of the fashion models of the early sixties to the Playboy types," he said. "That's how I could stand out from the other artists. They were doing, you know, a lot of blondes, a lot of Marilyns."

Somewhat out of the blue, McGinnis got a call from the art director Paramount had hired to design the *Tiffany's* poster. He asked McGinnis, who had no film poster credits to his name, if he was interested in contributing a few illustrations. "The art director told me that all they wanted was a single figure, just this girl standing, but with a cat over her shoulder, and that she would be holding her long cigarette holder. They sent me a few movie stills to work with and I said, 'Sure, why not?'

"The stills weren't really any good, so I sort of had to take a few leaps of my own. I was shooting pictures of a model for a book cover I was doing, and had her pose with the little orange cat I had back in those days. I put the cat on her shoulder, but the cat wouldn't stay, so she had to put her right arm up to hold it there. That was an accident. I didn't tell the model to put her hand there. It was just the only way she could keep the cat in place. That right there was the missing piece and it was the only variation from the many movie stills they gave me. Most of the photographs showed her with that hair, wearing those diamonds, and wearing that dress, so in the end, I didn't really stray too far from what they wanted and the direction they gave me.

"I did give the figure a little more through the hips and the bust, to idealize her just a little more. But the art director wanted more leg showing. In the photographs I got, Audrey's dress was long, all the way to the floor. But I was told to make her sexier, so I exposed that leg. That came from the art director, but I'm sure he got it from the studio. He told me they wanted to establish that *Breakfast at Tiffany's* was a movie about the city. They wanted a couple embracing with the skyline in the background, which they wanted to contrast with the elegance in the main figure of Audrey. But the main thing was the cat. They really wanted that cat in there."

McGinnis didn't know it, but that cat, which was so important to the studio, was—as their explicit definition indicates—part of their spin on "kook." Without it, the figure of Holly in the *Breakfast at Tiffany's* poster reads as simply seductive. The presence of the cat quite cleverly plays against that potentially alienating feature—and here's the key—without negating it.

The studio's idea to contrast Holly with the couple embracing in the background substantiates the same tension. *Breakfast at Tiffany's* is kookie, the poster says, but the good kind, the kind with an old-fashioned ending.

A TRÈS EXCLUSIVE ENTERTAINMENT

The West Coast premiere was held at Grauman's Chinese Theater in Hollywood on October 17, 1961. The invitation—if you were lucky enough to get one—was dipped head to toe in Tiffany blue with a two-inch-tall Holly caricature drawn at the bottom right.

In addition, the envelope contained a little card:

P.S. To my pet amis . . . After you've seen that marvelous "Breakfast At Tiffany's," I would adore to have you and your guest come right over to my apartment for Breakfast At Holly's— my friend Dave C's scrambled eggs, a snort of champagne and fun. Chez moi at the Hallmark House, 7023 Sunset Blvd., just a few blocks from the Chinese Theater. When you call for your premiere tickets, please tell me that you'll join my petit bash. [Signed, in blue] *Holly.*

In attendance that October evening, a year and two weeks after cameras turned on Fifth Avenue, were Nat King Cole, Henry Fonda, Glenn Ford, Dennis Hopper, Buster Keaton, Ernie Kovacs, Alan Ladd, Charles Laughton, Jerry Lewis, Karl Malden, Jayne Mansfield, Lee Marvin, Groucho Marx, Eva Marie Saint, and Marlon Brando. Wink Martindale was the master of ceremonies.

Audrey, when she saw the movie, told her agent Kurt Frings it was the hardest—and best—thing she had ever done. But what would the critics think?

WHAT THE CRITICS THOUGHT

The *New York Times* ("wholly captivating") and *Variety* ("surprisingly moving") came out with hearty thanks for an all-around good time. A few quibbles were noted, but they were easily overcome by Audrey's addictive appeal, the supporting performances, and for *Times* critic A. H. Weiller, a pair of inspired scenes: "A word must be said for the wild party thrown by Miss Hepburn and her visit to Tiffany's in which John McGiver, as a terrifyingly restrained clerk, solicitously sells a trinket for under $10: Both scenes are gems of invention." The uncharmed critics thought of *Tiffany's* as a soft comedy with a limp ending, but none were livelier, or more prophetic, than Brendan Gill. His *New Yorker* review, which began, *"Breakfast at Tiffany's* is one of those odd works that if they were any better would be a lot worse" ended with, "Millions of people are going to be enchanted with this picture; I will try not to feel lonely in my semidetached enchantment." If only the human body could learn to shrug and applaud at once.

No one seemed quite clear on the faithfulness of the adaptation. To one critic it was true in spirit, but not in fact; to another it was fact, not spirit; to this one it didn't matter because the picture worked; to that one, it mattered because it didn't. In the muddled free-for-all, moral agenda was often fobbed off as comparative analysis. As always, the central question was, was the film's Holly too clean or too dirty? Too sweet or too

sultry? All manner of answers poured forth, but for Penelope Gilliatt, the correct response was, keenly, both and neither. She wrote, "The achievement of the film, as well as its hedging flaw, is that one leaves this unquestioned at the time." Jurow and Shepherd would have been happy to read Arthur Knight on the subject, who noted, "Blake Edwards and his talented crew have touched a tawdry romance with true glamour . . ."

Clean may have won the *Saturday Review*, but it was far from pervasive. Out of the cacophony came one Irving A. Mandell, whose letter to *Hollywood Citizen-News* unearthed all the contentious taboos Team *Tiffany's* tried their best to bury. He wrote, "The *Tiffany* picture is the worst of the year from a morality standpoint. Not only does it show a prostitute throwing herself at a 'kept' man but it treats theft as a joke. I fear 'shoplifting' will rise among teen-agers after viewing this." Lest we forget. Just when the Production Code was beginning to look archaic, folks like Mr. Mandell appeared to crash the party. Writing of *Tiffany's* and the film *La Verite*, with Brigitte Bardot, Mandell asserts, "Neither picture has a story which makes sense. There is nothing in either to make one sympathetic with the main characters (these women cannot possibly be called heroines)."

WORKING GIRL

When she graduated from Brandeis University in 1959, Letty Cottin Pogrebin, the future cofounder of *Ms. Magazine,* was in need of a heroine. Right out of school, she started looking for a job in publishing, but found, despite her qualifications, that she couldn't get one. "I had a BA in English," she said, "and an

American Literature cum laude and distinction and all these other things, but when I opened the *New York Times* want ads, I couldn't apply for the jobs that I was qualified for because I could only apply for the job in the 'Help Wanted: Females' column. All the junior editor jobs were in the men's column."

Letty finally landed a secretarial job at Simon and Schuster. A year later, she moved to a small publishing house called Bernard Geis Associates where she advanced from assistant director of publicity, promotion, advertising, and subsidiary rights to director of each department. She was twenty-one. "I would take these editors out to lunch, but I had to establish charge accounts in these restaurants so men didn't see me signing the check. It was considered emasculating. I had to do all kinds of things to mask what was happening to make the men feel comfortable."

As the person in charge of promoting the soon-to-be-best-selling *Sex and the Single Girl*, Pogrebin trained author Helen Gurley Brown for her various interviews and media appearances. The two spent a great deal of time together, and before long, they forged a connection. "Helen was already married by the time I met her, but before that, she had led this fabulous single life for thirty-seven years." In her book, Brown was trumpeting a life of good times for the bachelorette, offering advice on everything from how a girl could add sensuality to her apartment, to advocating premarital sex, and even outlining ways to leave Manhattan for a rendezvous with a married man. It was racy, with an overarching idea of modern womanhood that looked ahead to *The Feminine Mystique*. But with more mystique. "Betty Friedan might have been embarrassed

to have Helen's book on her shelf," Pogrebin said, "but she definitely knew about it."

"I used to go to work in high-heeled shoes, gloves, hat, matching bag," she added, "and was very careful to always wear my hair in a bun. If my hemline was too high, I'd be sent home to change my dress. What I'm saying is, the demands of convention were merciless. I can't tell you what it was like, to be haunted by this set of feminine ideals wherever you went. Just imagine this: when I finally got married, I was the last one of my friends, and I was only twenty-four."

ONE OF SWIFTY LAZAR'S DINNER PARTIES

When he wanted to, Truman could pour it on. "Sometime after the movie came out," remembers Patricia Snell, "I met Capote at one of Swifty Lazar's dinner parties and I drove him back to the Bel-Air Hotel because he was acting, you know, so *nuts*. He was drunk or on drugs or something. He had created such a scene at Swifty's party and I lived by the hotel, so I took him. On the ride home he said, [slurring] 'it was a great, great thing to have your husband do the picture . . .' He told me he was thrilled with the end result, that he was really, really happy with the movie. Of course, I knew what he really thought."

For the rest of his life, when it didn't serve him to ingratiate, Capote would state his true position—a highly valid one—without reserve. "The book was really rather bitter," he said in a 1968 *Playboy* interview, "and Holly Golightly was *real*—a tough character, not an Audrey Hepburn type at all. The film became a mawkish valentine to New York City and Holly and,

as a result, was thin and pretty, whereas it should have been rich and ugly. It bore as much resemblance to my work as the Rockettes do to Ulanova." Decades later, with a few beverages in hand, Truman really let loose to journalist Lawrence Grobel. When asked what he thought was wrong with the adaptation, he replied,

Oh, God, just everything. It was the most miscast film I've ever seen. It made me want to throw up. Like Mickey Rooney playing this Japanese photographer. Well, indeed I *had* a Japanese photographer in the book, but he certainly wasn't Mickey Rooney. And although I'm very fond of Audrey Hepburn, she's an extremely good friend of mine, I was shocked and terribly annoyed when she was cast in that part. It was high treachery on the part of the producers. They didn't do a single thing they promised. I had lots of offers for that book, from practically everybody, and I sold it to this group at Paramount because they promised things, they made a list of everything, and they didn't keep a single one. The day I signed the contract they turned around and did exactly the reverse. They got a *lousy* director like Blake Edwards, who I could spit on! They got George Axelrod to do the script. I will say they offered it to me, but I don't like to do scripts of my own work, I prefer doing scripts of other people's.

They didn't offer it to Truman. They offered it to a writer who wouldn't fight their changes.

"Truman was strongly opposed to the screenplay," Shepherd said. "But I only found out about that after the picture

was released. We never had any day-to-day dialogue with him about the screenplay, directly or through his agent. Frankly, I don't recall having a single face-to-face meeting with Truman until the picture was going into release. After he acquired the novel, neither did Marty, but we were not obligated to share the development of the script with him."

ONE OF AKIRA KUROSAWA'S DINNER PARTIES

"When I was an agent at CMA [Creative Management Associates]," said Shepherd, "one of my clients was Akira Kurosawa. I went to Japan when he was directing his sequences for *Tora! Tora! Tora!* and when he realized that I had been involved with the decision to cast Mickey Rooney as a Japanese man, he almost couldn't talk to me. I felt awful. I was so embarrassed. Here was Akira Kurosawa, one of the masters, and he had invited me to his home for dinner, where I watched his wife serve me on her hands and knees, and then [trails off] . . . it was . . . painful."

Blake Edwards has since apologized. As for Rooney, he pleads ignorance. When the actor was alerted that a public screening of the film in Sacramento had been canceled in the wake of a substantial protest against Yunioshi, the Mick told the *Sacramento Bee* that he was heartbroken. He added that he hadn't received a single complaint about the portrayal since the film's opening.

LETTY COTTIN POGREBIN GOES ALL THE WAY

"When *Breakfast at Tiffany's* came out, it blew me away," Pogrebin said. "In those years, I really considered myself an

alter ego of Holly Golightly. First of all, it was because she was so unlike the usual Hollywood caricature of a woman. She was a woman you wanted to be. Of course, she didn't have a profession and I was career oriented, so that was a little troublesome, but the fact that she was living on her own at a time when women simply weren't, was very validating to me. It was very affirming. Here was this incredibly glamorous, quirky, slightly bizarre woman who wasn't convinced that she had to live with a man. She was a single girl living a life of her own, and she could have an active sex life that wasn't morally questionable. I had never seen that before." Inspired to adopt some of Holly's kookiness for herself, Letty went out and bought a scooter, a dog, a rabbit, and a little duck.

"Back in 1961," she says, "all we had to represent change was a young male president. But morally, nothing had changed. We were exactly in the same place. Then came Audrey Hepburn, this very good girl—so it can't be wrong, right?—as Holly Golightly and she was wearing these gorgeous Givenchy gowns. And they were black!" Like thousands of other American women, Letty bought one, or one like it, for herself. Before long, her closet was filled with black dresses and black hats. "That's when I was starting to begin to think seriously about black. They weren't pink or lime green like they were supposed to be. They didn't have lace around the collar or little doily patterns. There was only one secretary at Simon and Schuster who wore black all the time and I thought she was dynamite. That was really something. Phyllis was her name."

I'D MARRY YOU FOR YOUR MONEY IN A MINUTE

Letty and Phyllis were not alone. *Breakfast at Tiffany's* was well on its way to grossing $4 million domestically, and $6 million worldwide. That wasn't monster money, but it was enough to earn Jurow and Shepherd hearty handshakes around the studio. They had delivered a popular film on time and at budget. Their star was pleased, the sound track was selling, and if they wanted to impress the barons of art, they could show them the *New York Times* review. "See? It's good! It says so right *here!*"

That year, *Breakfast at Tiffany's* was nominated for five Academy Awards. There was one for Audrey (Best Actress), George Axelrod (Best Adapted Screenplay), the film's team of art directors, and there were two for Henry Mancini—Best Score, and Best Song, which, if he won, he would share with Johnny Mercer. Jurow and Shepherd weren't nominated, but they might as well have been; without them, those who were nominated never would have gotten their jobs. That right there was so much of producing. Putting the right people on the movie.

THE ENVELOPE PLEASE

Audrey flew to Los Angeles from Switzerland to attend the Oscar ceremony only to be confined to her hotel room with a sore throat. She watched it all in bed.

Though he wasn't nominated, Blake Edwards accompanied his team to the Santa Monica Civic Auditorium, the honorable

Bob Hope presiding. That night, Blake didn't have the jitters of a nominee, but he was still tense.

George Axelrod, try though he did to laugh it off—the bullshit of the business and all that—wanted to win as much as anyone else. If he were a long shot that night, he might have been able to relax more, but the cruel fact of it was George had a chance—a good chance. Three weeks earlier, he'd picked up the Writers Guild Award for Best American Comedy, for which he had been nominated three times prior (*The Seven Year Itch, Bus Stop,* and *Phffft*). Having never won until now, George finally had that gold-getting blend of momentum and freshness. It was just the combination to sway undecided Academy voters.

Mancini and Mercer arrived together. Their limo pulled slowly through the crush of screaming youngsters and stopped in front of the red carpet. A moment later, the door was held open, and out came Hank and Johnny, accompanied by their wives, Ginny and Ginger. But the screaming died when they showed their faces to the crowd. No, they weren't Elvis.

Inside the auditorium, the couples took their seats on the aisle, the Mercers in front of the Mancinis. To their utter shock, they were seated on folding chairs that weren't only hard on their backs, but creaked throughout the ceremony, which, incidentally, was the longest in the Academy's thirty-four years of Oscar. As is customary, the nominated songs were performed. Andy Williams sang "Moon River," which had already become his theme.

As Tony Martin and Cyd Charisse took to the stage, Mancini braced himself. Listening to the names of his fellow nominees roll by, he was reminded that he was in the company

of (and up against) legends, each and every one of them. The names Rozsa, Stoloff, Tiomkin, and Elmer Bernstein were packed side by frightful side, and then there was his name— Mancini—blaring out like a bum note from a tuba. How could he even compete?

There was silence as the envelope was opened. And then Mancini heard his name again—"Henry Mancini"—this time followed by heavy waves of applause, which grew louder the longer Hank stayed frozen in his chair. Every face in the auditorium turned back toward him, Ginny kissed his cheeks, and Mancini bolted up. He was not thinking now, he was running.

Seconds later he was onstage. This was it, his first Oscar.

"I'm deeply grateful to the members of the Academy and my good friend Blake Edwards. Thank you."

And after that, he was onstage again. But this time, Johnny Mercer was standing next to him.

"I've said my bit," Mancini said, "go ahead."

Mercer edged up to the microphone. "I'd like to say that I'm very proud that you liked our song. I'd like to thank you, Audrey; thank you, Andy; and martinis for everybody."

"Thank you," Mancini added.

That night, those two Oscars for Best Song and Best Score of a Dramatic or Comedy Picture were the only two wins for *Breakfast at Tiffany's*. George lost to Abby Mann for *Judgment at Nuremberg*. So did *Tiffany's* art directors lose, but to *West Side Story*. And Audrey Hepburn, along with Piper Laurie, Natalie Wood, and Geraldine Page, lost to Sophia Loren for *Two Women*.

Audrey smiled it off. George was devastated. But when he was asked, he told everyone that it didn't matter. The bullshit of the business and all that.

AFTERGLOW

At the party to follow, Blake gave as many congratulations as he received. With his wife on his arm, he passed through the ballroom on the precipice of glory, offering phony and sincere strains of deference in switch combinations that surprised even himself. Handshakes, backslaps, and across-the-room waves were exchanged around like a hooker at an all-night orgy, and by the end of the evening, as he tried to remember how or when his bow tie got untied, Blake wouldn't be able to recall what he said to whom. His wife, Pat, dutifully reminded him that the evening's successes were rightfully his to share, and yet there was no getting around the fact that *Breakfast at Tiffany's,* no matter how good, wasn't really A Blake Edwards Movie. Yes, the cocktail party was his. The ending was his, too, but he wouldn't tell people that. Going around claiming credit for it would just make him look greedy, and gallantry was Blake's preferred mode of manipulation.

What Blake didn't know was that he was on his way—and in a big way. The new Blake Edwards—the one whom *Tiffany's* would inaugurate into the critical firmament—was not making movies until Andrew Sarris—who would soon *become* the critical firmament—formally christened *Breakfast at Tiffany's* the directorial surprise of 1961. If that wasn't sufficient indication of Blake's potential, then his Best Director nomination for *Breakfast at Tiffany's* from the Directors Guild of America surely was. Though he lost to the directors of *West Side Story,* there was no doubt that this recognition—Hollywood's first formal acknowledgment of his directing—meant he had upped

his ante and had been dealt a winning hand. Now, he was pre-
pared: when the time came, Blake could wield the long leash
he'd been storing up for years and make the kind of comedy he
really wanted to. All he needed was the ace.

It came in the form of *Days of Wine and Roses,* and it handed
Blake more prestige than ever, but he had no idea what he was
going to do with it when he sat down with Maurice Richlin to
write *The Pink Panther.*

THE END OF THE ROMANTIC COMEDY

As the days passed, Mel and Audrey spent more time in si-
lence. Their marriage had become a Rubik's Cube they scram-
bled and unscrambled in the dark, he turning it one way, she
turning it another.

In 1965, they bought an old farmhouse in the hills above
Lake Geneva. "La Paisible" (The Peaceful) they called it. There
was a white picket fence, orchards, and a marvelous view of
the Alps. Best of all, there was no sign of the world of film pro-
duction Audrey had come to resent. *My Fair Lady* had wrung
her dry, and here at last she could soak up her life again. But
seeing his wife at rest unsettled Mel. He wanted her to work,
to have more ambition—his own.

Perhaps it was to ensure herself a long period of rest that
Audrey, after finishing *How to Steal a Million* in Paris, became
pregnant once again. The new baby, she felt, would be a friend
to Sean, and moreover, a salve to their marriage—the turn of
the Rubik's Cube they had been grappling for. But it did not
work out that way. Audrey miscarried in January 1966.

Gamine parts, Mel sensed, were beginning to look strained

on his wife, now thirty-seven. Likewise, Hollywood's idea of the romantic comedy—the genre she had done so much to evolve—was growing tired, if not a little irrelevant to the politically charged sixties. Movies were now about struggles, not dreams. Their subject, reality, was taking asunder the naive glow of love, and the relevance of Audrey Hepburn, its patron saint, was falling down with it. One glance at her marriage and she would understand exactly why: romantic comedy, like any marriage, didn't end at "I do." *The Philadelphia Story* was only half of the story.

It was the other half that worried Audrey. She didn't know if it was in her to play a real and ordinary woman. The last time she tried to revamp her image—*The Children's Hour* in 1961—nothing happened. Assuming the role of a maybe-lesbian did try the limitations of her persona, but it brought her some of the worst notices of her career. Audrey assured herself that light comedy was really where she belonged, and followed it with *Paris When It Sizzles*, a picture so problematic, Paramount shelved it for two years, only to release it in 1964 to more awful reviews. *Charade*, directed by her pal Stanley Donen, came next, but it was more of the same old-fashioned stuff. So were *My Fair Lady* and *How to Steal a Million*.

That's why Mel thought she should take *Two for the Road*. The story was not only experimental in its structure, which was temporally fractured like a film of the French New Wave, but it called for Joanna Wallace—the character Audrey would play—to use profanity, engage in adultery, and perform a seminude love scene ("If you want to be a duchess, be a duchess! If you want to make love, hats off!") What's more, Stanley Donen, the director, told Audrey that if she were to do the

picture, she would be wardrobed not in couture but in ready-to-wear. Givenchy, he said, would be too formidable for Joanna. Of course, the character would have to have style, but it had to be relatable, or at least *au moment*. The gamine was out of the question.

Audrey read the treatment and turned it down. But Donen and his screenwriter, Frederic Raphael, were not deterred. Script in hand, they flew to La Plaisible, where, mustering the kind of persistence Marty Jurow had himself mustered once upon a time, they convinced Audrey Hepburn to take the final leap in her career.

8

WANTING MORE

THE 1960S

THE BEGINNING OF THE ROMANTIC COMEDY

Stanley Donen said, "The Audrey I saw during the making of this film I didn't even know. She overwhelmed me. She was so free, so happy. I never saw her like that. So young! I don't think *I* was responsible. I guess it was Albie." Albert Finney, her costar.

They began giggling the moment they were introduced, and they didn't stop until the end of the shoot. It took acting like children to make them feel like grown-ups, and sometimes it didn't feel like acting at all. They entered that blurry realm *after* acting called surprise, when actors let go of their own thoughts and feelings and, as if through intravenous transfusion, fade into each other.

In those few months of production on *Two for the Road*,

Audrey and Albie lived a brief lifetime of romance. Whatever happened to them in the hushed moments before a take, or privately, in seaside alcoves away from the set, can only be extrapolated from what they left on film: a dictionary's worth of silent shorthand, realized in split-second nuance. And then their romance ended quickly, as soon as it had begun.

Fearing the adultery suit Mel could bring against her, and the toll it would most likely take on her relationship with Sean, Audrey had no choice but to call it off. She and Albie parted on good terms, though the film's cast and crew (and indeed a slice of the world's reading population) knew better than to file the proceedings under "Just One of Those Things."

"Audrey's the one who asked for the divorce," Mel said many years later. But what's the point in assigning blame? He was her husband, she was his wife, and whatever passed between them had now passed. Once, it was true that they had loved each other.

"*Two for the Road* is that rare thing," wrote Judith Crist in her review, "an adult comedy by and for grown-ups, bright, brittle, and sophisticated, underlined by cogency and honest emotion. And, far from coincidentally, it is a complex and beautifully made movie, eye-filling and engrossing with a 'new' (mod and non-Givenchy) Audrey Hepburn, displaying her too-long-neglected depths and scope as an actress . . ."

Truly, for the first time, Audrey Hepburn played a woman— not a lovely one, but a real one—with all of her defects, desires, and unrefined human pains. "Director Stanley Donen," wrote Richard Schickel, "and Writer Frederic Raphael (who also wrote *Darling*) have sensibly noted that girls don't become women just because they were sexually awakened (overnight,

as it were). The process takes considerably longer." For Audrey Hepburn, that process, which began in *Roman Holiday* and climaxed in *Breakfast at Tiffany's* had finally reached its port of call.

From *Two for the Road*:

EXT. THE FRENCH-ITALIAN FRONTIER—DAY.

The Mercedes is snaking up the steep approach to the frontier station.

MARK
(*philosophizing*)
We've changed. You have to admit it.

JOANNA
I admit it. We've changed.

MARK
It's sad, but there it is. Life.

JOANNA
It's not that sad.

THE FIRST *MS.*

Several years later, in 1971, Letty Cottin Pogrebin, along with Gloria Steinem and several other women journalists, founded *Ms. Magazine.* "Holly was my formative prefeminist role model," Letty said.

ADIEU EDITH

The last time Audrey saw Edith was in the Universal commissary a full decade after *Tiffany's*. Spotting Ms. Head dining alone, Audrey popped her head over her booth and said, "Why Edith, you haven't changed a bit!"

Edith—most likely working on her regular three scoops of tuna salad, cottage cheese, and sorbet—looked up to Audrey, who was not employed at the time, and shot back, "I haven't had time to. I've been too busy working."

It was rare that Edith, renowned for her diplomacy, would let her proverbial glasses drop before such a powerful actress, but her retort shows how deep the wound really was. Of all the stars in her hundreds of films since 1925, it was Audrey Hepburn, the most timid of titans, who hurt her the most.

Edith would not have known it then, but she was on her way to obsolescence. First she would be out of fashion, then she would be out of date. Rita Riggs was there for the change. "When Gulf & Western bought Paramount in 1966," she said, "they filled Ms. Head's fitting rooms with machines, and wiped her out in two weeks. They cleared out an inventory of fashion and accessories that she spent her entire career collecting. At one time, her work rooms of long tables—perfectly situated to catch the northern light—were big enough to fit twenty ladies doing rolled hems for the likes of Ginger Rogers and Joan Crawford. Now they were no longer cost effective. Out they went, and Edith's studio became the accounting department."

Edith Head, who played it safe, who hated trends, and who never wanted to be a designer, wore white gloves, tailored

suits, and her hair up in a tight chignon. She was nominated for the Oscar thirty-five times.

TRUMAN'S SWAN SONG

There are those who believe they are truly loved when they truly aren't, and others who suspect that despite sincere reassurance to the contrary, no one really loves them at all. At some point in their lives, most people suffer from one or the other, wrongly convinced that all is well or all is not, but Truman Capote, who was good at losing love, was terribly right about both. Simultaneously overadored and falsely adored, Capote rode a carousel of affections from his first day to his last, changing horses as it suited him, even turning them against each other on his way around to the prettiest next. Unbeknownst to him, he was preparing the herd for a stampede that would one day run him to the ground. Even as he fell, he'd claim he didn't see it coming, but no one else was surprised.

In 1975 *Esquire* published "La Côte Basque, 1965," the first shaving off Capote's much-talked-about, long-awaited maybe-masterpiece, *Answered Prayers*. It was narrated by Jonesy, a clear Capote surrogate, who listens as Lady Ina Coolbirth dishes society inside and out. Most of the dirt is directed at thinly veiled versions of Truman's swans, figures like Cleo, who Jonesy calls "the most beautiful woman alive," and the affair her husband attempts with a governor's wife (it fails: she ends up menstruating all over the bed). All of Truman's friends and all of Truman's enemies—two categories that were beginning to merge—knew exactly whom the repugnant episode referred to, and when Babe read it, she recognized herself and Bill

immediately, and shut Capote away—forever. Truman wrote her two long letters; she ignored them. Jack Dunphy called her at Kiluna asking her forgiveness; she rejected him.

What Truman wanted to tell Babe, if only she would have listened, was that he never intended to betray her. He wanted only to give Bill his due. Destroy Paley, he thought, in a public literary lynching, and avenge Babe's suffering. But it didn't happen that way—at least, not immediately.

Ironically, long after Babe and Truman stopped speaking, friends of the Paleys' noted that the bad press Truman handed Bill had begun to pay off. Now that her husband was a known philanderer, Babe could turn away from him without worrying. More than simply justified, suddenly, leaving him was mandatory. And Bill began to feel it—he began to repent. As Babe fell to cancer, he spent literally millions fighting it off, catering to her every comfort. To the complete shock of his children, he even allowed himself to be seen in a state of desperation, sitting beside her on the bed as Babe, very slowly, put on her face for the last time. She died on July 6, 1978.

Truman died six years later. Among his last words were "Beautiful Babe" and "Mama, Mama." Both had fled from him. But both were preserved in Holly Golightly. Of all his characters, he always said, she was his favorite.

END CREDITS

It started with a phone call from my agent, David Halpern. He told me I was about to get a phone call from Julia Cheiffetz, an editor at the newly formed imprint HarperStudio. An hour or so later, I was on the phone with Julia, and about fifteen minutes after that, we had an idea for a book about *Breakfast at Tiffany's*. People like to throw around the phrase "I couldn't have done it without . . ." and a lot of the time they're overstating it or trying to be modest, but in the case of Halpern and Cheiffetz, I quite literally could not have done it without them. Halpern, with his patience, directness, humor, and unerring eye on integrity, is a kind of dream agent, and very likely the secret love child of Max Perkins and Swifty Lazar. What he does, he does with a finesse so refined it's practically invisible. I don't know how, but I think his wardrobe has a lot to do with it. And Cheiffetz: how she listened, considered, gave space, understood, challenged, soothed, had faith, and charged forth! As an editor, she readily dedicated herself to the consideration and reconsideration of what may have seemed trivial to anyone else, and, quite courageously, allowed us—

both of us—to listen to the book reveal what it wanted. To me, a nervous writer stepping out onto the ledge, she was the trampoline below.

David Freeman, this book's minder, is my first reader for the very simple reason that he probably knows more about show business than anyone anywhere in the world. He also knows how to make the best martini (about six to one), which is an essential skill for anyone who knows anything about show business to have, if only because it's the most efficient way to assuage the inevitable feeling of hopelessness that comes from discussing it at any length. Without Freeman, I would have been on my own, and the process of writing this book would have been confined to the cramped screening room of my mind—the only place, outside of David's house, where I can get a laugh from a joke about Geoffrey Shurlock.

For their time, recollections, and/or expert punditry, I thank Jeffrey Banks, Jeanine Basinger, Peter Bogdanovich, Chris Bram, David Chierichetti, Gerald Clarke, Robert Dawidoff, Illeana Douglas, Blake Edwards, Gene Lees, Molly Haskell, Travers Huff, Elaine Kagan, Kip King, AC Lyles, Robert McGinnis, Fay McKenzie, Joyce Meadows, Billy Mernit, Miriam Nelson, Brad Peppard, Letty Cottin Pogrebin, JP Radley, Rita Riggs, Aram Saroyan, Patricia Snell, Edmund White, and Albert Wolsky.

I want to extend my most profound gratitude to Judith Crist, Sean Ferrer, Patricia Neal, Richard Shepherd, and Robert Wolders. These wonderful people didn't have to devote all those hours to answering my questions, nor did they have to speak honestly and personally about themselves and their work, but they did, and with the kind of trust, openness, and

generosity that ensures a writer like me will have great material for his book. Thank you Judith, Sean, Pat, Dick, and Rob for giving so much. Thank you, thank you, thank you.

And for making a call, solving a problem, or just plain lending me a hand, Karen Abbott, Sandra Archer, Tessa Dahl, Bob Dolman, Jack Dolman, Jennifer Edwards, Kate Eickmeyer, Judy Gingold, the Goldblatts, Barbara Hall, Lisa Hoffman, Noah Isenberg, Gary Khammar, Ian King, Selina Lin, Lynne Littman, Andrea Martin, Mark McVeigh, Lynn Povich, Melanie Rehak, Kathy Robbins, Jenny Romero, Sara Rutenberg, Steve Shepard, Ed Sikov, Mom, Dad, Maria and Sophie, I owe you a big lingering hug that could potentially go on too long and make you slightly uncomfortable.

At HarperStudio, my team behind the scenes was always warm, and on occasion, addictively fun to watch from afar. Thank you, Sarah Burningham, Bob Miller, Mumtaz Mustafa, Katie Salisbury, Jessica Weiner, and Debbie Stier.

And finally, Amalia—who got me sandwiches, held my hand, eased my mind, and deliberated with me over every page, paragraph, and period—we can talk about something other than *Breakfast at Tiffany's* now.

A NOTE ON THE NOTES

What follows is a hybrid of traditional sourcing and open-hearted homage to those works that influenced the writing of *Fifth Avenue, 5 A.M.* Because this book contains a considerable amount of factual re-creations, I thought it best, when citing their origins, to take the time to explain how and from where I extrapolated what I had, rather than spill out a list of endless citations. In those cases, for the simple reason that entire works, not merely direct quotations, fed the mill of my own writing, these little paragraphs seemed the most comprehensive and least clinical way of describing the unscientific process by which I set out to capture the experiences of my real-life characters.

Nonfiction of the sort I endeavored here, the kind that strives to re-create history more than merely recount it, must negotiate a perilous path between the analytic interpretation and the imaginative one. To keep them distinct is no easy task, and one hell of a slippery slope, which is why it struck me as disingenuous to present my research in an exclusively empirical form. Though, naturally, any person or work I quoted directly has been cited the old-fashioned way.

SAM WASSON
LOS ANGELES
NOVEMBER 2009

NOTES

COMING ATTRACTION

xix Irving A. Mandell's remarks about *Breakfast at Tiffany's* appeared in Hazel Flynn's *Hollywood Citizen-News* column, February 20, 1962.

1. THINKING IT, 1951–1953

1 *The First Holly*: It's madness to write about Truman Capote without looking to Gerald Clarke's *Capote* (Linden, 1988), and thankfully, I could supplement knowledge I gleaned from Clarke's book with knowledge handed to me from Mr. Clarke himself. The e-mail correspondence he and I exchanged proved essential to both my portrait of little Truman and his absentee mother, as well as to my investigation of the real-life Holly Golightly. Also useful were *Too Brief a Treat: The Letters of Truman Capote* (Random House, 2004); George Plimpton's rollicking oral history, *Truman Capote: In Which Various Friends, Enemies, Acquaintances, and Detractors Recall His Turbulent Career* (Doubleday, 1997); and Lawrence Grobel's *Conversations with Capote* (New American Library, 1985), all of which made an impression on this book's Capote. Each of those impressions has been sourced in more detail in the notes below. So too have those occasions when I explicitly quoted Clarke, his great book, or a voice heard in it. Without them, my own Truman would have been airless.

3 *The White Rose Paperweight*: The account of Capote's meeting with
Colette was pieced together from Nancy Caldwell Sorel's sketch,
"Colette and Truman Capote," which appeared in *The Atlantic
Monthly* (May 1995), as well as Truman's own essay, "The White
Rose," collected in *Portraits and Observations: The Essays of Truman
Capote* (Random House, 2007), from which I took this section's
dialogue.

5 *Audrey Awoken*: One account of Audrey's breakfast regimen can be
found in Eleanor Harris, "Audrey Hepburn," *Good Housekeeping*
(August 1959).

6 *Colette Awoken*: The story of Colette's discovery of Audrey has been
written about so many times and from so many differing points of
view, that by now, it's got to be 50 percent legend, 50 percent myth.
How much can one be certain of? The description in this book is culled
from a variety of sources (and is peppered with miscellaneous details
about Colette I pulled from Judith Thurman's *Secrets of the Flesh: A Life
of Colette* [Random House, 2000]), including Eleanor Harris, "Audrey
Hepburn," (*Good Housekeeping*, August 1959) and "Audrey Is a Hit"
(*Life*, December 1951), but none checked out better than the evoca-
tion in Barry Paris's *Audrey Hepburn* (G. P. Putnam's Sons, 1996) for
the simple reason that his presentation of the meeting had more in
common with all of the other variations of the scene than any of the
variations had with each other (chief among them was producer Gil-
bert Miller's own variation, published as "The Search for Gigi," [*The-
ater Arts*, July 1952]). Apropos, it should be said that Paris's account
of Audrey's life is a favorite of both Sean Ferrer and Robert Wolders.
That only won Paris more of my favor. On separate occasions, Ferrer
and Wolders were quite direct with me on this point ("It is the *only*
one," Wolders said. "It comes the closest to her"), and after consider-
ing a great many biographical alternatives, I can finally agree with
them. Paris is definitive. Perhaps more so than any other movie star,
Audrey Hepburn incurs in her admirers the kind of idolatrous, cliché-
ridden fan writing that sounds sincere when spoken, but falls flat on
the page. "Elegant," "lovely," and—worst of all—"perfect" are three
such easy, throw-pillow-type examples, and though Paris can't help
but succumb on occasion (I can't see how anyone could be completely
exempt), his gaze is not quasi-religious. He looks Audrey Hepburn

squarely in the eye, is modest with his superlatives, and maintains formal and scholarly integrity throughout.

9 *Everything That Is Important in a Female*: Colette and Audrey's brief exchange is taken from the sources listed above. "Everything that is important in a female" from Anita Loos, "Everything Happens to Audrey Hepburn" (*The American Weekly*, September 12, 1954).

11 *The Cigarette Girl*: Scene from *Laughter in Paradise* (Transocean/Associated British Films-Pathe, 1951).

13 *Mrs. James Hanson, Deferred*: For a full list of *Gigi* reviews, consult David Hofstede, *Audrey Hepburn: A Bio-bibliography* (Greenwood Press, 1994). Brooks Atkinson's review, which included "charm, honesty, and talent," is from the *New York Times*, November 26, 1951.Walter Kerr's review, in which he praises Audrey's "candid innocence and tomboy intelligence" is from the *New York Herald-Tribune*, November 26, 1951. "Oh dear, and I've still got to learn how to act" is from "Princess Apparent," *Time*, September 7, 1953.

14 *The Electric Light*: The description of Hanson's time spent on the sidelines of *Roman Holiday* was extrapolated from interviews with Hanson quoted in Paris's *Audrey Hepburn*. Audrey's remark "I'm not like an electric light" was selected from Mary Worthington Jones, "My Husband Doesn't Run Me," *Photoplay* (April 1956). For more on Wyler's rigid working style, see Jan Herman, *A Talent for Trouble: The Life of Hollywood's Most Acclaimed Director, William Wyler* (Putnam, 1996).

15 *The Enchanting Unknown*: The effect the *Roman Holiday* dailies had at Paramount was described to me in an interview with AC Lyles at his office on the Paramount lot, on April 2, 2009.

16 *The Market*: The startling statistic, "one-third of the nation's . . ." I uncovered in Marjorie Rosen, *Popcorn Venus* (Coward, McCann and Geoghegan, 1973). The even more startling portrayal of Mr. and Mrs. Tony Curtis, "In 1954, a close friend relates, 'Janet made the greatest sacrifice she had ever made . . .'," is from *Modern Screen* (1959).

19 *The Product*: There is no shortage of books about the Hollywood star system, though most of them are too misty-eyed to see their subject(s) clearly. Jeanine Basinger's *The Star Machine* (Knopf, 1997) is loving and brutal; she lets the magic in without keeping us from the factory truth of how and why these often-unremarkable people became the world's most brilliant stars.

21 *Doris and Marilyn*: My thinking about Doris Day and Marilyn Monroe
was informed by Molly Haskell's indispensable *From Reverence to Rape*:
The Treatment of Women in the Movies (Holt, Reinhart and Winston,
1973). Though she's more generous to Doris Day than I could ever be,
Haskell is the most elegant of critics, and quite simply the last word
on the phenomenon of star meaning and making. When paired with
Marjorie Rosen's *Popcorn Venus*, it's safe to assume that one has exam-
ined every culture-making actress, and from every significant angle.

23 *Birth of the Cool*: "Audrey had it in her to be the sugar coating on a
bad-tasting pill," AC Lyles to SW on April 2, 2009. "She thinks the au-
thenticity . . ." from "H.R.H Audrey Hepburn," by Dorothy Kilgallen
(*American Weekly*, September 27, 1953).

26 *Mrs. James Hanson, Deferred, Again*: Audrey sums it up in Mike Connolly,
"Who Needs Beauty?" *Photoplay* (January 1954). "We decided this was
the wrong time to get married," she said. "I've told you my schedule:
a movie here in Hollywood, then back to the stage, then back to
Hollywood, and so forth. He would be spending most of his time taking
care of his business in England and Canada. It would be very difficult
for us to lead a normal married life. Other people have tried it but it
has never worked. So we decided to call it off. Oh, maybe sometime in
the future—but not now, not for a while." See also Joe Hyams, "Why
Audrey Hepburn Was Afraid of Marriage," *Filmland* (January 1954).

2. WANTING IT, 1953–1955

27 *One Hot Spurt*: Patrick McGilligan's sprawling interview with George
Axelrod, "George Axelrod: Irony!" from *Backstory 3: Interviews with
Screenwriters of the 60s* (University of California Press, 1997), captures
the wild, willful spirit of Axelrod's quixotic sensibility, and, along
with several other extended interviews (namely, Axelrod's in *Screen-
craft: Screenwriting*, [Focal Press, 2003] and "A Hit in a Hurry" from
Theater Arts [January 1954]), laid the groundwork for my character-
ization. Thanks also to Illeana Douglas, Axelrod's former daughter-
in-law, who spent a great deal of time remembering with me, quite
fondly, those days and nights she spent in George's company talking
Hollywood, debating movies, and—most of all—cooking dinner. She
described a great laughing Falstaff of a man who, despite his achieve-

ments, always struggled to assert himself as a writer of serious, adult romantic comedies. Axelrod said as much throughout his career, from Dennis Stack, "Films: Views and Interviews" (*The Kansas City Star,* January 28, 1958) to Vernon Scott, "Axelrod Emphasizes the Marital Theme" (*The Philadelphia Inquirer,* December 24, 1967). "*The Seven Year Itch,* in fact, is concerned with . . ." from *The New Yorker's* review of the play, December 6, 1952. "The bulk of my sex-comedy career . . ." from *Backstory 3.*

31 *Does Edith Head Give Good Costume?*: Reading David Chierichetti's *Edith Head: The Life and Times of Hollywood's Celebrated Costume Designer* (HarperCollins, 2003) alongside *The Dress Doctor* (Little, Brown, 1959), by Head and Jane Kesner Ardmore, and *How to Dress for Success* (Random House, 1967), by Head and Joe Hyams, a consistent picture of Edith fades into view. Though she tried her best to appear cool, she was, beneath the glasses, a bundle of nerves, and as much an actress as the women she dressed. When I interviewed him at his home on March 6, 2009, David Chierichetti was generous enough to show me the last filmed interview with Edith, which he conducted shortly before her death. Before the first question is asked, with the camera rolling, Edith carefully, nervously, strikes a pose, reconsiders it, and readjusts. Image was all for her, even to her dying day. However, a distinctly vulnerable side to Edith, which she showed more of to Grace Kelly than she did to Audrey, is on display in her various personal items—journals, photographs, and sketchbooks—available in the Edith Head Collection at the AMPAS Margaret Herrick Library in Los Angeles. She laughs in candid photographs. Speaking with Rita Riggs, Edith's former apprentice, in her loft in West Hollywood on February 13, 2009, offered me a vivid picture of Ms. Head—as Riggs still refers to her, over forty years later—in taskmaster mode, and was essential to my understanding of the pressures she placed on her coterie of employees as well as herself. She would be reluctant to admit it, but as Chierichetti assured me, Audrey broke her heart. "She was Miss Head's favorite to dress," Rita Riggs to SW on February 13, 2009.

34 *The Memo*: These pieces of correspondence, as well as many other *Sabrina*-related memos exchanged in the days leading up to Audrey's Parisian shopping spree, are kept in the AMPAS Margaret Herrick Library in Los Angeles.

37 *31½-22-31½*: Audrey's meeting with Hubert de Givenchy, like her dis-
 covery by Colette, is ensconced in legend. The combination of Amy
 Fine Collins's "When Hubert Met Audrey" (*Vanity Fair,* December
 1995), from which I borrowed a great deal of dialogue; as always, Barry
 Paris's version in *Audrey Hepburn*; and *Audrey Style* (HarperCollins,
 1999) by Pamela Clarke Keogh, which gives one a good feeling for
 Audrey's taste and the reasons behind it, all helped to separate the
 imagined from the likely, and formed the foundation of my own re-
 creation. Also of use were Charla Carter's "Audrey Hepburn" (*Harper's
 Bazaar,* December 1991), and "Co-Stars Again: Audrey Hepburn and
 Givenchy," by Gloria Emerson (*New York Times,* September 8, 1965).
 While a great deal has been written on Audrey and Givenchy's collab-
 oration, there is little by way of meaningful interviews. These pieces
 are exceptions. "Whether the skirt is wide enough . . ." Givenchy
 quoted in *W Magazine* (March 2008).

42 *Mel*: Audrey describes her first meeting with Mel in David Stone, "My
 Husband Mel" (*Everybody's Weekly,* March 10, 1956). "Our first meet-
 ing was in London," Audrey said, "at a film party, and it was very
 formal. I was enchanted by meeting him, very interested to meet him.
 I'd loved his performance in the film *Lili.* The thing I remember most
 about that first meeting was that he was so serious. He didn't smile. I
 liked him . . . but that was all. He'd seen me on Broadway, in *Gigi,* and
 we talked about doing a play together, the way actors and actresses do.
 And we said that if either of us found a play that would suit us, we'd
 send it to the other."

43 *The Most Sophisticated Woman at the Glen Cove Station*: The hilarious
 business of Wilder and Lehman straining over the question of Au-
 drey's sexuality in *Sabrina* came by way of Maurice Zolotow's *Billy
 Wilder in Hollywood* (Putnam, 1977), which, in conjunction with the
 best biography on Wilder, Ed Sikov's *On Sunset Blvd: The Life and Times
 of Billy Wilder* (Hyperion, 1998), fill in most of what was left unsaid
 in Cameron Crowe's *Conversations with Wilder* (Knopf, 1999). Screen-
 writer and novelist David Freeman, who inherited the script of Hitch-
 cock's unmade *The Short Night* from Ernest Lehman, served me a
 hearty stew of anecdotes about the man he called "the Robert Wise
 of Screenwriters," which is probably the greatest remark anyone has
 ever made or will ever make about Lehman. "This girl, singlehanded,

may make bosoms a thing of the past," Billy Wilder quoted in "Princess Apparent" (*Time*, September 7, 1953).

46 *The Dream Begins*: Audrey's remark, the baby "will be the greatest thing in my life, greater even than my success," is from Ellen Johnson, "Will Hollywood ever see Audrey Hepburn Again?" *Modern Screen* (April 1955).

47 *Oscar Night*: Edith Head's acceptance speech on record at the AMPAS Library.

47 *Mrs. Mel Ferrer*: "My mother wanted to have a kid because she wanted to right the wrongs of her childhood," Sean Ferrer said to me on September 17, 2009. "She carried that into her UNICEF work." For a woman who didn't like to give interviews, Audrey was quite vocal about the importance of motherhood in her life. "I don't think I was a whole woman then. No woman is without love," Audrey quoted in Carl Clement, "Look Where You're Going, Audrey (*Photoplay*, April 1956). "He's a protective husband, and I like it. Most women do . . ." from "Audrey's Advice: Have Fun, Let Hubby Wear the Pants" (*New York Journal American*, August 19, 1957). "She was in part attracted to Mel . . ." Robert Wolders to SW on October 23, 2009. All through her life, Wolders assured me, Audrey had no qualms about trumpeting the kind of domesticity that many women found regressive. Naturally, she gave it a lot of airtime here, in the mid-1950s. "She's known dictators in her early war-shadowed life," Audrey quoted in Mary Jones "My Husband Doesn't Run Me," *Photoplay* (April 1956). "Mel was jealous of her success," Brynner quoted in Warren Harris, *Audrey Hepburn* (New York: Simon & Schuster, 1994). "Of course, it's a problem . . ." Ferrer quoted in Joseph Barry, "Audrey Hepburn at 40," *McCall's* (July 1969).

3. SEEING IT, 1955–1958

49 *The Swans*: Gloria Vanderbilt and Carol Matthau's own memoirs provided me with valuable firsthand accounts of swan life. "I rarely asked anyone to my studio," from Gloria Vanderbilt, *It Seemed Important at the Time: A Romance Memoir* (Simon & Schuster, 2004). "You have freed yourself," Capote quoted in Carol Matthau, *Among the Porcupines* (Turtle Bay Books, 1992). Also of service was Aram Saroyan's

Trio: Oona Chaplin, Carol Matthau, Gloria Vanderbilt: Portrait of an Intimate Friendship (Simon & Schuster, 1985), as well as my correspondence with Mr. Saroyan about the effect *Breakfast at Tiffany's* had upon his mother. "I think Carol was pleased to be associated with Holly Golightly," he wrote in an e-mail of January 14, 2009, "and to some degree dined out on the association. When I recently reread the book, I did see touches that reminded me of Carol, specifically the zingers like 'The next time a girl asks for change for the powder room, don't give her 50 cents.' That sounded like Carol to me. I think Carol relished the association more than the other two. Gloria had her own fish to fry, and Oona was an extremely shy person. Then too, looking at the three of them exclusively, Carol does seem to have had more of Holly Golightly's qualities than either Gloria or Oona."

52 *Beautiful Babe: In All His Glory* (Simon & Schuster, 1990), Sally B. Smith's magisterial account of Bill Paley, contains such a wealth of information about Babe it's practically a dual biography. Her strange and fractured relationship with Truman, however, is, understandably, explored only peripherally, and here is where Clarke's *Capote* was of immeasurable help. The book works in perfect counterpoint to Smith's, balancing both sides of the Capote/Babe love story, such that, when taken together, a diptych of startling sadness, and perhaps even tragedy, comes into view. In this section, Truman's quotations— the passages beginning "When I first saw her . . . ," "whose sole creation . . . ," and "I was madly in love with her . . ."—are all from *Capote*, and the evocation of Truman and Babe's conversation about her marriage to Bill was adapted from dialogue related in Smith's book. The Billy Wilder remark is also from *In All His Glory*.

57 *George Axelrod Dreams of Rich People Saying Witty Things and Screwing*: "The film version of *The Seven Year Itch* . . ." from *Daily Variety* film review of *The Seven Year Itch*, January 1, 1955. "In the Eisenhower years, comedy resides in how close one can come to the concept of hot pussy while still living in the cool of the innocent," from Norman Mailer, *Marilyn, A Biography* (Grosset & Dunlap, 1981).

59 *The Producers*: A substantial portion of the information I used to evoke Marty Jurow came from his own book, *Marty Jurow Seein' Stars: A Show Biz Odyssey* (Southern Methodist University Press, 2001), and what I know of Richard Shepherd and his own career was relayed to

me, over the course of several interviews, from Shepherd himself.

60 *What Truman Capote Does in Bed*: Truman's interview with Patti Hill, "The Art of Fiction No. 17," originally published in *The Paris Review* (Spring-Summer 1957), goes into Capote's working methods, as does Gerald Clarke's *Capote*. "When it's a quarter to two and sleep hasn't come . . ." from Capote's essay "The White Rose," collected in *Portraits and Observations: The Essays of Truman Capote* (Random House, 2007). The morsel of Capote's old purple prose style, "he was spinning like a fan blade through metal spirals . . . ," is from *Other Voices, Other Views* (Random House, 1948). Capote's observation, "Every year, New York is flooded with these girls . . . ," is taken from his interview with Eric Norden, *Playboy* (March 1968).

64 Breakfast at Tiffany's, *Traveling*: The exact words Nancy White objected to are noted in some file somewhere in Gerald Clarke's possession. "Of one thing I am certain," he wrote to me on November 2, 2009, ' "Fuck' was not one of the four letter words to which *Esquire* objected. That would have been much too strong for the fifties, and Truman would have known it wouldn't pass. I think the words were more like 'hell' and 'damn.' " Capote's letter to Cecil Beaton, "The Bazaar is printing it in their July issue . . . ," is excerpted from *Too Brief a Treat: The Letters of Truman Capote* (Random House, 2004). "Truman Capote I do not know well, but I like him . . ." Norman Mailer, *Advertisements for Myself* (G. P. Putnam and Sons, 1959). "Whenever Capote tries to suggest the inner life of his heroine . . ." Alfred Kazin, from "Truman Capote and 'the Army of Wrongness'" collected in *Contemporaries* (Little, Brown, 1962).

65 *The Real Holly Golightly*: "The Bonnie Golightly Sweepstakes" is detailed in "Golightly at Law" (*Time*, February 9, 1958). James Michener's side of things, from which I drew all of the quotations that appear in this section, takes up a hunk of his introduction to Lawrence Grobel's *Conversations with Capote* (New American Library, 1985). Truman's typically slippery take comes from his interview with Eric Norden (*Playboy*, March 1968). "Truman mentioned such a woman to me too . . ." Gerald Clarke to SW on December 23, 2008. "Beatnik" coined by Herb Caen in his column in the *San Francisco Chronicle*, April 2, 1958. Here it is: "Look magazine, preparing a picture spread on S.F.'s Beat Generation (oh, no, not AGAIN!), hosted a party in a

No. Beach house for 50 Beatniks, and by the time word got around the sour grapevine, over 250 bearded cats and kits were on hand, slopping up Mike Cowles' free booze. They're only Beat, y'know, when it comes to work . . ."

4. TOUCHING IT, 1958–1960

71 *Jurow and Shepherd Make Their Move*: This sequence between Marty Jurow and Richard Shepherd comes to the page by way of Jurow's own book, *Marty Jurow Seein' Stars: A Show Biz Odyssey* (Southern Methodist University Press, 2001), in addition to the several conversations I had with Shepherd, who, with astonishing generosity, made himself, as well as his own shooting script of *Breakfast at Tiffany's,* exceedingly available to me. All of his quotations come from those exchanges. "Well-written, off-beat, amusing . . ." quoted in a Paramount reader's report on file in the Special Collections in the AMPAS Margaret Herrick Library. The dialogue between Truman and Jurow, and Jurow and Paula Strasberg, is as reported by Jurow himself in *Marty Jurow Seein' Stars.* "I remember it this way . . ." Shepherd to SW on November 24, 2009.

77 *Marilyn*: Truman's intense feeling for Marilyn survives in "A Beautiful Child" from *Music for Chameleons* (Random House, 1975). After reading the piece, she ends up looking a lot like Holly. Or Holly a lot like her. "It's not that she was mean . . ." Billy Wilder quoted in Michel Ciment, "Billy Wilder urbi et orbi," *Positif* (July–August, 1983). Strasberg's phone conversation with Marty Jurow is recounted in *Marty Jurow Seein' Stars.*

80 *The Serious Writer*: The details of Jurow-Shepherd's deal with Sumner Locke Elliott are drawn from an extended correspondence kept in the AMPAS Library Special Collections. Contained there are all of the various memos, changes, and legal stipulations of his contract, as well as the draft he turned out.

80 *The Gag Man Gagged*: "Truman, they won't use me . . ." / "Well, bullshit . . ." This brief exchange comes by way of Joan Axelrod, quoted in George Plimpton, *Truman Capote: In Which Various Friends, Enemies, Acquaintances, and Detractors Recall His Turbulent Career* (Doubleday, 1997). George tells another version of the same story in *Backstory 3* (University of California Press, 1997).

81 *The Serious Writer Gagged*: Shepherd's terrific memo, like all of the material related to Sumner Locke Elliott's deal, is kept in the AMPAS Library Special Collections.

83 *The Pitch*: The list of screenwriters under consideration for the *Breakfast at Tiffany's* rewrite is kept in the AMPAS Library Special Collections. My description of Axelrod's intended revision comes from Axelrod's own explanations of the process (to be found in the various interviews sourced in the section "One Hot Spurt," above), as well as what was passed down to me from my conversations with Shepherd and Illeana Douglas. Comparing Elliott's treatment and draft (AMPAS Library) with Axelrod's revision(s), the changes are readily apparent. Joan Axelrod relates her husband's bedtime epiphany in George Plimpton, *Truman Capote: In Which Various Friends, Enemies, Acquaintances, and Detractors Recall His Turbulent Career* (Doubleday, 1997), and Axelrod's recognition of his low-class standing is prevalent in his interview with Patrick McGilligan in *Backstory 3* (University of California Press, 1997).

85 *Audrey's Retreat*: "I blamed God," Audrey Hepburn quoted in Ian Woodward, *Audrey Hepburn* (St. Martin's Press, 1984). Robert Wolders told me that when he asked Audrey about the details of the Hitchcock affair, she was very unclear, leading him to believe that a significant part of the deal was orchestrated by Kurt Frings behind her back. Herbert Coleman, Hitchcock's right hand, told it differently. In his book, *The Man Who Knew Hitchcock* (Scarecrow Press, 2007), Coleman maintains Audrey was complicit. Of the added rape scene, he has Hitchcock saying, "We won't let her see that sequence until we're ready to film it." Coleman refused outright and sent Audrey the new pages directly to Durango where she was shooting *The Unforgiven*. Audrey said, "Herbie, I've always wanted to work with Mr. Hitchcock. Take that scene out and tell me when you want me to report." Hitch retaliated: "Tell Paramount they must make her report when you call her or I will cancel my contract." Audrey's quote that children were "indispensable for a woman's life and happiness" is from Claude Berthod, "Audrey Hepburn," *Cosmopolitan* (October 1966). "The pregnancy transported her . . ." Sean Ferrer to SW on September 17, 2009. "She loved family more than her career . . ." Robert Wolders to SW on October 23, 2009.

88 *Romantic Comedy*: "They offered him Rhode Island and a piece of the gross . . ." Joan Axelrod quoted in George Plimpton, *Truman Capote: In Which Various Friends, Enemies, Acquaintances, and Detractors Recall His Turbulent Career* (Doubleday, 1997). From the cigars, to the vodka, to the picture of Marilyn, the evocation of Axelrod at work on *Tiffany's* was passed down to me from Illeana Douglas. "Most sex comedies involve men cheating on their wives . . ." from Vernon Scott, "Axelrod Emphasizes the Marital Theme" (*The Philadelphia Inquirer*, December 24, 1967).

90 *Doing It for Money*: All quotations from Geoffrey Shurlock's memos as well as his review of Axelrod's draft are from the *Breakfast at Tiffany's* Production Code Files in the Special Collections of AMPAS Library.

5. LIKING IT, 1960

100 *The Seduction*: "Frings was pretty sure . . ." Shepherd to SW on November 24, 2009. Jurow's description of his meeting at Dinty Moore's and his courtship of Audrey Hepburn in *Marty Jurow Seein' Stars: A Show Biz Odyssey*, along with input from Richard Shepherd, helped to rebuild the chronology of events leading up to the moment when Audrey, finally, accepts the part of Holly Golightly. The dialogue is all Jurow's. "Audrey's reluctance was wrapped up in Mel's . . ." Robert Wolders to SW on October 23, 2009. Interestingly, Jurow never placed Axelrod at the scene, but according to Axelrod, he was absolutely there. Considering the consistency between George's own versions of the story, I'm inclined to believe Axelrod's memory and conclude that Jurow, being of Hollywood, omitted George from the scene for the sake of claiming sole credit for the casting coup.

104 *Changing Partners*: "Pressure was brought to bear . . ." John Frankenheimer in Gerald Pratley, *The Films of John Frankenheimer* (Golden Cockerel Press, 1988).

105 *Beachside Interlude*: "Dearest Audrey, With two such parents . . ." Truman's letter from Ellen Erwin and Jessica Diamond can be found in *The Audrey Hepburn Treasures* (Atria, 2006).

106 *Mr. Audrey Hepburn*: "With the baby I felt I had everything . . ." Audrey quoted in Joseph Barry, "Audrey Hepburn at 40," (*McCall's*, July 1969).

"It's true that Mel was puritanical in his outlook . . ." Robert Wolders to SW on October 23, 2009.

106 *Audrey's New Man*: For a more extensive discussion of Blake Edwards's career, his handling of Cary Grant on *Operation Petticoat*, and a fuller analysis of his "Peter Gunn" style, see Sam Wasson, *A Splurch in the Kisser: The Movies of Blake Edwards* (Wesleyan University Press, 2009). "My mother was very Victorian," Audrey Hepburn quoted in a very wonderful interview, certainly among her most candid, broadcast on *Living Treasures,* 1990. "It was really a big step up for Blake . . ." Patricia Snell to SW on February 9, 2009.

108 *Bing Crosby in a Dress*: Directing *High Time* was little more than a paid gig for Blake Edwards, a job. He struggled with the material as well as Bing Crosby himself. Patricia Snell confirmed, "Bing Crosby was very, very difficult. He was having an affair with the French lady [Nicole Maurey] who was in the picture with him. Blake was very, very unhappy on that picture." "It was too cynical . . ." Blake Edwards quoted in Jean-François Hauduroy, "Sophisticated Naturalism: Interview with Blake Edwards," *Cahiers du Cinéma in English 3* (1966). "With that film we became grownups . . ." Judith Crist to SW on January 30, 2009.

112 *Jazz*: Henry Mancini's autobiography, *Did They Mention the Music?* (Cooper Square Press, 1989), written with Gene Lees, lays out Mancini's biographical and artistic orientation quite clearly, and along with conversations I had with Lees himself, considerably advanced my sense of the subject and his place in the history of motion picture music. Where there were gaps, the facts of Mancini's involvement in *Breakfast at Tiffany's* were clarified for me by Richard Shepherd, who spoke of "Moon River" with a passion and conviction matched only by his love for Audrey Hepburn.

113 *Casting*: That Mel Ferrer blocked Tony Curtis from getting the part of Paul Varjak comes to this book by way of Curtis himself. In his book, *American Prince* (Harmony, 2008), Curtis, a longtime friend of Edwards's, goes into slightly more detail about why he believes he was kept out of *Tiffany's*. "Who knows why?" Shepherd to SW on November 24, 2009. Though he didn't address Curtis specifically, during one of our meetings, Edwards admitted to me that George Peppard was not his first choice for the film. He did not explain why. "After coming

out of the film . . ." Blake Edwards quoted in Stephen Michael Shearer, *Patricia Neal: An Unquiet Life* (The University Press of Kentucky, 2006). On January 27, 2008, Patricia Neal, sitting with me in her New York apartment, told me, laughing, the story of having to dye her hair red so as to visually distinguish her from Audrey. The PR snippet about Vilallonga, dated September 19, 1960 ("He received word from Spain . . ."), comes by way of the Academy's Special Collection material on *Breakfast at Tiffany's,* held in its Paramount files. Edwards's decision to cast Buddy Ebsen was typical of the director's aptitude for finding the right talent where no one else would think to look. "Casting Buddy Ebsen as Doc Golightly . . ." Patricia Snell to SW on February 9, 2009. Buddy Ebsen's memoir, *The Other Side of Oz* (Donovan, 1994), contains the anecdote about the champagne. Frank Inn, a legend among Hollywood animal trainers, is quoted twice in this section. The first, "I have a sitting cat, a going cat . . ." is from Jon Whitcomb, "On Location with," *Cosmopolitan* (February 1961); the second, "He's a real New York type cat . . ." is from APMAS Special Collections. Paramount Publicity, dated November 23, 1960.

116 *Yunioshi*: I was shocked too. For substantiation, turn to the Paramount Files in the Special Collections of the AMPAS Library. It's all there in wonderful, horrible detail, and there's more of it than I included here.

119 *The Sound of Tulip: Did They Mention the Music?* (Cooper Square Press, 1989) contains many of these details. "Marty and I believed the song. . ." Richard Shepherd to SW on March 13, 2009.

120 *Hubert de Givenchy Undresses Edith Head*: The politics of costume design would be an utterly incomprehensible blur to me without the patient guidance of David Chierichetti, who explained the procedures of out-of-studio and out-of-country affiliations between stars and costumers, and in so doing, shed a considerable amount of light on how Edith Head would have come to be so hurt by Audrey. "The 'Costume Supervisor' credit . . ." David Chierichetti to SW on March 6, 2009. "I was sort of inadvertently thrown . . ." Blake quoted in Steve Garabino, "The Silver Panther Strikes Again" (*New York Times Magazine,* August 8, 2001).

122 *An Octave and One*: The process by which Mancini arrived at the music for "Moon River" is so well documented in the literature of the

movies, it seems almost silly to source it; however, Mancini's own account (which appears in print and on film in a number of occasions) is at its best and most thorough in *Did They Mention the Music?* (Cooper Square Press, 1989). "Hank brought a 78 record up to our office . . ." Shepherd to SW on August 24, 2009.

123 *What Johnny Mercer Does in Bed*: Deference is due to Wilfrid Sheed, whose dreamy book, *The House That George Built* (Random House, 2007), when paired with Alec Wilder's bracingly technical *American Popular Song* (Oxford University Press, 1972), gave me what I needed to see Mercer clearly, as both artist and man. Also, without the biographies of Gene Lees (*Portrait of Johnny* [Pantheon, 2004]) and Philip Furia (*Skylark* [St. Martin's Press, 2003]), and the tutorials of Mercer Scholar Robert Dawidoff, the Johnny Mercer file on my computer would be blank.

127 *The Little Black Dress*: My brief history of black was filtered through several sources. There are many books devoted exclusively to the LBD, but none was more useful to me, or indeed more illuminating, than the historical tour provided by Nancy MacDonnell Smith in her book *The Classic Ten: The True Story of the Little Black Dress and Nine Other Fashion Favorites* (Penguin, 2003). My theories about Audrey's transgressions in black were confirmed and enhanced by two pros, Rita Riggs and Jeffrey Banks, quoted here (on February 13, 2009, and August 15, 2009, respectively), as well as Letty Cottin Pogrebin (quoted later), who saw for herself the transformation that certain women of New York underwent from poofy florals to pitch black glamour. "I was in Paris for the fittings . . ." Patricia Snell to SW on February 9, 2009.

6. DOING IT, OCTOBER 2, 1960–NOVEMBER 11, 1960

133 *Fifth Avenue, Sunday, October 2, 1960, Dawn*: Just about every biography of Audrey Hepburn recounts her sadness and anxiety at having to leave Sean to shoot *Tiffany's*. Creating the scene was only a matter of filling in the details. Audrey's admiration for Patricia Neal was conveyed to me by Neal herself, who told me on January 27, 2008, that Audrey often told her that she wished she had Neal's talent, that she wanted to be her kind of actress. When I asked him, on November 5,

2009, if Audrey was as timid about acting as she was said to be in the literature about her life, Peter Bogdanovich replied, "Acting was never her favorite thing."

136 *The Northeast Corner of Fifty-seventh and Fifth, Hours Later*: Edwards's outfit that morning of October 2, 1960, is evident in the photographs of him taken on that day. Ever since his first days as a director, Blake was very much a turtleneck man. For other such details, consult *A Splurch in the Kisser: The Movies of Blake Edwards* (Wesleyan University Press, 2009). His working style, which I attempted to elicit here, is explored there in greater detail. As for Audrey's emotional connection to Givenchy's designs, one can find it documented just about anywhere, but the notion of the "armor of love" was passed down to me by Sean Ferrer on September 17, 2009, as was the detail about the two versions of the dress, one for walking and one for standing. "The little black dress," he added, "is nothing more than the inner elegance of the person that wears it."

137 *128.54 Carats*: Marty Jurow, in *Marty Jurow Seein' Stars: A Show Biz Odyssey*, goes into more detail about the negotiation that won him the permission to shoot inside Tiffany's. Information about the famous Schlumberger necklace is readily available, but I relied on Joseph Purtell's *The Tiffany Touch* (Random House, 1972).

139 *The Diamond in the Sky*: The article "On Location with Jon Whitcomb, Audrey (Golightly) Hepburn," *Cosmopolitan Magazine* (February 1961) furnished me with the many details and complications Planer and his crew encountered lighting and shooting the difficult scene inside Tiffany's.

141 *Action!*: The ordeal of the 220-volt shock, as well as Blake and Audrey's remarks from the section, appeared in Eugene Archer, "Playgirl on the Town" (*New York Times*, October 9, 1960).

144 *Lunch*: Richard Shepherd to SW on March 13, 2009.

146 *George Peppard, in Method and Madness*: I really wanted to give George Peppard a fair shake here, but the more I heard, the harder it became. Even Blake Edwards, who rarely utters an impolitic word, couldn't help but intimate, on one occasion when I spoke with him, that Peppard was a source of frustration for him. Audrey saw it similarly. Her remark, "Of course, all actors have a 'method' . . . ," was taken from "On Location with Jon Whitcomb, Audrey (Golightly) Hepburn,"

Cosmopolitan Magazine (February 1961). Patricia Neal really cut loose with me on the subject on January 27, 2009, and March 13, 2009. All these years later, she's still seething. Elizabeth Ashley's observation, which I found quite illuminating, "George never was one of those actors . . . ," is from her book *Actress: Postcards from the Road* (Fawcett, 1975; with Ross Firestone). Blake Edwards's admission, "I liked George; he was such a ham . . . ," is from *Patricia Neal: An Unquiet Life*, by Stephen Michael Shearer (The University Press of Kentucky, 2006). Patricia Snell's hypothesis, which begins "I think the problem with George . . . ," is from our conversation of February 9, 2009. In the midst of all this, I was comforted to find some sort of explanation. Although it doesn't clear everything up, I hoped Peppard's side of things would provide some healthy complexity. His story, beginning with "My whole world fell apart in one day," is from "Behind the Scenes with *Breakfast at Tiffany's*" (*Screen Stories Magazine,* October 1961). I should add that I had a brief conversation with Peppard's son Brad, who was unable to offer more insight. He told me that his father was very careful about keeping his family and work lives far apart.

150 *Audrey & Mel & Blake & Audrey*: Patricia Neal's story about Mel and Audrey, which begins "He was very tricky with her, you know . . . ," was taken from our interview of January 27, 2009. Edwards's quotation, "I don't know whether her men had a lasting effect on her career. . . ," comes by way of an extended riff on the subject of Audrey and her men, "Style, Elegance and Bad Luck with Men" (*Newsweek,* June 28, 1999), in which Edwards laments the needy side to Audrey's disposition and explains how it accounted for her many difficult relationships. Buddy Ebsen's description of Audrey's working style, "No two takes are identical . . . ," is from his memoir, *The Other Side of Oz: An Autobiography* (Donovan, 1993; with Stephen Cox). Audrey's line, "You know, I've had very little experience . . . ," came from Eugene Archer, "Playgirl on the Town" (*New York Times,* October 9, 1960). Finally, Edwards's remark, "In those days, everyone fell in love with Audrey," arrived by way of an e-mail exchange dated July 29, 2009. When I quoted Edwards's e-mail to Robert Wolders, he chuckled. His reply, "I can assure you that there wasn't any of that . . . ," came from our conversation of October 23, 2009.

154 *Throwing a Party to Shoot a Party*: "It was indicated in the screen-

play . . ." Blake Edwards in Jean-François Hauduroy, "Sophisticated Naturalism: Interview with Blake Edwards," *Cahiers du Cinéma in English 3* (1966). The rest of the quoted material from this section came directly from my interviews from the original party people. They are Miriam Nelson (interview of February 23, 2009), Fay McKenzie (interview of February 20, 2009), Joyce Meadows (interview of February 26, 2009), and Kip King (interview March 11, 2009). And Shepherd's loving tribute to Audrey, "Everything you have read . . . ," is from our conversation of March 13, 2009.

163 *The End*: Patrick McGilligan's interview with Blake Edwards, from *Backstory 4: Interviews with Screenwriters of the 1970s and 1980s* (University of California Press, 2006), started me on the notion that the ending Edwards used in *Breakfast at Tiffany's* was not written by George Axelrod. That the image of the cage, which Edwards uses to introduce the party scene, and was recapitulated in Fred's famous monologue, led me to believe that Edwards hadn't merely revised Axelrod's scene, but had totally rewritten it. Also, many of Edwards's later films end, like *Tiffany's*, on a somewhat unconvincing note of romantic union (see *A Splurch in the Kisser: The Movies of Blake Edwards* [Wesleyan University Press, 2009]), so when I got the idea that the surviving ending was all Edwards, I was all but positive when I asked Blake, in an e-mail correspondence of July 29, 2009, to confirm my suspicions. He did, though somewhat reluctantly. "How the hell did you find out?" he croaked to me on the phone the next day, and added, "I didn't want to go around telling everyone that I had written it. That wouldn't have been nice." Patricia Snell's echo, "Blake shot both endings . . . ," is from our conversation of February 9, 2009.

167 *The Cat in the Alley*: "As a woman . . ." Judith Crist to SW on January 30, 2009.

168 *The Raincoat*: "Edith did the raincoat . . ." Patricia Snell to SW on February 9, 2009.

7. LOVING IT, 1961

171 *One of Bennett Cerf's Dinner Parties*: Joan's story is from *Truman Capote: In Which Various Friends, Enemies, Acquaintances, and Detractors Recall His Turbulent Career* (Doubleday, 1997).

172 *One of Billy Wilder's Dinner Parties*: We can see now that Blake was right
 to go for his ending, however unconvincing it might be. It is of a piece
 with the misty, wistful tone of the picture. George's ending, though it
 makes more emotional sense than Edwards's, was out of step with the
 conventions of the romantic comedy of the early 1960s, and as such,
 had to be forsaken. Both are equally right and equally wrong, but that
 wouldn't keep George from harboring resentment toward Blake, es-
 pecially considering his long history of getting screwed out of his own
 material. Pat Snell's explanation, "What Blake did with the cocktail
 party . . . ," came from our conversation of February 9, 2009. George's
 anger at the Mickey Rooney segments, "Each time he appeared I
 said . . . ," can be found in George Axelrod in *Screencraft*: *Screenwrit-
 ing* (Focal Press, 2003). What Billy said to Axelrod about leaving New
 York is paraphrased from *Backstory 3* (University of California Press,
 1997). Axelrod would repeat the same conversation, with negligible
 variations, throughout his career.

174 *Mancini Is Ready to Score*: Mancini's autobiography, *Did They Mention
 the Music?*, was indispensable here, as was *The Sixties*, Paul Monaco's
 volume in the *History of the American Cinema* (University of California,
 2001). There is simply no way to write about Hollywood without con-
 sulting this series. Audrey's letter to Mancini can be found online at
 http://www-personal.umich.edu/~bcash/music.html.

175 *That Fucking Song*: As I state in the book, there are many versions of
 this story, and most of them credit Audrey with saving "Moon River."
 In my conversations with Richard Shepherd, I was sure to remind him
 of this, and he was sure to confirm that he was the one to stand up and
 speak out. Fay McKenzie's anecdote about Mel Ferrer, "After the pre-
 view . . . ," came from our conversation of February 20, 2009. Richard
 Shepherd's summary, "The song had been an issue for Rackin . . . ," is
 from March 13, 2009. The quote of Mancini's version of that meeting,
 "Audrey shot right up out of her chair . . . ," was taken from Warren
 Harris's *Audrey Hepburn*: *A Biography* (Simon & Schuster, 1994)

178 *The Kook*: The kook stuff was everywhere. "Let's face it now, what is a
 'kook'?" from the AMPAS Library's Paramount Publicity Files, Octo-
 ber 26, 1960. "When you publicize this unusual role . . ." from "Behind
 the Scenes with *Breakfast at Tiffany's*," *Screen Stories* (October 1961).
 "If you're an Audrey Hepburn fan . . ." from *Photoplay* (July 1961).

"Since Miss Audrey Hepburn has never played . . ." from the AMPAS Library's Paramount Publicity Files, September 13, 1960.

181 *The Poster*: Robert McGinnis interview with SW on August 5, 2009.

184 *What the Critics Thought*: For an authoritative listing of reviews of *Breakfast at Tiffany's*, consult David Hofstede, *Audrey Hepburn: A Bio-bibliography* (Greenwood Press, 1994). Weiller's notice in the *New York Times* from October 6, 1961; *Variety*'s review from October 5, 1961; Brendan Gill's glorious *New Yorker* review from October 16, 1961; and Penelope Gilliatt's review can be found in her book, *Unholy Fools* (Viking, New York: 1973). Irving Mandell's letter to columnist Hazel Flynn, which includes "The *Tiffany* picture is the worst of the year . . . ," comes from *Hollywood Citizen-News*, February 20, 1962.

185 *Working Girl*: Letty Cottin Pogrebin interview with SW on March 6, 2009.

187 *One of Swifty Lazar's Dinner Parties*: "Sometime after the movie came out . . ." Patricia Snell to SW on February 9, 2009. "The book was really rather bitter . . ." quoted in an interview with Eric Norden, *Playboy* (March 1968). Capote's lament, "Oh, God, just everything . . ." from *Conversations with Capote* (New American Library, 1985). "Truman was strongly opposed to the screenplay," Richard Shepherd to SW on March 13, 2009..

189 *One of Akira Kurosawa's Dinner Parties*: The incredibly funny, incredibly sad story about Kurosawa, beginning "When I was an agent at CMA . . . ," came from my conversation with Shepherd on March 13, 2009. Mickey Rooney's feelings about playing Mr. Yunioshi have been paraphrased from a remark he made in Bruce Calvert, "Racism in Reel Life" (*Sacramento Bee*, September 9, 2008), after what was to be a free outdoor screening of *Breakfast at Tiffany's* was canceled on account of anti-Yunioshi protests. *Ratatouille* was screened instead, which, given the chance, I would have protested. Blake Edwards has apologized—publicly, on various editions of the *Breakfast at Tiffany's* DVD—for casting Rooney in the part.

189 *Letty Cottin Pogrebin Goes All the Way*: Letty Cottin Pogrebin to SW on March 6, 2009.

191 *The Envelope Please*: In *Did They Mention The Music?* Mancini describes the events leading up to his Oscar acceptances. He and Johnny Mercer's dialogue was pulled verbatim from the telecast of April 9, 1962.

The transcript from the Thirty-fourth Academy Awards can be found at the AMPAS Margaret Herrick Library in Los Angeles.

195 *The End of the Romantic Comedy*: For more specifics on how Audrey overcame her concerns about *Two for the Road* and finally accepted the role, consult *Dancing on the Ceiling: Stanley Donen and His Movies* (Knopf, 1996). "I must confess to having been uncertain about taking on the role," Audrey writes in her introduction to the book, "but it was Stanley who, through sheer persistence, convinced me to accept it. Freddie Raphael had done a brilliant script, perhaps one that was slightly ahead of its time. It was extremely sophisticated, both in its exploration of the various stages of the man's and woman's infatuation with one another and in the way the story played itself out backward and forward in time."

8. WANTING MORE, THE 1960S

199 *The Beginning of the Romantic Comedy*: "The Audrey I saw during the making of this film . . ." Stanley Donen quoted in Ian Woodward, *Audrey Hepburn* (St. Martin's Press, 1984). "Audrey's the one who asked for the divorce" from Lina Das, "Another Audrey," *Mail on Sunday* (London), November 7, 1999. Judith Crist, *New York World Journal Tribune*, April 28, 1967. Richard Schickel, *Life*, May 12, 1967.

201 *The First Ms.*: Letty Cottin Pogrebin to SW on March 6, 2009.

202 *Adieu Edith*: The story about Edith and Audrey's encounter in the commissary is well told in David Chierichetti's *Edith Head*. Rita Riggs's anecdote, beginning "When Gulf + Western bought Paramount," is from our conversation of February 13, 2009.

203 *Truman's Swan Song*: Sally Bedell Smith's *In All His Glory: The Life & Times of William S. Paley and the Birth of Modern Broadcasting* features what could very likely be the best biographical material that will ever be written about Babe and catalogues her reaction to "La Côte Basque, 1965" in exquisite and painful detail. Naturally, Gerald Clarke's *Capote* tells the same story from Truman's side, and contains, on its final page, a record of his last words.

ABOUT THE AUTHOR

SAM WASSON studied film at Wesleyan University and
the USC School of Cinematic Arts. He is the author of
A Splurch in the Kisser: The Movies of Blake Edwards, and the
forthcoming *Paul on Mazursky.* He lives in Los Angeles.